THE BARD BROTHERS

*Painting America
Under Steam and Sail*

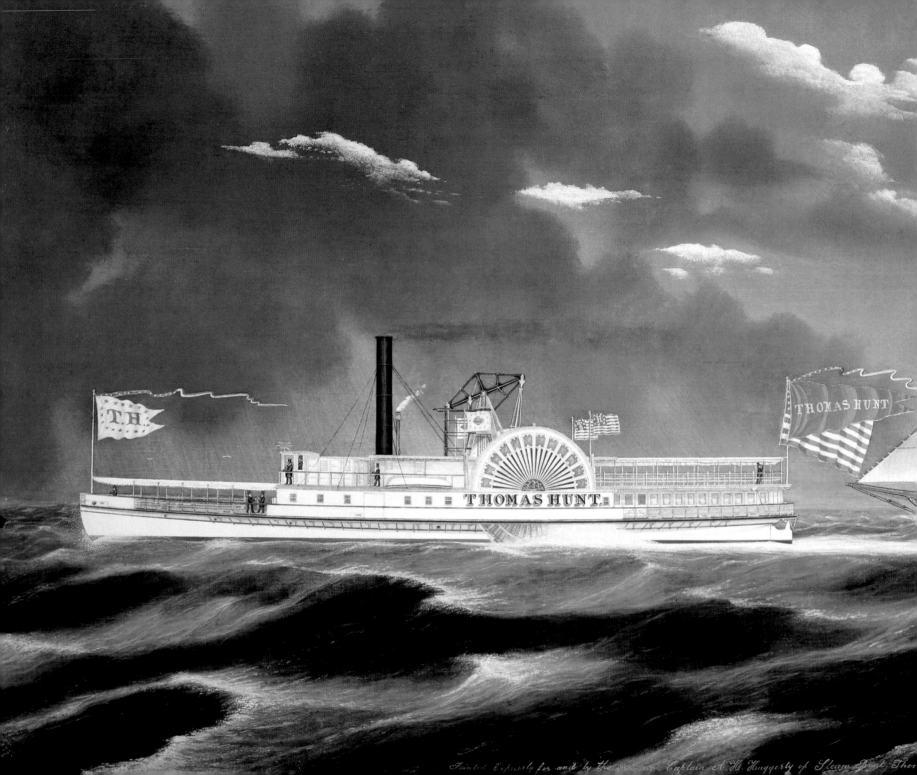

Painted Expressly for and by the ————— Captain A. H. Haggerty of Steam Boat Tho———

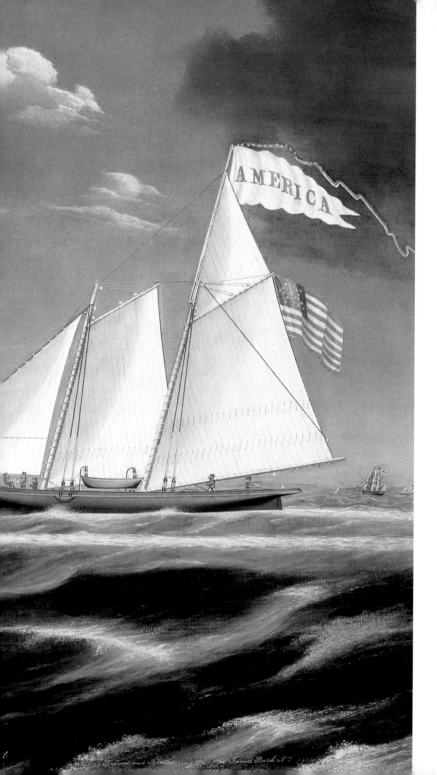

THE BARD BROTHERS

*Painting America
Under Steam and Sail*

THE MARINERS' MUSEUM

IN COLLABORATION WITH

ANTHONY J. PELUSO, JR.

*Harry N. Abrams, Inc., Publishers
in association with The Mariners' Museum*

EDITOR: Robert Morton
EDITORIAL ASSISTANT: Nola Butler
DESIGNER: Dana Sloan

Library of Congress Cataloging-in-Publication Data
The Bard brothers: painting America under steam and sail / the Mariners'
Museum in collaboration with Anthony J. Peluso, Jr.
p. cm.
Includes bibliographical references and index.
ISBN 0–8109–1240–6 (clothbound)
1. Bard, James, 1815–1897—Criticism and interpretation. 2. Bard, John,
1815–1856—Criticism and interpretation. 3. Artistic collaboration—New
York (State) 4. Hudson River (N.Y. and N.J.) in art. 5. Steamboats in art.
6. Primitivism in art—New York (State)
I. Peluso, Anthony J. II. Mariners' Museum (Newport News, Va.)
ND237.B262B37 1997
759.13—dc20 96–34075

Published in 1997 by Harry N. Abrams, Incorporated, New York
A Times Mirror Company

Printed and bound in Hong Kong

PREVIOUS PAGES:
James Bard. *Thomas Hunt and America*. 1852.
Oil on canvas, 34½ × 64½". Private collection
This double portrait was completed shortly after the yacht *America* won her
historic victory and the steamboat *Thomas Hunt* had just been launched.
Bard joined these two events on one of his largest canvases. This painting and
others have a very small hole in the center of the paddlebox, where the artist
set his compass when fashioning the paddlebox's circular decoration.

Contents

PREFACE
John B. Hightower, President and CEO, The Mariners' Museum 7

INTRODUCTION
Lynda Roscoe Hartigan, Curator of Painting and Sculpture,
National Museum of American Art, Smithsonian Institution 8

Chapter One
A CAREER BORN YOUNG 15

Chapter Two
CLIENTELE: CAPTAINS, COMMANDERS, COMMODORES, FRIENDS 35

Chapter Three
THE MARINE PAINTER'S TRADE AND ART 89

Chapter Four
TECHNIQUE OF THE BARDS 105

Chapter Five
PAINTING AMERICA UNDER STEAM AND SAIL 141

Notes to the text 162

Select bibliography 164

List of known Bard works 165

Index 172

PREFACE

American folk art does not easily conform to the chronological canons of art history. Occasionally it transcends the relevance of its own time and instantly illuminates a particular period. It may also appear to be timeless—as recent as yesterday, as long ago as the beginning of our nation. All folk art has a powerful innocence emanating from not being encumbered by the formalities and elegance of fine art. There is an almost toylike quality to much of its exuberance. With the added cosmetic of age, its raw, unexpected clarity takes on a depth, beauty, and warmth that transcend the images it conveys. Biblical scenes, a favorite category of folk art subjects, can be startlingly literal and passionate as a result. Purveyors' signs radiate scents and flavors by revealing more than their basic fare.

The noted seminal designer and filmmaker Charles Eames was fascinated with toys. His short film *Toccata for Toy Trains* contains all the condensed magic and wide-eyed wonder of one's first remembered impressions of a train. Over time the huge machines born of childhood memory, hissing and spitting steam, spewing black, acrid coal smoke softened into a fond familiarity and the embrace of special moments.

The paintings of the Bard brothers, and especially James, as their chronicle would have it, possess the qualities Eames saw infused in toy trains. Their subjects were boats and ships gliding more often than not along New York's Hudson River—the Rhine of the New World. Bearded men in top hats gesture stiffly to one another. River spray literally dapples with tiny dots of paint the bows of tugs and day liners. Shiny brass finials, like sentinels for the engine's walking-beam heart, are made round and shiny with bits of paper under gold paint. The sky is a muted rainbow of color. Slowly, seductively, the knowing innocence of the Bards' untutored painting captures the imaginings not of a day on the Hudson a century ago, but the essence of that day—of what we would have wanted to remember it to be.

Tony Peluso has lived under the spell of James and John Bard's paintings for a long time. His beneficent addiction appears with unmasked enthusiasm throughout the pages of this book, and in the 1997 exhibition he has organized for The Mariners' Museum. We are indebted to him for sharing his insights on these paintings with us. We are also grateful to him for guiding us to their irrepressible delights.

John B. Hightower
President and CEO

Introduction

"Give me insight into to-day, and you may have the antique and future worlds."
—RALPH WALDO EMERSON, "AMERICAN SCHOLAR," 1837

In 1997, as we mark the centennial of James Bard's death, consider two events, some two hundred years apart, as noteworthy brackets to the year 1897. In 1790 the federal government convened a commission to settle the patent claims of rival steamboat inventors. From that commission emerged the U. S. Patent Office, testimony to the steamboat's impact on the country's technological evolution and spirit of invention. In 1995 watercolors and oils by James Bard attained record prices for the artist's work—exceeding $200,000 in some instances—in Sotheby's fall and winter folk art auctions in New York. Bought primarily by private art collectors oriented more toward connoisseurship than history, this trove of paintings has come a long way from the twenty to fifty dollars paid by their original commissioners in New York's maritime business community between 1827 and 1890.

Despite the breathtaking disparity between these two sets of figures, both accurately reflect the success of the twin "picture painters" John (1815–1856) and James Bard (1815–1897) according to ideas and values in different times and markets. The longer life of James especially coincided with the cultural, economic, and demographic changes effected not just by the steamboat's ascendancy over sailing ships but by equally momentous events, such as the country's decisive victories in the War of 1812, and revolutionary inventions, from the telegraph in the 1830s to the Brownie camera in 1888.

Westward expansion during the nineteenth century has so defined our perception of the American frontier that it has often overshadowed the equally significant if not primary role of oceans, coasts, and inland waterways in the country's history. Crossing the ocean, of course, had launched the colonists on a voyage of life, and provided their first exposure to the challenging frontiers that awaited them. By the early nineteenth century, American artists expressed a full-blown interest in the ruggedly pristine beauty of the New World, idealized as much as documented in increasing numbers of landscapes and seascapes by such artists as Fitz Hugh Lane.

Ship portraits also emerged as a subject in demand during the heyday of American maritime enterprise. Following the American Revolution and the War of 1812, the young republic experienced a burst of commercial growth and national pride that generated a domestic market for images of national figures, heroic events, and progress. Painters and sculptors—with or without academic training—as well as illustrators and printmakers rose to the occasion. Among the images favored by artists and patrons alike were sailing vessels (especially clippers) and steamers, all rendered with

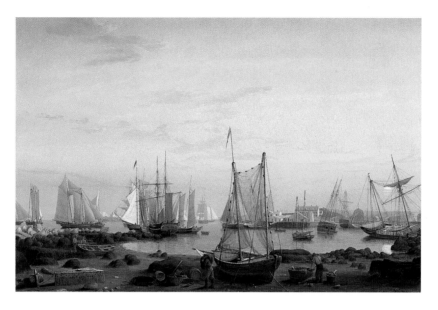

Fitz Hugh Lane (1804–1865). *Gloucester Inner Harbor*. 1850.
Oil on canvas, 24 × 36". Collection The Mariners' Museum

attentive detail as symbols of speed, beauty, and national advancement in the commercial and natural worlds.

With precedents dating back to antiquity, ship portraits and marine painting in general had flourished in Europe during the seventeenth and eighteenth centuries, especially among the English, Dutch, and French. American artists were introduced to these traditions through travel abroad, contact with European artists visiting or immigrating to this country, and a variety of printed sources. Before long, the topographic, documentary, and romantic possibilities of marine painting in its principal expressions—seascapes, harbor views, naval scenes, and ship portraits —were familiar to many.

Although European artists developed a brisk business in painting portraits of American vessels themselves, they soon competed with American practitioners from coast to coast and from the Great Lakes to the Gulf. Preeminent among them were John and

James Bard, working together in lower Manhattan from the 1830s until 1849, when John entered a period of personal decline. Thereafter, James pursued an independent career until his last commission in 1890.

The Bards were ideally situated to meet the demand for ship portraits because the principal market was among the maritime entrepreneurs, merchants, and seagoing men active in New York City and to the north and east. The requirements and expectations of these clients were well known. Accuracy of representation was paramount. In keeping with the era's preference for combining the practical and the artistic, an ability to create atmospheric effects and landscape settings was desirable but secondary, if only because neither element could upstage the ship as subject. Once completed to a client's satisfaction, a work's destination was usually commercial rather than domestic. Displayed in wharfside offices, taverns, and elsewhere, the portraits fulfilled the desire of

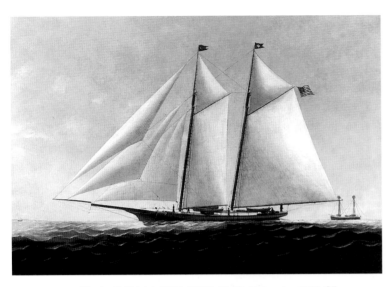

Charles S. Raleigh (1830–1925). *The Yacht America.* 1877. Oil on canvas, 27 × 40". National Museum of American Art, Smithsonian Institution, gift of Mrs. Eugene O'Dunne

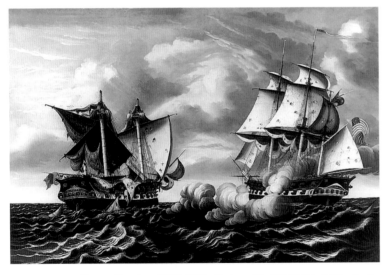

Thomas Chambers (1808–1879). *Capture of the H.B.M. Frigate* Macedonian *by U.S. Frigate* United States, *October 25, 1812.* 1852. Oil on canvas, 34¾ × 50¼". National Museum of American Art, Smithsonian Institution, gift of Sheldon and Caroline Keck in honor of Elizabeth Broun

owners to record their ships for posterity, and signaled their success within the maritime industry.

The range and numbers of vessels painted by the Bards—from river and coastal steamboats to legendary racing yachts, from commuter ferries to schooners—attest to their patrons' confidence in the pair's ability to produce the meticulously accurate depictions required. Their early efforts were understandably immature (they first tried their hands at the subject at the age of twelve), but promising enough. Although much has been made of the time James spent measuring ships during and after their construction and making preparatory drawings and corrections, this is only one element in the equation responsible for the brothers' progress toward assured illustration.

Natural talent and hands-on experience aside, the Bards may have called upon other resources. They probably had access to painted or printed ship portraits from which they learned the basics—for example, creating a water-level view of a ship seen broadside and moving from right to left in a horizontal composition. James Bard's habit of incorporating inscriptions about a ship and its owner into a painting recalls a similar custom in many European ship portraits of the period and their counterparts in widely distributed prints. Also indicative of familiarity with printed sources is the phrasing of his signature—"drawn and painted by"—that claims these acts as his, much in the manner that a print publisher would cite the painter of an original work being reproduced as a print in conjunction with the name of the illustrator and engraver responsible for the translation from one medium to the other.

Comparing Bard ship portraits to other European and American examples of the period is crucial to understanding the degree to which the brothers, James especially, absorbed the conventions of their chosen genre. Recurring details—carefully contained settings, an emphasis on the clean, the fresh, and the new, ships shown uncharacteristically flying a full set of flags, or with all

sails up—all had their purpose to suit an interdependent community of artists and patrons. From this should emerge a closer appreciation of Bard's compositions, not just as literal documents of the ships themselves but also as the artist's response to ships under steam and sail as cultural symbols. Discerning these kinds of distinctions helps to refine an estimation of what constitutes traditional and original facets of the Bard portraits.

The abundance of gaily decorated, oversized flags displayed by each ship in these works, for example, has frequently been cited as one of the key features of the Bard signature style. Certainly, the consistent presence and treatment of the flags, which incorporate prominent renderings of each ship's name, suggest the artists' desire to please their clients. Consider, however, that the Bards may have also developed this feature as a literal and symbolic way of celebrating American ships, not unlike the manner in which fellow marine painter Thomas Birch emphasized the flags of warships as symbols of national achievement in his paintings inspired by the War of 1812.

In the final quarter of the nineteenth century, James Bard's advancing age, the railroad's triumph over river boats, and photography's increased applications all combined to diminish the call for his services. Despite a laudatory obituary, Bard and most of his works soon passed from sight literally and figuratively. This same fate befell other marine painters (especially ship portraitists), and diverse changes in tastes and ideas during this period would relegate other American artists to the fraternity of the forgotten or lost. Landscape and genre painters working in the expressive Barbizon mode and sculptors devoted to the neoclassical style come to mind in this regard.

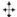

In 1924 a benchmark in posterity's estimation of James Bard's efforts occurred when painter Henry Schnakenberg included two Bard paintings in the Whitney Studio Club's exhibition, *Early American Art*. The exhibition helped draw the works to the attention of a new public even as it reinvented their origin, purpose, and audience. A gifted, commercially astute illustrator was now seen as an American folk artist—naive and primitive—from a bygone era. From this reinvention has evolved an entirely different way of valuing these steamboat portraits, one that persists even today as their recent successes in folk art auctions clearly indicate. To explore that difference, however, requires bringing an intermediary and still languishing chapter in the Bard story into greater relief.

The outline is this. Steam-powered ships continued to service American rivers and coasts into the twentieth century, and their oceanic cousins—from freighters to passenger liners—maintained their supremacy in long-distance shipping and transportation into the 1950s. Although James Bard had lived to witness an industry's declining interest in commissioning portraits of his specialty, the inland steamer, the likes of Antonio Jacobsen sustained his busy career painting portraits of transatlantic steamers for a full two decades past Bard's death in 1897. And by the turn of the century, not surprisingly, an invention as technologically and culturally significant as the steamship had attracted a community of enthusiasts, commentators, and researchers. It is this community that reinforced and perpetuated the high regard in which Bard's documentary and decorative ship portraits had been held by his original patrons.

The first known instance of this community's estimation of the Bard brothers occurred in 1895 when Samuel Ward Stanton praised James Bard's efforts in the preface of his book, *American Steam Vessels,* and acknowledged his paintings as one source for the numerous pen-and-ink renderings that Stanton drew for the volume. A friend to Bard in his later years, Stanton, also an artist, was a gifted illustrator whose love of steamboats inspired his career as a pioneering historian in this domain. By 1920 the American ranks of those dedicated to writing the steamboat's history had grown to include John H. Morrison, David L. Buckman,

C. Seymour Bullock, and Francis B.C. Bradlee, all of whom considered the Bards' contributions from a documentary perspective, and incorporated illustrations of their works in publications.

Bradlee in particular collected not just information, documents, and artifacts but images in printed, painted, or photographic form. Similarly acquisitive were George W. Murdock and Elwin M. Eldredge of New York, themselves widely known for their steamboat expertise in contemporary maritime history circles. All three assembled Bard paintings from diverse sources: Eldredge owned the greatest number of preparatory and finished works by far. All three included their Bards in the larger, primarily archival holdings that they transferred to institutions: Murdock to the New-York Historical Society in Manhattan in 1924, Bradlee to the Peabody Museum of Salem, Massachusetts, in 1928, and Eldredge to The Mariners' Museum in Newport News, Virginia, in 1940.

The activities of these history-driven collectors point up the value of the Bard works, and also raise the issue of how their paintings and watercolors entered a larger and different world. As owners of the steamboats sold their companies, went out of business, or died, the ship portraits they had commissioned suffered different fates. Sadly, an unknown percentage was destroyed. Of the balance, some were kept and then descended through owners' families, while others were lost, given away, traded, or sold— the traditional opportunities for dispersal, and, hopefully, collection and preservation, in other quarters by subsequent generations.

Enter organizations such as the Long Island Historical Society (now the Brooklyn Historical Society), which accepted the Union Ferry Company's collection of its New York Harbor ferry steamers by the Bards in 1890. Enter the likes of Bradlee, Murdock, and Eldredge as historically oriented private collectors. And enter, inevitably, pickers, dealers, and collectors with a taste for antiques, memorabilia, or curiosities. Once fully tracked and analyzed, what useful story could the provenance of Bard works tell us about the impetus and patterns of their dispersal?

It is in this mix of commercial, private, and public hands that Bard works existed by the 1920s. We may never know the basis of Henry Schnakenberg's familiarity with the material. Yet one senses the existence of an identifiable link, whether it was by way of a historical society's holdings or a dealer in Americana. During the 1920s Schnakenberg and a small but now well-known cast explored these sources as well as attics, barns, and junk stores up and down the Eastern seaboard. There they discovered a truly disparate universe of eighteenth- and nineteenth-century objects that they considered exemplars of early American folk art. The marriage between the functional and the decorative was an especially prized characteristic, and Bard's ship portraits fit the profile neatly, as did weather vanes, ships' figureheads, mourning pictures, theorem paintings, and the like.

Primarily domestic or commercial, the nineteenth-century audience for such works had originally valued this combination of the practical and artistic. In point of fact, however, functionalism had held sway in judging an object or an artist as successful. Oriented toward the fine arts, a new twentieth-century audience chose to favor the decorative partner in the marriage, seeing the same works primarily in terms of form, color, and pattern—the bolder, flatter, and simpler the better. The early twentieth century's fascination with progress precluded acknowledging a comparable rate of progress in the previous century, and a vocabulary emerged that revolved around concepts of the childlike, naive, and primitive. This seemed to serve the new century's need to demonstrate how far a country and its people had come, at least in terms of evaluating some of its early artistic efforts.

Evaluations of Bard ship portraits as folk art have regularly set aside the tradition of self-conscious accuracy and artistry that is the genuine heart of these works. Since the 1940s the same trend has also been evident in art historical studies of American

marine painting. Whether celebratory or interpretive, most such studies have identified the Bards with those amateur and self-taught but professional artists who contributed to the American tradition of ship portraits. One can hardly argue that John and James Bard were not self-taught, for they were, like many artists of their time. From a twentieth-century vantage, however, the inference in both folk art and marine art quarters is that the nonacademic origins of the Bard brothers prevented them from attaining anything more than a quaint or decorative rendering of their subjects.

Clearly, a remarkable inversion in the perception of their representational abilities and the context in which the Bards worked has occurred over time. The current orientation toward culturally derived reinterpretations of nineteenth-century American art will help to redress this inversion. A stronger understanding of the relationship between creativity and cognition is equally imperative if the presumption that self-taught artists tend to create a conceptual, rather than observed, version of reality is to be either confirmed or challenged.

As the sustained efforts of Anthony J. Peluso, Jr., make evident in this publication, and in the nationally touring exhibition that he has organized with The Mariners' Museum, it is possible to engage the efforts of John and James Bard on various levels—from the anecdotal to the interpretive, the regional to the national, the documentary to the artistic. Even as more works and information have surfaced, however, so, too, have tantalizing challenges. The Bard brothers, for example, may remain forever faceless to us, just as their biographies may defy completion, but where might additional inquisitiveness lead us on those fronts alone?

Notwithstanding the assumption that the Bards as children encountered steamboats, why and how did twin brothers at the age of twelve render their first ship portrait for someone no less prominent than "Commodore" Cornelius Vanderbilt? Did their industrious tradesman father work in any of Vanderbilt's varied businesses, affording an introduction and opportunities for the twins? In keeping with the times, had their father arranged for them to enter trades that facilitated familiarity either with mechanical drawing and steam engines or with ships and the increasing demand for ship portraits? That their father's last will and testament provided for apprenticing a younger brother enriches this possibility.

The cross section of New York's shipping industry represented by the loyal clientele of the Bards is indeed significant. What more can or should be made, however, of the triangle formed by James Bard and two of his earliest patrons, Cornelius Vanderbilt and Albert DeGroot? Vanderbilt had taken a young working-class DeGroot under his wing, from which grew the latter's colorful and lucrative ship captain's career between the 1830s and 1850s. James Bard's marriage to DeGroot's sister before 1843, and the early commissions he received from both men, suggest a confluence responsible not just for specific sources of income but for the crux of the network that he was able to build over the years. No less intriguing in this regard are Vanderbilt's railroad interests, which may someday shed light on two documentary references to James Bard as an engineer or as a mechanic affiliated with a railroad.

In considering watercolors and paintings by the Bard brothers today, romance and nostalgia vie with history and innovation for our attention. Through these images we can also examine patronage patterns that changed from their times to ours, as well as the nautical and technological advances that altered this country's economy and cultural geography. Ralph Waldo Emerson exhorted artists, amateur and academic alike, to pursue the "today" of America. His admonition still hovers over Bard ship portraits, inviting us to navigate provocative relationships between nature and science, art and commerce, and, finally, past and present.

A CAREER BORN YOUNG

Robert Fulton, the inventor of the first commercially successful steamboat, died in 1815. Ironically, the story of the most famous chroniclers of the American steamboat, the artists James and John Bard, begins in that same year.[1]

The twins, James and John, were born in New York City on October 4, 1815, on property known as Chelsea Farm and owned by Clement Clark Moore. (Their landlord is best remembered as the author of the story, "A Visit From St. Nicholas.") From his home, Moore could see the Hudson River and the tranquil traffic of schooner and sloop. The river's calm was occasionally broken by the passing of Fulton's steamboat, billowing smoke and sparks and making noises that had never been heard before. Moore's view also encompassed, in the words of a turn-of-the-century writer, the "little wooden houses in which dwelt folk of a humbler sort," those workers and their families who labored on his estate. It was in one of these houses that James and John were born.

In 1818, their English-born father, Joseph, moved his Scotch-born wife, Nellie Purvis Bard, and his small family to the bustle and crowding of lower Manhattan. They lived for a year at 22 Crosby Street and then moved to Elm Street (now Lafayette Street). A review of New York City directories for the years 1820–30 reveals that the twins grew up on Elm, a street lined with the modest homes of laborers and tradesmen, including their neighbors the gratemaker, the furrier, and the "colored" shoemaker.

The 1820s was a time during which the river and steamboats seemed to capture everyone's interest and imagination. Even the United States Supreme Court was involved. In February 1824, *Gibbons v. Ogden* was decided by Chief Justice John Marshall and the court. The ships that inspired the litigation were *Bellona* (captained by Cornelius Vanderbilt) and *Stoudinger*. This landmark decision loosed the competitive energies of the men who were

JAMES AND JOHN BARD
UTICA
Undated. Watercolor on paper,
15¼ × 22½" (38.7 × 57.1 cm).
Collection The Mariners'
Museum

This early watercolor is signed, enigmatically, "J. Bard Painters." Captain M. H. Truesdell ran *Utica* to Albany for The People's Line every other day.

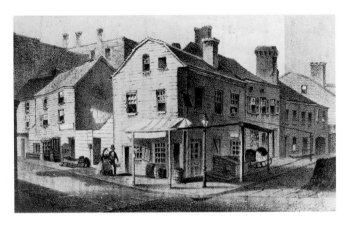

The etching, *Old Houses Corner Pearl & Elm* dates from 1860, but very likely shows the neighborhood in which the Bard family lived in the 1820s and 30s. (Peluso collection)

to fight for control of the river into the mid-nineteenth century and heralded the beginning of a new kind of race for power and profit.

In *Gibbons v. Ogden*, suit was brought by Aaron Ogden in the New York courts to prevent Thomas Gibbons from running steamboats between New Jersey and New York. Ogden claimed the protection of a monopoly granted by the New York legislature jointly to Robert Fulton, the inventor, and to Robert R. Livingston, the financial backer, who in turn licensed Ogden to navigate on state waters by steamboat. Gibbons asserted his own rights under a superseding federal license. The state court decided for Ogden, but in the Supreme Court the case turned over on the definition of the power of Congress under Article 1 of the Constitution "to regulate commerce. . .among the several states." John Marshall held that the term "commerce" applied to passenger steamboat traffic, and he struck down the New York monopoly as inconsistent with national power.[2]

A year after the *Gibbons v. Ogden* decision, in 1825, the Erie Canal was opened to the booming sound of echoing cannons up and down the length of the Hudson. The canal dramatically extended the reach of East Coast manufacturers and merchants not only up into northwestern New York State, but into the heartland of the continent. It was a time when the East River clipper ship builders were beginning to turn their attention to the profitable construction of steamboats.

In the midst of these events, the Bard twins, then twelve years old, painted their first picture, of the steamboat *Bellona* in 1827. The Bard painting partnership was consolidated within the next decade. Watercolors of several vessels built before 1837 have survived or have been recorded: among these are *Commerce, Dewitt Clinton, Fanny, General Jackson, Superior, Providence, Frank, Lexington, R. L. Stevens, Highlander, Cleopatra,* and *Rochester.* By 1836, the brothers had begun to date their work. From 1837 we have *Illinois, Telegraph,* and *Swallow.* At their father's death, in 1838, James and John are listed for the first time in the New York City directory as "painters."

Sometime in the previous decade, their father had acquired from Stephen Van Rennsselaer a leasehold on the house at 137 Elm Street, which provided his family not only with shelter, but also with rental rooms to supplement his income as a laborer and a porter. He must have been a prudent and frugal man, for when he died of what was then called dropsy he left his family with fewer of the worries of survival than were the lot of many at that time. He had wisely prepared a will that provided the following:

First, I require that my said trustees permit my wife Ellen Bard to occupy that portion of said premises which I now occupy during the continuance of said lease and also permit the use of my furniture during the period of her natural life. Second I require my said Trustees to rent out the remainder of said premises and from the proceeds thereof to pay the ground rent of the whole if there be a sufficiency. Third, out of the remainder of my personal property consisting of five hundred and twenty

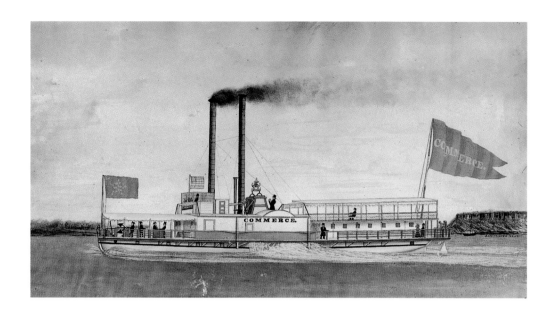

Signed "Bard, Painter"
COMMERCE
Undated. Watercolor on paper,
12½ × 24" (31.7 × 61 cm).
Museum of the City of New York,
Gift of Mr. Andrew Fletcher

It is not known which brother painted this watercolor or when, nor is the reason why it was once described as the "oldest steamboat painting in the world."

(JOHN BARD?)
COLUMBUS
Undated. Watercolor on paper,
22¾ × 32⅝" (57.8 × 82.8 cm).
Collection The New-York
Historical Society

Although it is unsigned, this watercolor may have been done by John working alone.

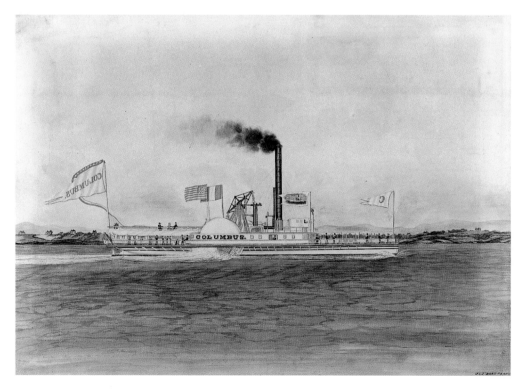

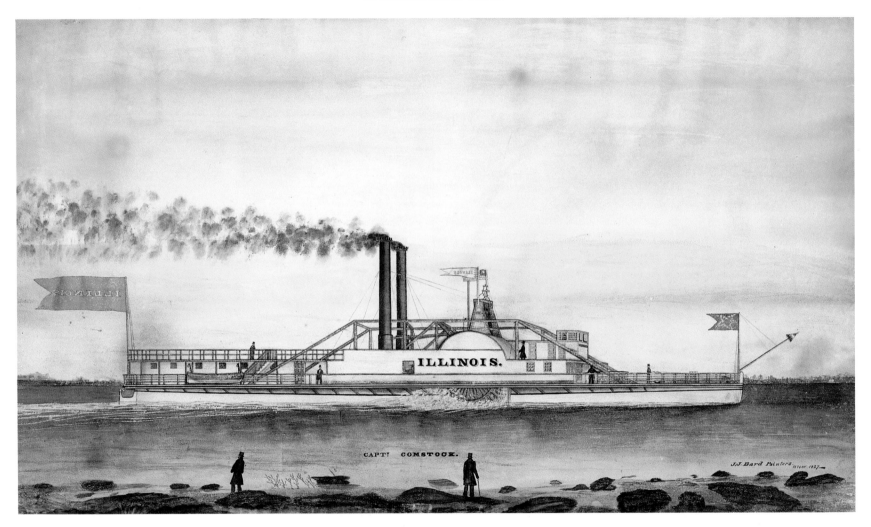

CAPT? COMSTOCK.

J.J.Bard Painters

This is among the Bard brothers' earliest dated works, perhaps before they learned that depicting a steamboat moving in a left to right direction is unsatisfactory because the name flag must, thus, appear in reverse. The silhouetted figures on the rocky shore may have been included to give the composition depth.

dollars in money I require my said Trustees to pay my said wife Ellen Bard one dollar and fifty cents per week during the continuance of said lease and after the occupation thereof to increase the said sum in their discretion. Fourth at the death of said wife I require that all that may remain of my personal property be equally divided among my children share and share alike and the share sum or portion which shall accrue thereby to my daughter, Margaret Bard, shall be held by said Trustees to be paid by them in their discretion for her support. Fifth I require that my son, Joseph, be bound by my executors to some useful trade or calling and further require the said Trustees support my said Joseph out of my personal property in their possession until be bound as aforesaid.[3]

No provisions were made for a sister, Mary, a brother, George, or for the twins James and John, since they had all reached majority. There is no data concerning the other brothers and sisters.[4]

The Bards' landlord at 137 Elm Street, Stephen Van Rennsselaer, died in January 1839. His will provided for the immediate collection of all back rent.[5] For some reason, the twins were not listed at the Elm Street address, nor is there any record of their having any address in Manhattan for the next two years. The biographical trail begins to thin out here.

While John's life and whereabouts remain a mystery for some years, James was his father's son—a stable, productive family man. Prior to 1843, James had married Harriet DeGroot, a woman six years his elder. In 1844, he moved his wife and infant son, James, to 143 Waverly Place, just off Washington Square. The address suggests a degree of prosperity, but during the following winter, the first of a series of family tragedies occurred, the death of James Junior in his second year. Bard was to lose five of his six children before 1870: another son, also named James, in 1851; a daughter, Julia, in 1856; and Emily shortly thereafter.[6] Only his daughter Ellen survived to old age. The name of the sixth child is

unknown. The loss of five children within so short a time was no more bearable then than it would be today.

Just as biographical detail is lacking, so is it impossible to identify the degree to which each twin was involved in the execution of the work and in what manner. There is nothing anywhere to suggest that this or that characteristic represents James's or John's work. Close study, however, reveals an unmistakable, steady, and seemingly shared progression from the primitive watercolors of the 1830s to the more sophisticated oils of the 1840s. This very lack of personal idiosyncrasies, however, suggests that the Bards probably had a satisfactory working relationship. From about 1831, with *Fanny*, until 1850, most paintings were jointly signed J. & J. Bard. The 1846 painting *Southerner* was proudly signed "J. & J. Bard, Picture Painters."

No painting survives signed by John alone, although some early works are signed "Jas. Bard, Painter." One such is *Telegraph*, a ship painted in 1837. As far as is known, there was only one show at which Bard work was ever displayed during the brothers' lifetime. The American Institute of the City of New York in 1842 exhibited two watercolors by James, the subjects of which are unknown.[7] At this show, held at Niblo's Garden, there were thousands of diverse entries by artists and craftsmen who contributed, among other things, club boat models, model steamboats, model schooners, and other examples of naval architecture.

The Bard partnership presumably ended in the winter of 1849 with the last jointly signed paintings. They were of *Senator* and *Wilson G. Hunt*, which became "bonanza" boats to carry optimistic souls with the dream of gold to Sacramento, California. The *Hunt* left on March 2, 1850, the *Senator* on the 10th. During the period that follows, John apparently played no active role. The speculation that he traveled to the goldfields along with so many others is tempting. Even the steamboat mogul Cornelius Vanderbilt lost his son to the craze.[8] Whatever the case, we can precisely

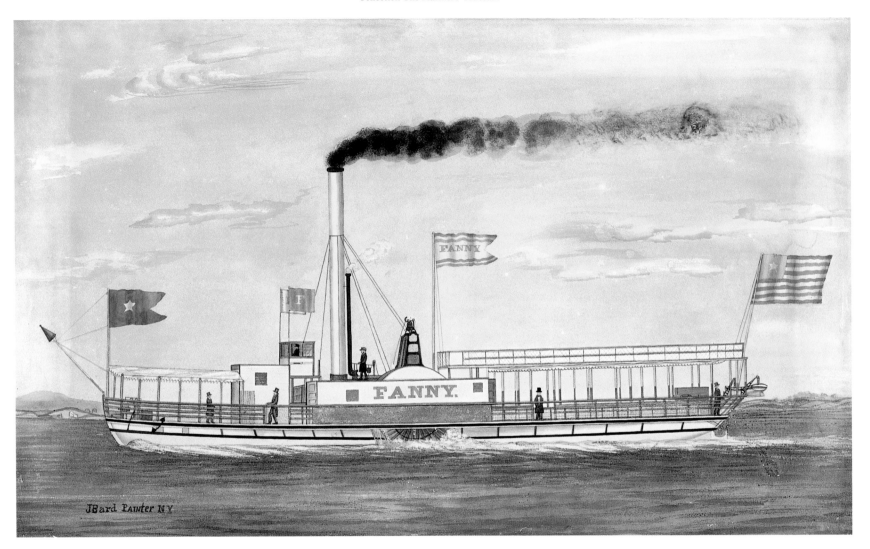

Opposite and above: Named identically, these are different vessels. They demonstrate the startling development of James Bard's talent in the thirty years between their painting. Compare the childlike rendering of the watercolor, when the brothers were sixteen years old, with the studied skill of the forty-eight-year old James Bard.

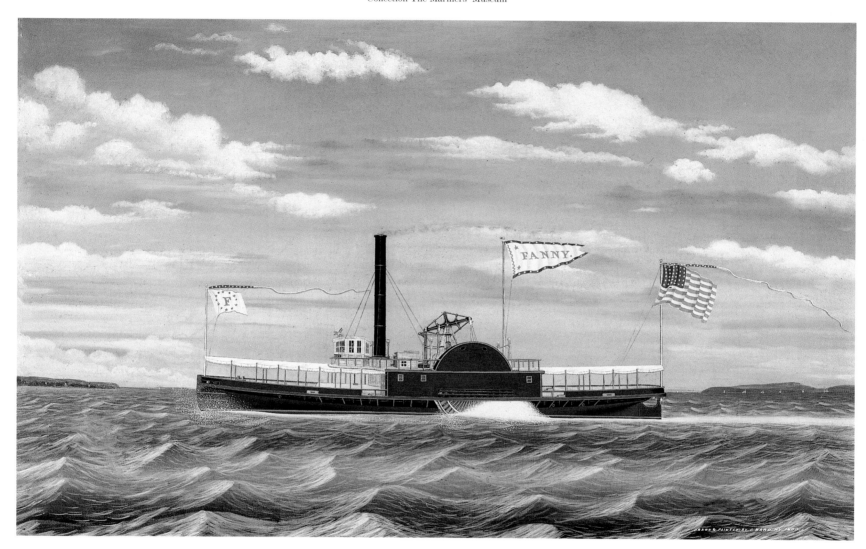

Steamboat historians suggest
that this heroic ice-breaking feat
occurred as pictured, although
another version assigns the job
to *Norwich,* shown here in the
background. Since the painting
is clearly of the period, Bard
probably told the correct story.

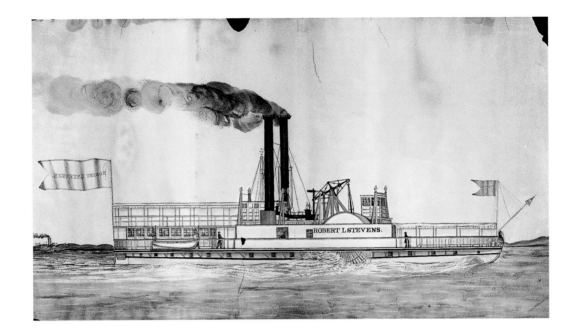

This very early painting displays
many of the characteristics that
James Bard would retain in later
years: the rowboat in the fore-
ground, the fireman, the poorly
drawn passenger, the use of land-
scape as a framing device, the
outsized flag.

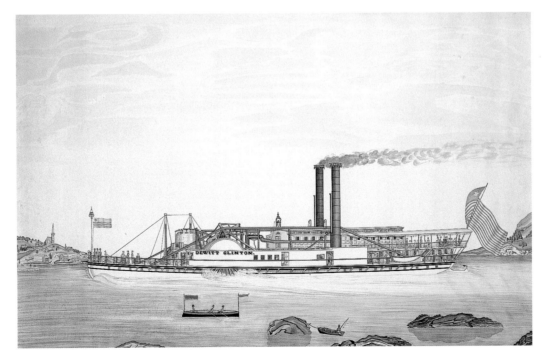

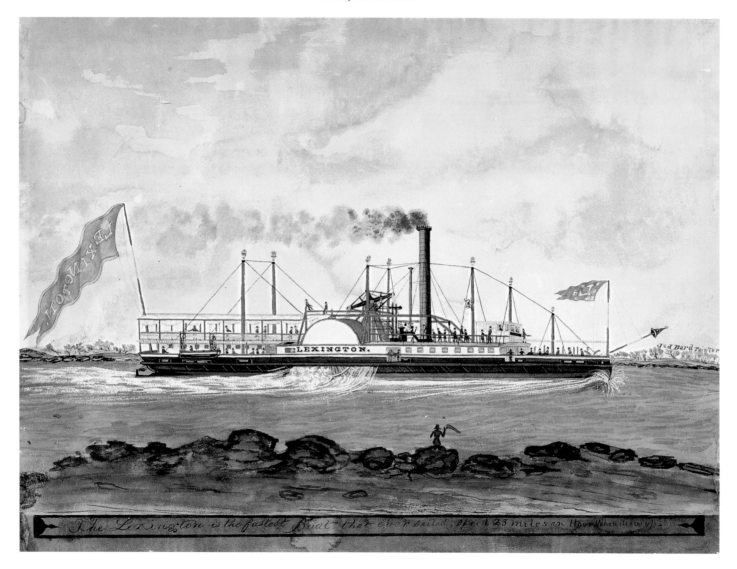

Shortly after this steamboat owned by Cornelius Vanderbilt was launched, the newspaper *New Yorker* on September 2, 1837, wrote, "Of all the steamers floating upon the waters of Long Island Sound commend us to the *Lexington* . . . an excellent sea boat . . . admirably fitted to breast the waves." On January 13, 1840, the boat burned with the loss of more than 100 lives.

JAMES AND JOHN BARD
CLEOPATRA
Undated. Watercolor on paper, 10 × 22¾" (25.4 × 57.8 cm).
Museum of the City of New York. Gift of Mr. Andrew Fletcher

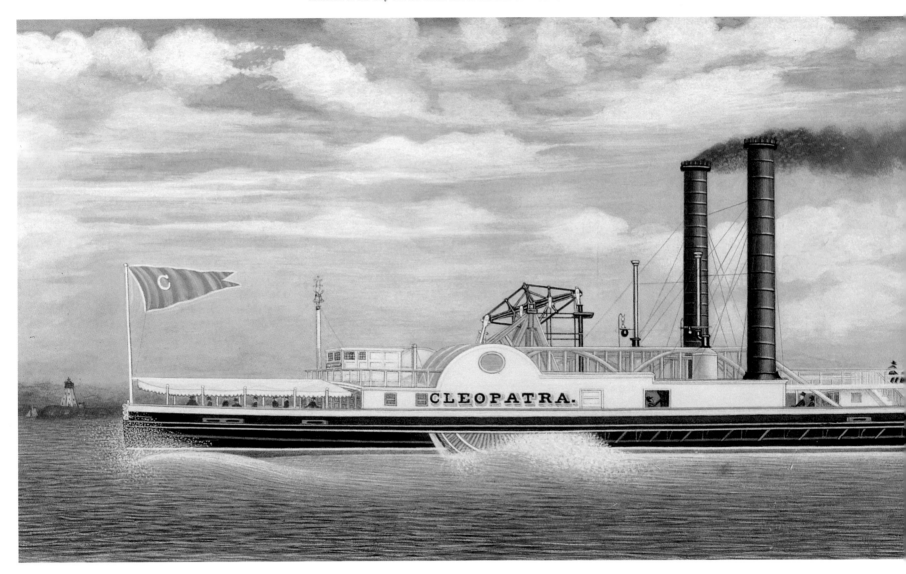

Bard often showed the stoker in the boiler room, perhaps for the first
time in this painting. *Cleopatra* was built for Cornelius Vanderbilt for
Long Island service, but by 1850 was owned by Daniel Drew.

mark the break: the Bard oils of Long Island Sound steamers *Ocean* and *Boston* were signed by James alone and dated March 1850. No painting thereafter is signed jointly.

For the next five years John's whereabouts are unknown. In November 1855, however, records show that he was sheltered temporarily on New York City's Blackwell's Island at the Alms House. The admissions document describes him as a forty-one-year-old destitute painter.[9] He was signed in by the Superintendent of Out-Door Poor (presumably what we now refer to as the homeless), the man in charge of the distribution of money for coal and food. The amount averaged but $10.00 per year per recipient. Those who could no longer survive as "out-door" poor with this meager sum, had to be institutionalized on that island in the East River along with criminals, lunatics, and black orphans.

It was the custom in those days for the city administration to seek out and require more affluent relatives to come to the aid of their less fortunate kin. It may have been that John's stay was shortened by James's aid, but there is no evidence to support this conclusion. Upon his release from Blackwell's Island, later that same month, John again disappeared from view.

The following summer, apparently unable to cope with the business of surviving unaided, John was admitted again. June 11, 1856, was his last day among free men.[10] Apparently, he was in very poor health, for at some point during his Alms-House stay, John Bard was transferred to the island's Hospital for Incurables. In that building were quartered those "who required no medical attention."[11] He contracted erysipelas, a strep infection of the skin— then life-threatening—which spread across his face butterfly fashion and back into his brain, causing periods of spiking fever and delirium. He died on October 18, 1856.[12] His body was ferried to Brooklyn's Green-Wood Cemetery by the Alms-House Charon, the "Captain of the Dead Boat." An 1857 guidebook, *Traveller's Steamboat and Railroad Guide to the Hudson River,* described the

John Bard spent some of his last
days in the Alms House Buildings
on Blackwell's Island in the East
River, shown here in 1853. (Peluso
collection)

ALMS HOUSE BUILDINGS.
Blackwells Island.

This Currier & Ives lithograph dated
1862, some six years after John
Bard's death, shows Blackwell's
Island. The steamboat is passing
the Work House. (Peluso collection)

BLACKWELLS ISLAND, EAST RIVER.
FROM EIGHTY SIXTH STREET, NEW YORK.

cemetery as "delightful." The elevations afforded beautiful views of Manhattan, the harbor, Staten Island, and the distant New Jersey Highlands. It indicated that the spot was a fine attraction and had become a "place of great resort." Such vistas were preserved for those who could afford them. John's unmarked grave faces in the opposite direction.

John's plight hints strongly of a completely deteriorated personal relationship with his brother. James, meanwhile, had not fallen on hard times. In 1850, during John's "absence," James painted *Confidence, Joseph Belknap,* and *Reindeer.* In 1851 he painted Thomas Collyer's *Henry Clay.* Noted for steamboats, he was also commissioned to paint George Steers's schooner yacht *America* (for which the America's Cup was named). His business success continued through and beyond the period of John's confinement.

The scene from *Harper's Weekly*, September 4, 1869, shows busy West Street in lower Manhattan. Perry Street runs into it from the left. (Library of Congress)

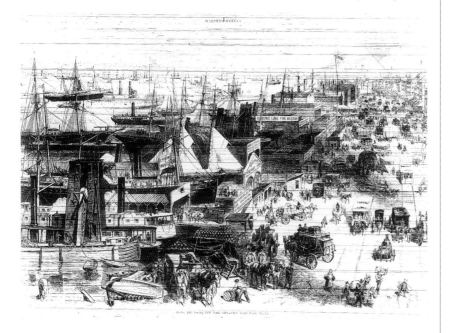

In fact, the early 1850s saw an increase in shipbuilding, and thus in customers for James. The demand for ships was "phenomenal" and was remembered, by John H. Morrison in his 1909 *History of New York Shipyards,* as a period of unequaled "good times."

James seems to have done well alone. He painted many of the important boats then launched, and he maintained and developed a clientele of the most important steamboat establishments, both on the Hudson River and on Long Island Sound. It seems likely that the rupture between the brothers was so fundamental and so devastating that even John's tragic circumstances were insufficient to bring James to his brother's aid. John Bard had performed whatever role it was that the fates had assigned him in his forty-one years. James Bard was assigned yet forty-one more.

James Bard was at least the equal of his brother as an artist and most probably the better. James continued to produce his pictures of steamboats, schooners, and an occasional yacht. The "artist," as he is often listed in most of the directories thereafter, had firmly established his reputation and was able to live modestly off its proceeds. Census records show, however, that he never bought a piece of property nor opened a bank account.[13]

There are two clues upon which to speculate on the circumstances in which he spent his later years, but they raise more questions than they answer. The first clue is a puzzling inscription that appears on the James Bard painting of the *John P. Jackson.* It asserts that the author of the work was "a mechanic in the shops of the New Jersey Railroad." The second clue, in the October 1939 issue of *The Magazine of Old Glass,* tells of an antique shop in Saugerties, New York, offering a Bard painting (*John Birkbeck).* The proprietor of the shop is quoted as having said that "James Bard was an engineer with a flare [*sic*] for oil painting." The assertions that Bard might have been a New Jersey Railroad mechanic and/or an engineer cannot be verified. The other inscription details on the *John P. Jackson* painting are certainly

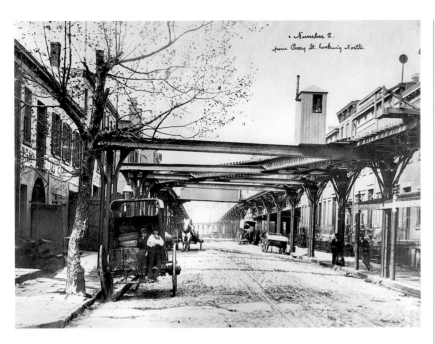

James Bard's neighborhood was much changed by 1876. The building of the elevated tracks for public transportation changed its look forever. Gustavus A. Powelson made this photograph. (Collection New-York Historical Society)

true, and its author, in 1911, was much closer to events than we are, as is the report from 1939. Nonetheless, neither clue provides any concrete information.

In the October 29, 1889, *Marine Journal,* Bard was referred to as "A perfect encyclopedia on the subject of New York harbor and Hudson River steamboats. . . . He remembers the names of the steamers, their builder, owners, captains and pilots for over a half century back." Except for his work, there is no further evidence that bears on the day-to-day life he led, what troubles or triumphs he experienced. It is evident that the number of commissions he received diminished in the 1880s. The last is dated 1890. The examples of Bard's work that exist from the late 1880s suggest that his powers were indeed diminishing. Nevertheless, he was able to

produce two fine, last watercolor portraits of *Saugerties* at seventy-five years of age.

A significant piece of memorabilia survives. It is dated 1892, perhaps just before James Bard moved his family from Manhattan to White Plains, New York, in Westchester County. It depicts in rough, penciled outline the early steamboat *Westchester,* a vessel launched some sixty years earlier. On the drawing, in Bard's now-enfeebled hand, are the boat's various details: "130' overall. 28' smokestack. 16' wheel." The notes reveal both the man's remarkable attention to detail, and his seriously deteriorating physical abilities. Obviously the man who sketched *Westchester* was no longer the man who only two years before had painted *Saugerties.* The sketch was done for Samuel Ward Stanton, who had sought Bard's help in the preparation of his book *American Steam Vessels.* Published in 1895, it contains a tribute to Bard's role in documenting steamboat history.

The move to White Plains, whose inland location seems an unlikely place for a man with Bard's interests, must have turned on his daughter Ellen's ability to earn enough to keep the small family together. So Bard's stay in White Plains was surely a lonely and a trying one. While it seems he never had to accept help from the County Overseer of the Poor, there is evidence that he had to rely on financial assistance from old friends.[14]

Bard's wife, Harriet, contracted pneumonia in the winter of 1896 and died the following January 5. Only two months later, on March 26, 1897, James Bard died. None of the local newspapers, the *Westchester News,* the *Eastern State Journal,* or the *Westchester County Reporter,* noted Bard's passing. A score of New York City newspapers allowed the event to pass virtually unnoticed. Bard's remains were consigned with Harriet's in the Rural Cemetery on North Broadway in White Plains, in a section reserved for indigents.

Bard's daughter, Ellen, the only surviving family member, moved frequently, at obvious pains to make ends meet. Her last

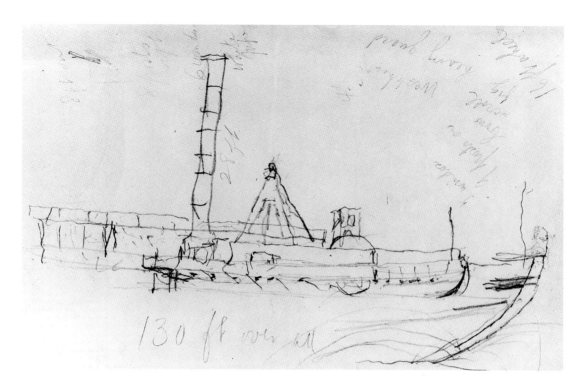

JAMES BARD
WESTCHESTER
1892. Sketch, 5½ × 9" (14 × 22.9 cm). Private collection

This tentative sketch was drawn by Bard for his friend Samuel Ward Stanton.

entry in the White Plains city directory indicates that she made her living as a maid. Samuel Ward Stanton, out of respect for her father's memory, sent Ellen monthly checks so that she would not have to rely on the county's benevolence.[15]

Stanton, meanwhile, had developed a reputation as both an excellent historian and an artist in his own right. His book *American Steam Vessels* was a success. By 1912, his comprehensive series of articles "American Steam Navigation" was appearing in the magazine *Master, Mate and Pilot.* He had finished his murals for the Grand Saloon of the Hudson River Day Line's *Robert Fulton* and he had been given the commission to paint the murals for the interiors of *Washington Irving,* a steamboat planned to be the epitome

of good taste in decor and passenger comfort. Stanton sailed to Europe with his sketchbook, to the sites of Irving's inspiration in Spain and the Alhambra. Fulfilling his quest, he booked passage home on the *Titanic.* He was tragically lost, and with him, were many cherished memories of his friend, James Bard.

Ellen Bard lived on in poor health, and her personal care became the concern of neighbors and acquaintances. She died in February 1919 of injuries sustained in a fall. She was remembered only as the "little old lady who had nothing." After simple services at the Chatterton Hill Church, she was laid to rest with her parents in the Rural Cemetery. Except for their legacy of paintings, the Bard brothers left no wills, no papers, no journals, no relatives, no friends.

TELEGRAPH

1837. Watercolor on paper,
18¾ × 32⅛" (46.6 × 81.6 cm).
Collection The Mariners' Museum

Not all the paintings done in the
early years were signed "J. & J.
Bard." This is signed "Jas Bard."
Telegraph was built for John S.
Odell of Tarrytown and presumably
named for Samuel Morse's tele-
graph apparatus, early versions of
which were demonstrated at New
York University in 1836 and 1837.

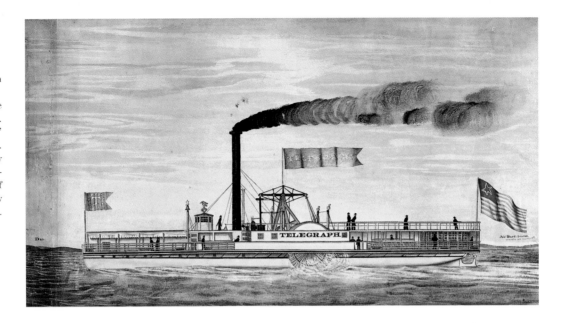

INDIANA

1840. Watercolor on paper,
25¾ × 31¾" (65.4 × 80.6 cm).
Collection The Mariners' Museum

Indiana became a New York to
Albany towboat; a very unsuccess-
ful one. In 1853–54 her ownership
changed hands five times. In 1857
she was turned into a barge.

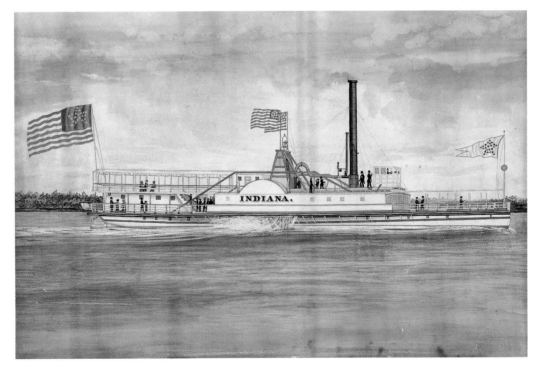

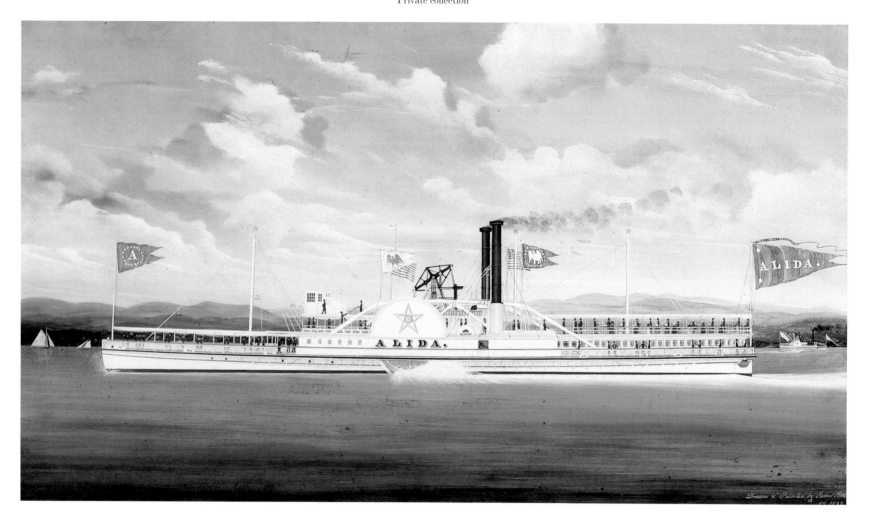

James McCullough, New York merchant, named two well-remembered steamboats for Alida, his wife, and Francis Skiddy, his best friend. This painting is signed by James Bard even though John was still at this time an ostensible partner. Nathaniel Parker Willis wrote in the *Home Journal*, precursor of *Town & Country* magazine, that

"the lady inhabitants of this neighborhood have a summer convenience . . .the largest, swiftest and most sumptuous of all the day-boats on the river, the steamer *Alida* comes swooping down the mirrored shore-line . . . she seems rather to be making an excursion of gaiety than a passage of convenience."

JAMES BARD
ALMENDARES
1848. Oil on canvas, 29 × 49"
(73.7 × 124.5 cm).
Private collection

The Bard brothers' partnership was still apparently intact at the time, but this painting is nonetheless signed "Jas Bard, Painter, 1848." The lettering, probably by James, was flawless: vertical strokes were precise; tops and bottoms of letters were perfectly parallel; each letter was delicately proportioned and spaced. Without this refined technique his boat portraits would have been much less widely accepted.

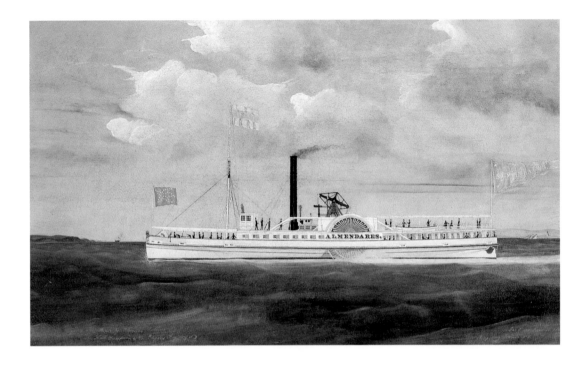

JAMES AND JOHN BARD
THOMAS POWELL
1846. Oil on canvas, 30½ ×
53½" (77.5 × 135. 9 cm).
Rob and Michelle Wyles
Collection

The many women aboard suggest a festive event, the maiden voyage, perhaps. *Thomas Powell* was built to replace *Highlander* shown in the background. *The Evening Post,* June 1, 1847, reported that *C. Vanderbilt* chased *Thomas Powell* to Sing Sing but gave up the pursuit; "finding all her endeavors to overtake the *Powell* ineffectual."

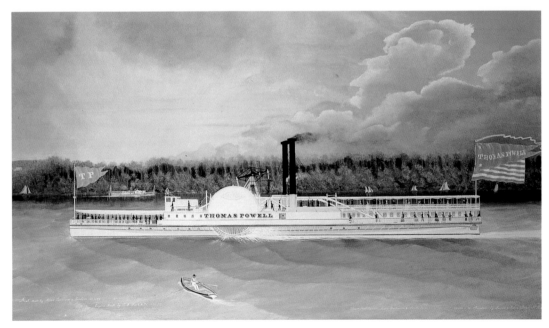

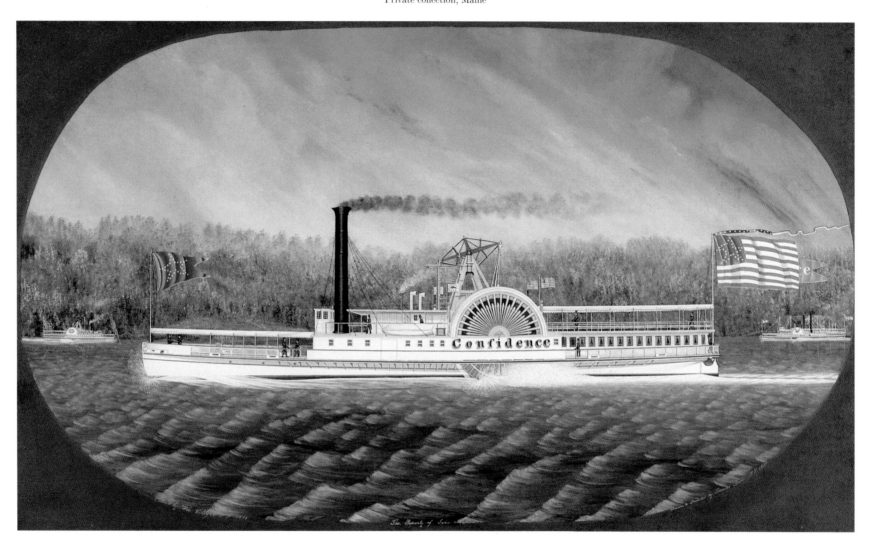

When Bard finished painting *Confidence* she had already been running for two years. She had been built for Thomas Hunt and the Shrewsbury & Long Branch route but had lately run to Albany with *Hendrik Hudson*. She was replaced by *New World* and went to the Pacific in the spring of 1850.

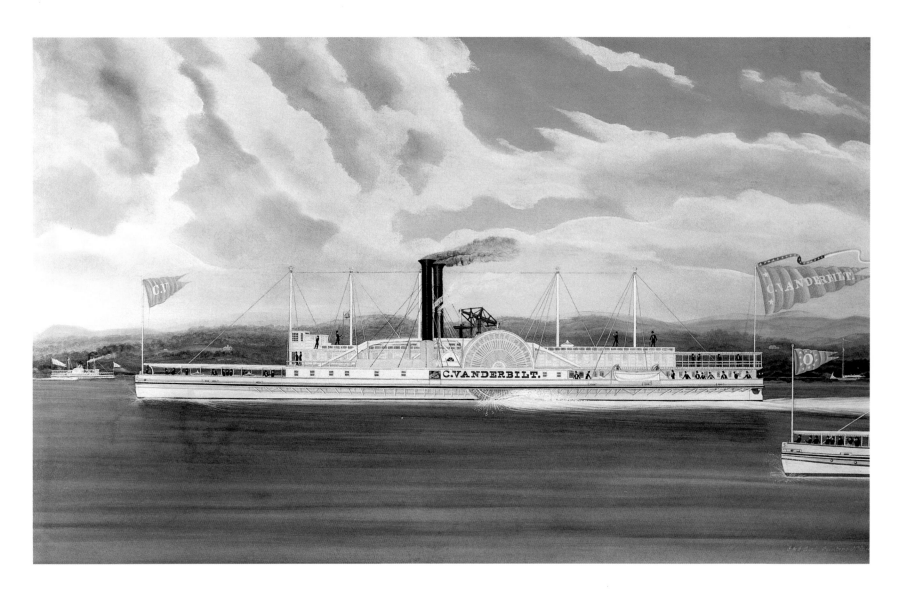

CLIENTELE: CAPTAINS, COMMANDERS, COMMODORES, FRIENDS

JAMES AND JOHN BARD
C. VANDERBILT
1847. Oil on canvas, 28 × 47"
(71 × 119.4 cm).
Shelburne Museum, Shelburne,
Vermont (Photo by Ken Burris)

Cornelius Vanderbilt almost certainly commissioned this portrait since his boat figures most prominently in it, but the race depicted was won by *Oregon*, seen at the right.

Walt Whitman would call it a "City of Ships," whose bowsprits, in Charles Dickens's phrase, "almost thrust themselves into the windows" of South Street merchants. It was an age of the Black Ball, the Red Star, and the Swallowtail packet lines. It was the age of the clipper ships *Great Republic* and *Sovereign of the Seas;* the age of ocean steamers *City of New York* and *Great Eastern;* an age of growth for the United States Navy, particularly during the Civil War; and it was the age of successful defenses of America's Cup. Yet none of it shaped the world of the Bards. They painted only the everyday, the commercial Hudson River and New York harbor steamboats and sailboats.

As noted earlier, John Bard's passing was sad and unmarked by any notice. His brother, James, received only one obituary, in the *Seaboard* magazine, but he was recognized as having lived

during the time of the day when shipbuilding at this port [New York City] was the greatest of any in the country, and when myriad of beautiful river, sound and ocean craft were turned out every month. Mr. Bard with his talent had opportunities of becoming acquainted with all of the leading shipbuilders and vessel owners in the days before the [Civil] War. He knew them all and was held in high regard by them

The majority of Bard commissions came directly from these men. Although there is little firsthand evidence, the relatively large body of work left by the brothers provides good inferential evidence from which to identify their principal patrons. (After 1849, when the paintings are no longer signed by John and James Bard together, it seems clear that James was operating by himself. After John's death in 1856, that is a certainty. In the following list, because most, if not all, of the documentary evidence mentions James's name only, it is he who is exclusively referred to. Some of the works created, however, were done by both men.)

Cornelius Vanderbilt

Cornelius Vanderbilt contributed greatly to the development of the Hudson River's steamboat commerce. Significantly, the first Bard painting was done of *Bellona*, Vanderbilt's first steamboat command. Bard paintings survive of others: the *Fanny*, *Cornelius Vanderbilt*, *Lexington*, and *Cleopatra*. His steam yacht *North Star* was also painted by Bard. Others such as *Traveller* and *General Jackson* were owned or controlled by Commodore Vanderbilt, "with whom," the *Seaboard* obituary stated, James Bard "was well acquainted." It is quite probable that his career was successfully launched with Vanderbilt's approbation.

Alfred Van Santvoord

Another steadfast customer was Alfred Van Santvoord, owner and founder of the Hudson River Day Line. Every vessel owned by Van Santvoord, prior to James's retirement, was painted by the brothers. Van Santvoord was born in 1819, served an apprenticeship with the Swiftsure Line from 1838 until 1846, and then branched out on his own. The Bards' first commission from him was *Oswego*, a towboat, designed to haul numbers of cargo barges and canal boats. This idea would develop into the propeller tugboats of later years. Van Santvoord retired from his successful towing business in 1868 but continued to enlarge his well-established trade of transporting people.

There is no contemporary evidence to suggest the esteem with which James Bard's work was held by Van Santvoord, but it is known that several Bard paintings hung at the Hudson River Day Line's Manhattan office on Desbrosses Street until the 1920s. Some even hung in the dormitory rooms used by employees on long layovers.

The business records of the Hudson River Day Line have been preserved, and ledger entries record payments to James Bard:

August 5, 1862 for *Jesse Hoyt*: $20.00
August 28, 1863 for *City of Albany*: $20.00.
August 24, 1864 for *Seneca*: $25.00.

These same records indicate that about this time one of Van Santvoord's captains was receiving $50.00 per month in salary, a cook earned $20.00, and that a box of his favorite cigars was $6.50. The prices for Bard paintings compared favorably with his contemporary James Buttersworth, whose paintings were commanding anywhere from $27.50 to $44.00 at the National Academy.

Andrew Fletcher

When the North River Iron Works was organized by Andrew Fletcher in 1853 it proved a windfall for James Bard. Of the 118 vessels finished by that company through 1890, the year Bard retired, seventy paintings of Fletcher vessels by Bard still exist. Fletcher family tradition holds that Bard painted all the ships and that forty-eight have simply disappeared over the years. This same tradition has it that it was yard routine for Bard to paint the boat at the time of launching. His price had risen to $50.00 by the end of his association with Fletcher. The last Bard painting of a Fletcher craft was *Red Ash* from 1889. The paintings that had hung in the Fletcher offices in Hoboken until the 1940s, and subsequently in the family's home, have since been given to the Museum of the City of New York.

Collyer Brothers

The largest number of Bard pre–Civil War commissions are attributable to the Collyer brothers: George, Thomas, and William. They launched more than 100 barges, lighters, sloops, schooners, yachts, and steamboats.[1] They first built at Sing Sing, New York, in 1838 and then, in 1844, at a boatyard at Twelfth Street on the East River in Manhattan. More than thirty Bard portraits of the

JAMES BARD
ENOCH DEAN
1852. Oil on canvas, 29 × 49"
(73.7 × 124.5 cm).
Abby Aldrich Rockefeller Folk
Art Center, Williamsburg, Virginia

Enoch Dean saw service with the quartermaster's department of the Union army in the Civil War. In 1865 the boat sank at the entrance to St. Catherine's Sound below Savannah while carrying freedmen and their farming equipment north.

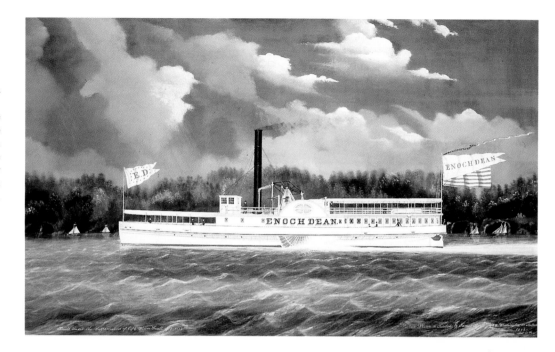

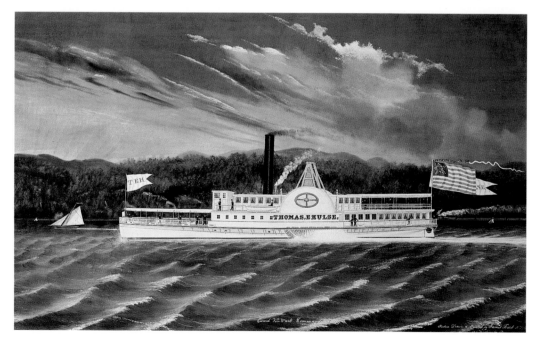

JAMES BARD
THOMAS E. HULSE
1851. Oil on canvas, 29¾ × 50"
(75.6 × 127 cm).
Collection The New-York
Historical Society

James Bard included in this scene a railroad train running along the western shore of the Hudson River. Ironically, it was the railroad that would gradually erode the steamboat's usefulness, thus also dooming the livelihood of all the steamboat artists. This painting was completed only months after the brothers' partnership broke up.

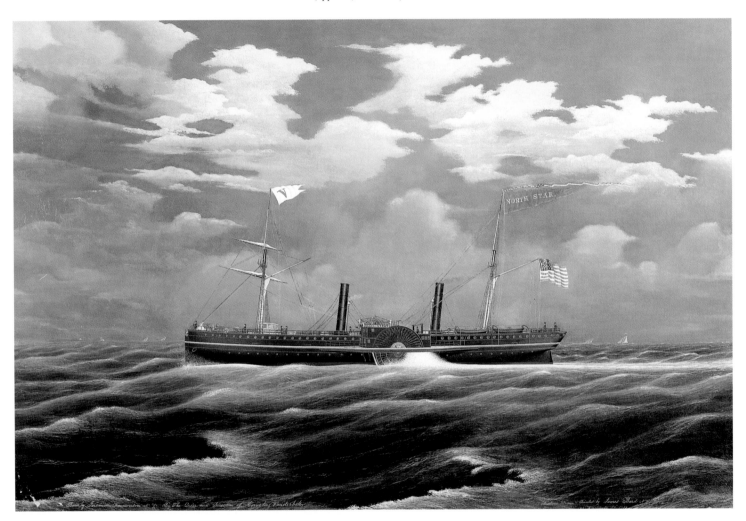

A somber sky effectively dramatizes this 262-foot long, elegant steam yacht, built "By the order and direction of Cornelius Vanderbilt." Its first cruise was to the Mediterranean and the Baltic with a stop at Southampton, where Vanderbilt received "a reception commensurate with his rank as a merchant prince—one who goes abroad in a style not inferior to their own youthful sovereigns," according to Reverend Choules in his book *The Cruise of the Steam Yacht North Star.* Note the detail and Bard's tour-de-force handling of the paddlebox and the churning water.

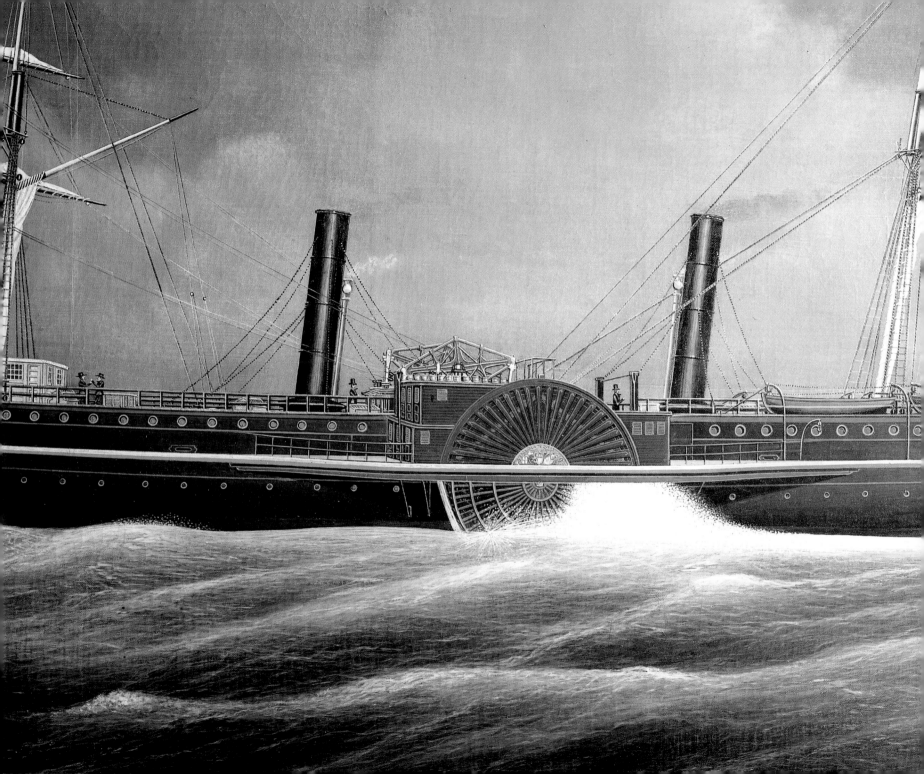

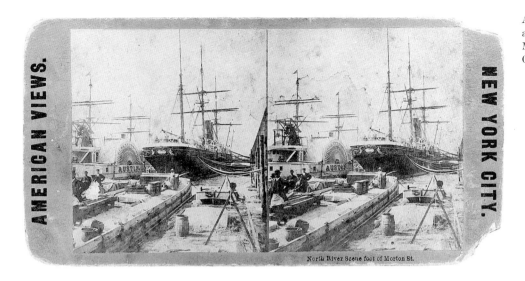

North River Scene foot of Morton St.

A stereograph of 1853 shows *Austin* among other vessels at the foot of Morton Street in New York City. Collection The Mariners' Museum

steamboats have survived. Many have inscriptions indicating their commissions, such as the Trojan, "William & Thomas Collyer, Builders." "Built by George Collyer NY 1854" appears on the *John Griffith*. The *Henry Clay* is inscribed, "Presented to Palmer Crary by Thomas Collyer, 1851." Thomas Collyer died in 1863, and the driving force behind the business disappeared with him. At the same time, Bard lost an important source of income.

Benjamin C. Terry

A Collyer competitor, Benjamin C. Terry of Keyport, New Jersey, was also a major client of the Bards. His name first appears on the *Cayuga* with the inscription "Terry & Sons, Joiners." Of the fifty-two vessels he built (most at his Raritan River yards), thirty Bard paintings survive. After 1867, Terry built only four more ships. Bard painted *Castleton* and *Pleasant Valley,* of which there is more than one privately owned version. For several years Terry supported himself as a ship chandler, at first in Brooklyn Yards. In 1870 he built two steamers *San Rafael* and *Saucelito.* They were fabricated into component parts in Brooklyn, transported cross-country by rail to San Francisco, and assembled there like a jigsaw puzzle. Terry followed to assist in the operation. James Bard painted portraits of each vessel, but we do not know whether he painted them in an unfinished state in Brooklyn, or if he followed them to California. There is no record of his having done so, but it seems unlikely that he painted portraits of ships he had never seen assembled.

Englis Shipyard

James Bard worked for another major yard, that owned by the Englis family, but of the more than eighty ships built by the firm from 1854 to 1884, only a few of them were painted by Bard or, at least, only a few have survived.[2] They include: *Menemon Sanford, Forest City, Southfield, Jas. F. Fisk, Jr., Jay Gould, Highlander,* and *Saratoga.*

Other Builders

The surviving Bard steamboat portraits, a number of which are inscribed with the names of the ship and engine builders, represent a generous sampling of the work of New York area shipyards:[3]

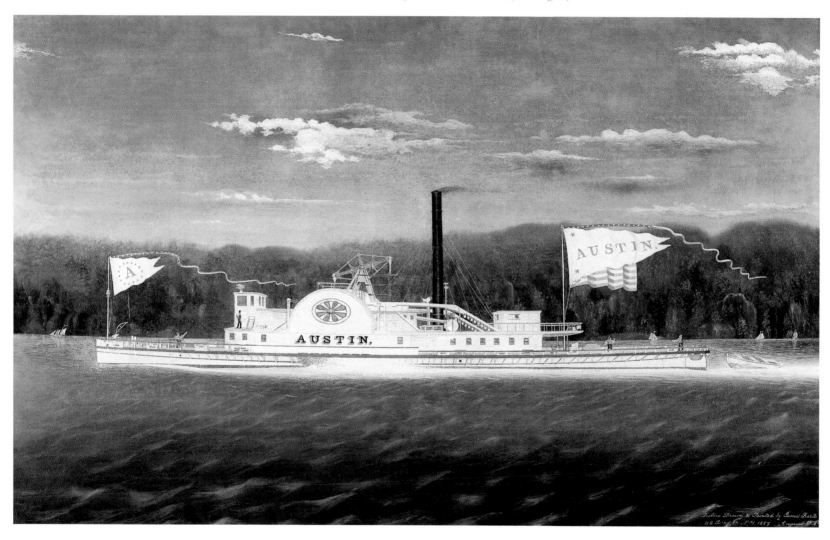

Built for the Austin & Gillespie towing company of Albany and ded-
icated to the hard work of hauling barges, she was refitted and re-
built over time, but was broken up at Perth Amboy, New Jersey, in
1898. There is no hint of her mundane purpose in Bard's portrait.

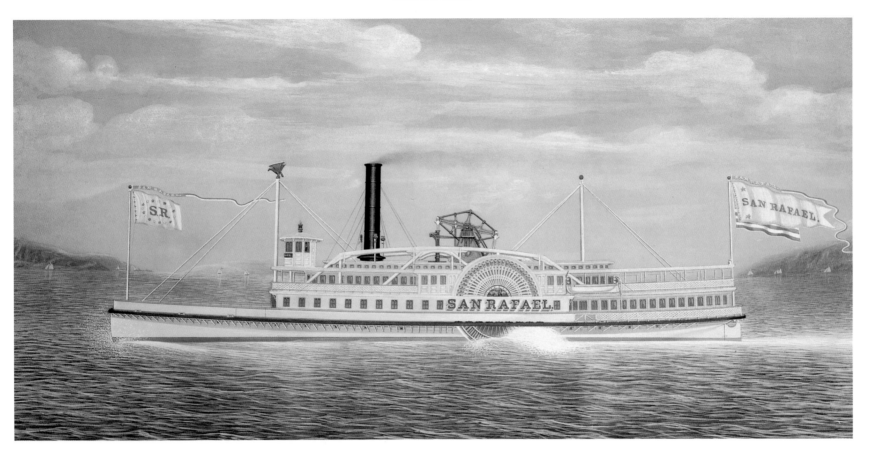

The *San Francisco Call* opined that she was, "By far the prettiest
boat that ever cleft the waters of San Francisco Bay."

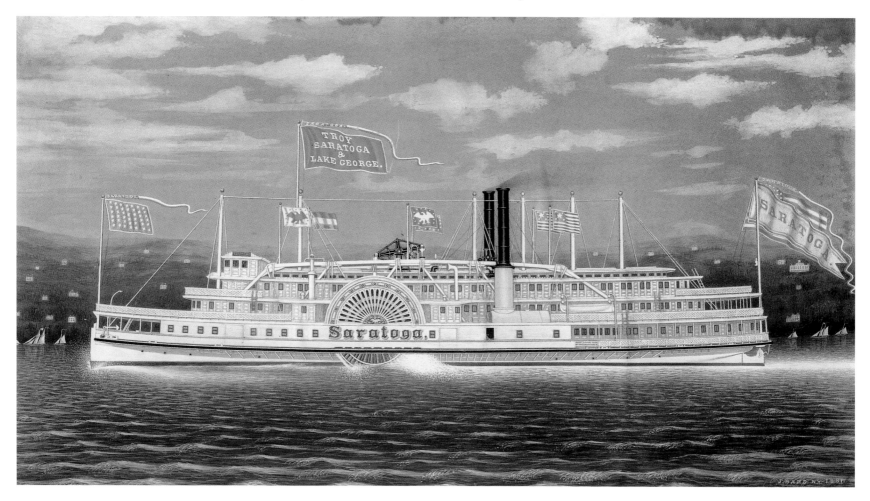

A night boat on the Citizen's Line, she accommodated 600 passengers. Many trips were adventures. In 1882 she collided with *St. John*. In April 1884 she ran into a bridge at Troy, and in November ran aground at Coxsackie. In 1886 she ran aground at Tivoli. In August 1888 she sank the schooner *Holbrook*, and in November ran aground at Cedar Hill. In 1897 she ran into the steam yacht *Hermione*. In 1906 she was sunk by *Adirondack*. On the bright side she could boast 300 incandescent lamps installed in 1888 by the Edison Electric Light Company.

In the background of this photograph of *Saratoga* can be seen a furniture company's advertisement painted on the Palisades. Collection The Mariners' Museum

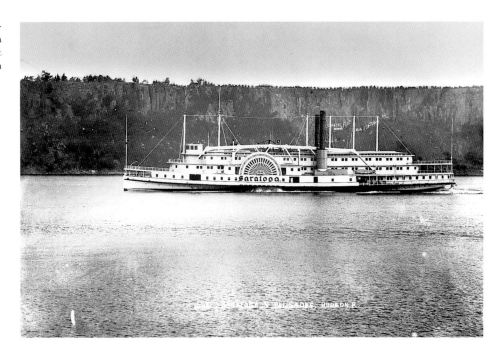

Saratoga aground.
Collection The Mariners' Museum

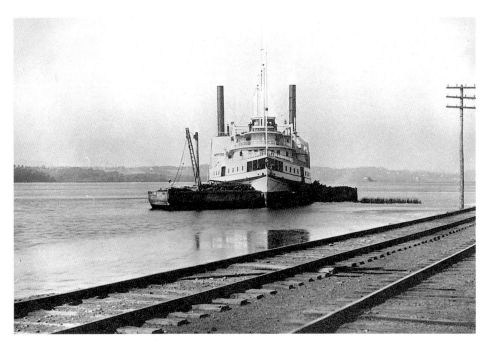

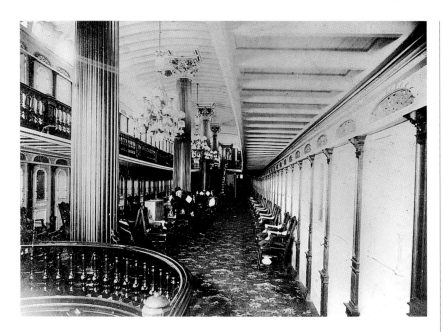

Saratoga: a rare view of the interior of an elegant Hudson River steamboat. Collection The Mariners' Museum

1832–36 five portraits of steamboats built by Brown & Bell

1836–48 eight portraits of steamboats built by Bishop & Simonson

1838–46 nine portraits of steamboats built by William H. Brown

1839–54 six portraits of steamboats built by Devine Burtis

1835–75 thirty-two portraits of steamboats built by Lawrence
 & Sneeden (later Lawrence & Foulkes).

An ongoing maritime depression caused many New York and Brooklyn yards to close and much of the shipbuilding business moved upriver. Bard painted four steamboats built by Morton & Edmonds (Athens, New York) between 1862 and 1865; five built by Brainard & Lowler (East Albany, New York) between 1862 and 1863; and four steamboats built by Van Loon & Magee (also Athens) between 1879 and 1882.

From the engine builders we can identify another group of abiding business relationships:

1830–53 thirteen portraits of steamboats with Allaire engines

1838–49 six portraits of steamboats with H. R. Dunham engines

1846–65 four portraits of steamboats with T. F. Secor engines

1852–60 nine portraits of steamboats with Morgan Iron Works engines

1854–60 six portraits of steamboats with Neptune Iron Works engines

Many other commissions came from captains and engineers who carried on the day-to-day business of steamboating. They were a hard lot. Francis B. C. Bradlee in *Steam Navigation in New England,* (Salem 1970), describes the men and their boats with uncompromising candor:

Many of the engineers of the early steamers were grossly ignorant and careless men; some of them hardly knew more than how to stop and start the machinery. There were no lynx-eyed inspectors about and no limit was placed on the amount of steam to be carried, nor were boilers tested, or the hulls of the boats examined for seaworthiness. The results were the frequent boiler explosions so often mentioned in the newspapers of years ago; they happened less often on "down east" routes simply because there was less competition and racing than on the Hudson River or Long Island Sound.

But on the other hand, it is well known that many of the early steamers brought to north eastern New England from comparatively placid inland waters were notoriously wanting in strength and seaworthiness for open sea navigation, and the habit persisted in until not so very many years ago. As regards the deck department too, on early steamboats, the only qualifications thought necessary for captains and pilots were those required by their "owners." That there were many able and daring steamboat men in those days there is no doubt, but there were also some who did not come up to the mark and effects of intemperance on deck and engine officers were more marked than in our time.

JAMES BARD
AMERICA-DISPATCH
Undated. Watercolor on paper, 15 × 23¾" (38.1 × 60.3 cm).
Museum of the City of New York, Gift of Andrew Fletcher

JAMES BARD
UNITED STATES
1852. Oil on canvas,
42 × 64" (106.7 × 162.6 cm). Private collection

United States was initially chartered to the New York & Galway Line:
she later took gold-seekers to Chagres, Panama, in 1852, served the
Graham Line to Mobile, and was finally sold to a Cuban firm, which
changed her name to *Mexico*.

Bard chose to frame the schooner, built in Nyack in 1850, with a
mountainous shore at the right and an island to the left. His dynamic
composition causes the eye to follow the downward sweep of the
mountain, the sheer of the fore-sail, and the upward direction of the
windswept water to the point of the bowsprit.

James Bard
ANDREW FLETCHER
1864. Oil on canvas, 16 × 26"
(40 × 66 cm). Museum of the
City of New York, Gift of Mr.
Andrew Fletcher

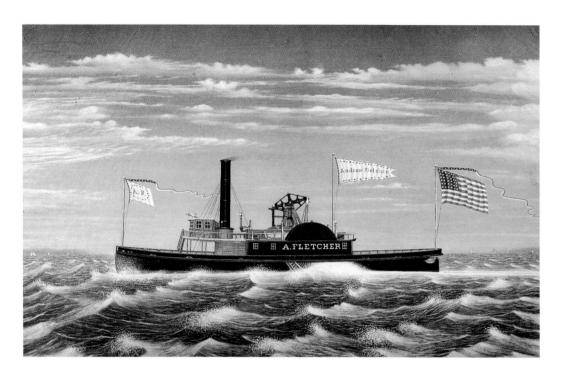

James Bard
ANDREW FLETCHER
1864. Pencil on paper, 15⅛ × 26¾"
(38.4 × 67.9 cm). Collection The
Mariners' Museum

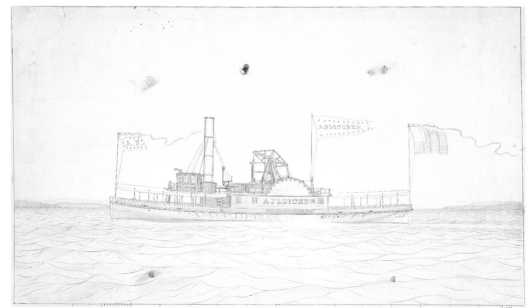

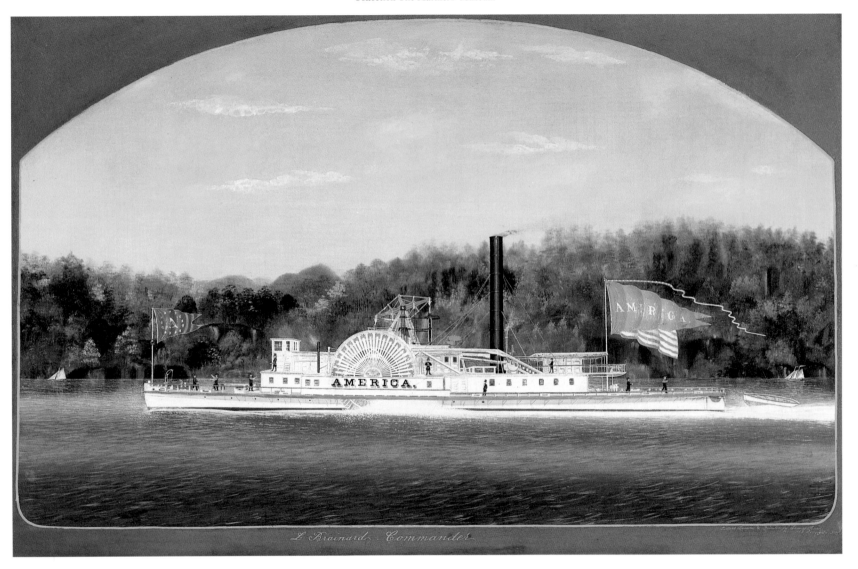

There are six versions of this *America*, an ordinary towboat but for
her name. (Other versions are by James Gale Tyler and Antonio Ja-
cobsen.) She labored for a number of owners until 1896.

JAMES BARD
JOHN BIRKBECK
1854. Oil on canvas, 29⅞ × 52⅜"
(75.9 × 133 cm).
National Gallery of Art,
Washington, Gift of Edgar
William and Bernice Chrysler
Garbisch

She performed pedestrian service
as a towboat, had her share of mis-
fortune (she ran into the schooner
J. S. Terry in 1880 and into the
ferry boat *Baltic* in 1882), but had a
change of luck and a name as *J. G.
Emmoms,* serving the immigration
center at Ellis Island without mishap
until 1912. Why the crewmen at the
bow seem to be fighting may forever
remain a mystery.

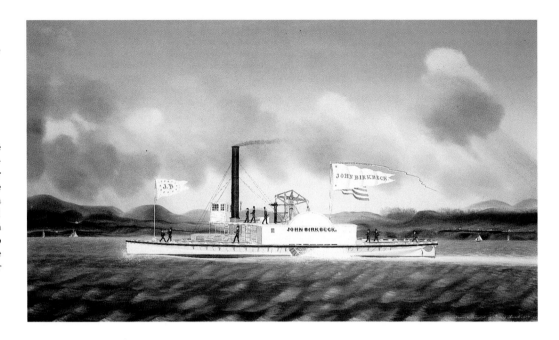

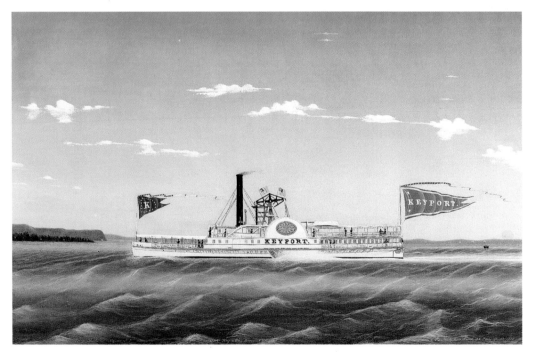

JAMES BARD
KEYPORT
1853. Oil on canvas, 32 × 52"
(81.3 × 132.1 cm).
Private collection, New Jersey

She initially served as a commuter
boat between Keyport, New Jersey,
and Staten Island, New York. Her
first captain was T. V. Arrowsmith,
after whom another steamboat would
be named.

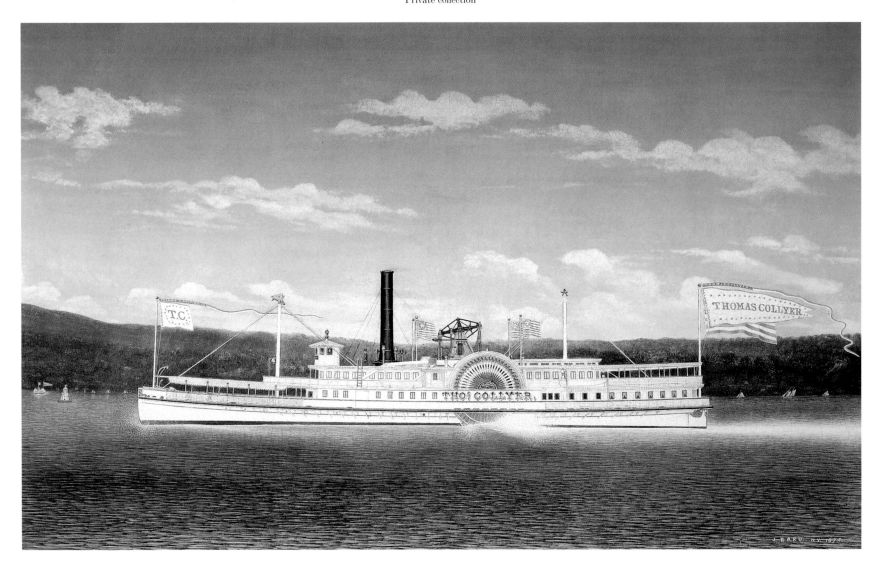

There were three steamboats with the *Thomas Collyer* name. This
is the last, the "big" *Thomas Collyer*. In May 1874 (the approximate
date of the painting) George Collyer sold her to John H. Starin for
$70,000. Note the deer on the paddlebox.

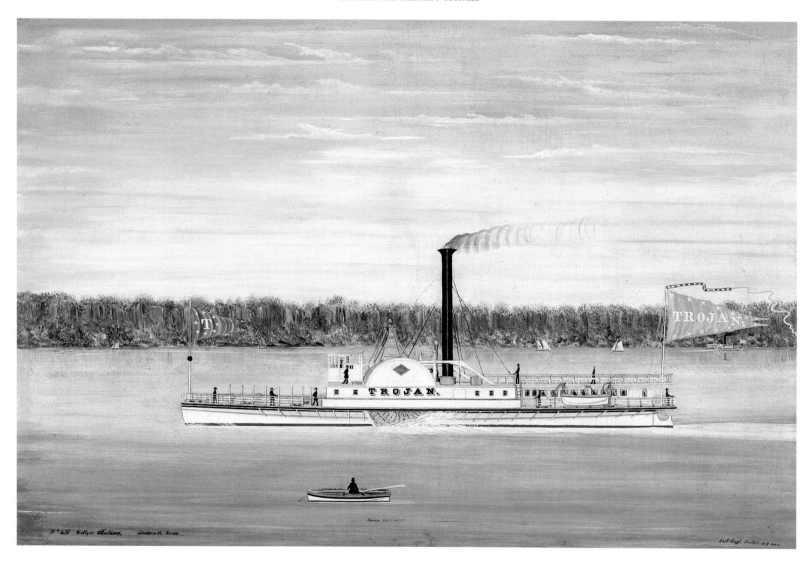

The inscription indicates that J. J. Austin was the commander;
perhaps it is he standing next to the pilot house. He later had a
steamboat named after him. *Trojan* was put into service at Troy,
New York, where she burned at her Haight Street pier in 1851.

JAMES BARD
SEAWANHAKA
1868. Oil on canvas, 33 × 52"
(83.8 × 132.1 cm).
Private collection

Seawanhaka served the Long Island & North Shore Passenger & Freight Transportation Company before she caught fire on June 28, 1880, on an afternoon trip to Glen Cove, ran ashore at Sunken Meadow and burned, losing forty lives. The accident spawned years of litigation and pages of lurid newspaper coverage.

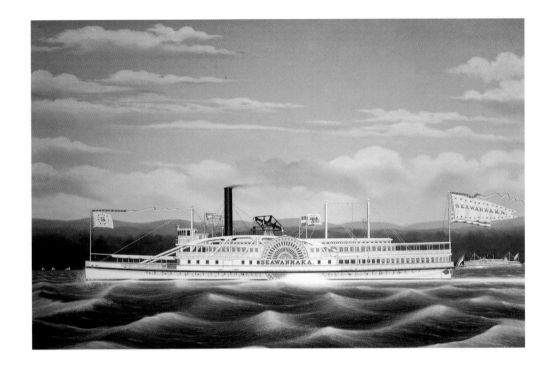

JAMES AND JOHN BARD
ARMENIA
1848. Watercolor on paper,
29³⁄₁₆ × 49³⁄₁₆" (74.2 × 125 cm).
Wadsworth Atheneum, Hartford,
The Ella Gallup Sumner
and Mary Catlin Sumner
Collection Fund

Carl Carmer, in his book *The Hudson*, wrote: "The *Armenia* tooted proudly on her new 34-whistle calliope, arousing strange echoes among the jealous Highlands with 'The Belle of the Mohawk Vale', 'Way Down Upon the Swanee River', and 'Jordan's a Hard Road to Travel.'"

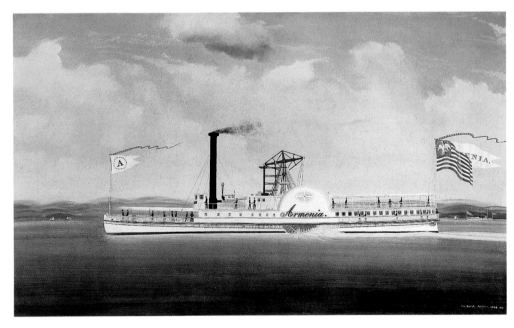

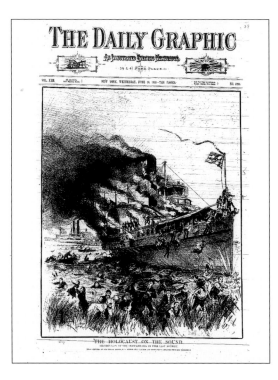

THE DAILY GRAPHIC

THE HOLOCAUST ON THE SOUND.

The front page of *The Daily Graphic* for June 30, 1880, pictures the destruction of the *Seawanhaka* by fire. Library of Congress.

John Tallman

One of this notorious company was Captain John Tallman.[4] Born in Nyack, New York, in 1816, he began his career on the sloops, then the principal means of river transportation. He owned the *Dart,* which he subsequently sold to John Jacob Astor as a yacht. He stayed on as captain. In 1848, he and Thomas Collyer launched *Armenia,* whose ownership they shared with Isaac Smith of Nyack. Bard painted *Armenia* in the same year and inscribed the painting with both Collyer's and "Commodore" Tallman's names. In 1852, Collyer and Tallman jointly owned the steamboat *Henry Clay.* Iron-ically, the two boats were linked in a tragic encounter.

One version has it that on a hot July day in 1852 Tallman was asleep in his cabin aboard *Henry Clay,* suffering from indigestion. Collyer was on board and took it on himself to order a race with the steamboat *Armenia,* passing nearby. When the boats approached Yonkers, New York, *Henry Clay* burst into flames and sank: seventy lives were lost. The next day the *New York Times* reported that when Tallman was taken from the water "he was unable to speak. It is feared he will not recover." He was strong enough, however, to mutter an aside to a friend that unfortunately for him found its way into print: "Only 10 to 15 people perished. And they were all common people." Later that July he issued a feeble state-ment, not retracting his previous remark, but hoping to exculpate the owners: "*Henry Clay* was not racing . . . the fire started by hot cinders falling from the furnace and permitted to collect, instead of being raked up."

Collyer's reckless race and Tallman's reckless remarks were typical of nineteenth-century rivermen. Most of them were swash-buckling and devil-may-care. Hardly a year went by that a serious accident didn't occur, and they continued to occur. Frequently the crashes resulted from racing and ended in loss of life. The crash of *Henry Clay* was simply the latest chapter. The public outcry prompted those who might have previously ignored such events to bring manslaughter indictments against Collyer, Tallman, and the engineer, John Germain. They were acquitted.

Tallman, with a tarnished reputation, turned briefly to man-aging the Cozzens Hotel in Manhattan. But in 1855, he and his brother Tunis, James Mapes (his partner in the hotel), and Cora Osborne (who owned a grocery business on Washington Street) launched *Metamora,* painted by James Bard in 1859. Bard's in-scription reads, "Steamboat Metamora of the New York and Al-bany Steamboat Passenger Line, John F. Tallman, Commander." This time it ran with *Armenia* calmly and without mishap.

JAMES BARD
METAMORA
1859. Oil on canvas, 28¾ × 49"
(73 × 124.5 cm). Collection
The Mariners' Museum

James Bard made several paint-
ings of *Metamora*, all dated in the
1850s. The boat's name almost
certainly derived from the hugely
successful 1829 play, *Metamora,
Chief of the Wampanoags*, which
starred Edwin Forrest. Bard's
rendering of the noble savage ap-
pears in the flags, on the paddle-
box, atop the pilot house, and
in a figurehead carving.

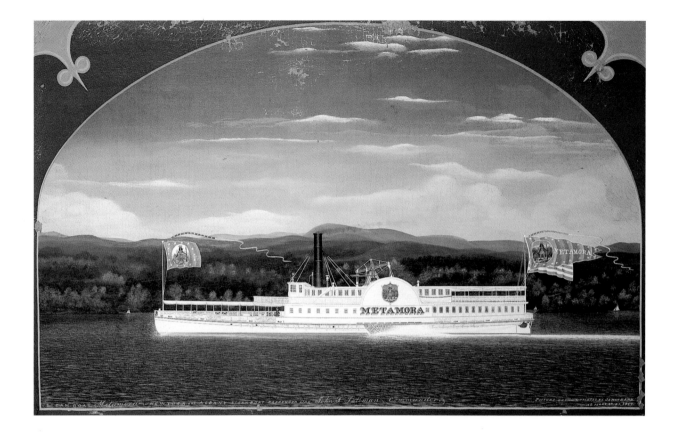

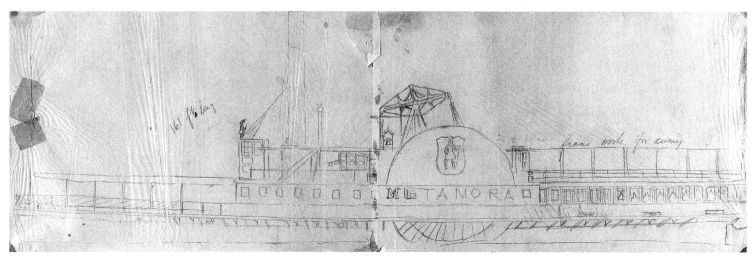

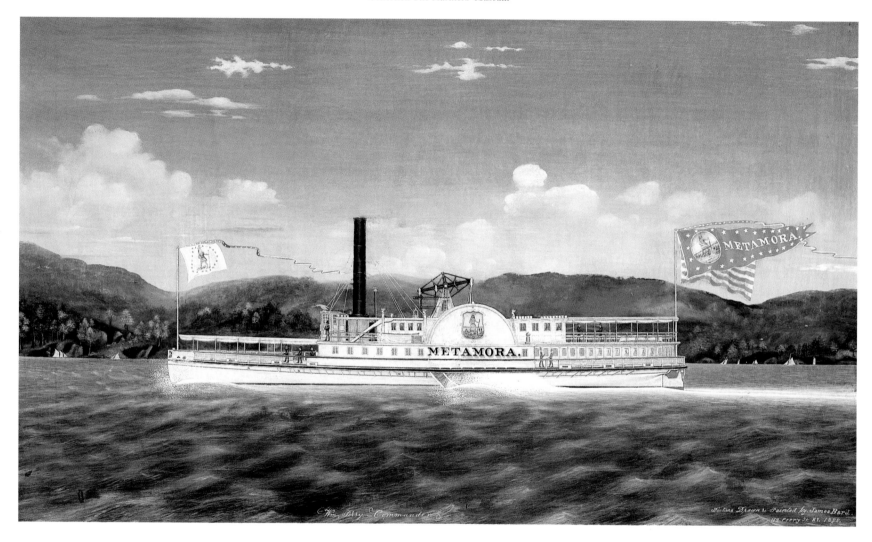

In 1860, Tallman launched *Daniel Drew* from Collyer's yard. Again, Bard immortalized the event with one of several versions of the steamboat. And again, it seems that the lesson of *Henry Clay* was not learned. Tallman took up another racing challenge, this time with *Chauncy Vibbard*, but this race was against the clock, and no casualties resulted. *Chauncy Vibbard* had run a measured race from New York City to Yonkers at a speed of twenty-seven miles per hour. Before Tallman retired he would make the same run at thirty miles per hour.

Tallman's health declined and he retired as a steamboat captain in the 1860s. He helped, however, to finance the building of the *Sylvan Dell,* of which there are five Bard paintings. Tallman then took on the management of the fleet of commuter boats named *Sylvan Dell, Sylvan Grove, Sylvan Shore,* and *Sylvan Stream.* (One form of commuter then was someone who took a *Sylvan* on the twenty-minute ride from Peck Slip in the Wall Street area to the Harlem suburbs, a trip that cost six cents.)

Tallman, who lived in Harlem at 345 East 116th Street, not far from the Harlem Bridge Dock, died of heart disease in 1870. His pallbearers included Burr Wakeman, the president of the Harlem Gaslight Company and the New York & Harlem Transportation Company (Tallman's employer and owner of the *Sylvans*); Joseph Belknap, an engine builder (Bard painted the *Joseph Belknap* in 1850); Andrew Fletcher; and Alfred Van Santvoord. It seems likely that James Bard would have been among the mourners. Tallman was carried aboard *Sylvan Dell* to Nyack for burial. The boat was a fitting choice since he had supervised the construction of this last of the *Sylvans,* which was, according to Eric Heyl's *Early American Steamers,* the fastest and the finest of the five boats and the "prettiest, the most comfortable and the best kept boat of the New York area."

The Nyack Connection

Bard had several customers in Nyack, New York, on the Hudson River below Hook Mountain. Isaac Smith was the owner of a suc-cessful shipyard there. He built *Chrystenah* and had Bard paint her portrait in 1867. A relative, James Smith, built the yacht *Tidal Wave* at Nyack, and Bard painted the portrait. William Dickey, another Nyack yard owner, built the sloop *Ella Jane* in 1857, and his name is inscribed on the 1860 canvas. Her captain, Simon Banks, once ran the *Chrystenah.*

William M. Tweed

New York politician William M. "Boss" Tweed owned three steamboats: *Mary Jane Tweed,* named for his wife; *William M. Tweed,* for himself; and *Americus,* for his yacht club. A photograph of Bard's painting of the "steam yacht" *William M. Tweed* survives, and depicts the ship complete with brass starter cannon on the foredeck. A Bard drawing of *Americus* sports a paddle wheel-box decoration of the Tammany Tiger.

The yacht club that Tweed founded in Greenwich, Connecticut, where he also had a home, was made up of 100 members. Tweed, of course, was president and the others were members of The Ring. To reach the club from Manhattan, the Boss would take his guests aboard the elegant *Americus,* complete with "Oriental rugs, a library, monogrammed linens, sterling silver, a crew of twelve, and for large parties—an orchestra." Members wore a uniform of "blue navy pantaloons with a gold cord running down the sides; blue navy coat; white vest and a white navy cap." The club wasn't cheap: "The initiation fee was $1,000, monthly dues $250." A special badge denoted membership: "a tiger's head made of gold on a relief of blue enamel," probably much the same as the decoration on *Americus.*[5]

One of Tweed's commissioners, Henry Smith, owned a steamboat named for himself and a steam yacht, *America Dispatch,* both of which he had painted by Bard. With the robber barons, Bard left a mixed record. There is the oil of *Jas. F. Fisk, Jr.,* an 1870 ferry boat; a drawing of *Jay Gould,* an 1868 ferry boat; and

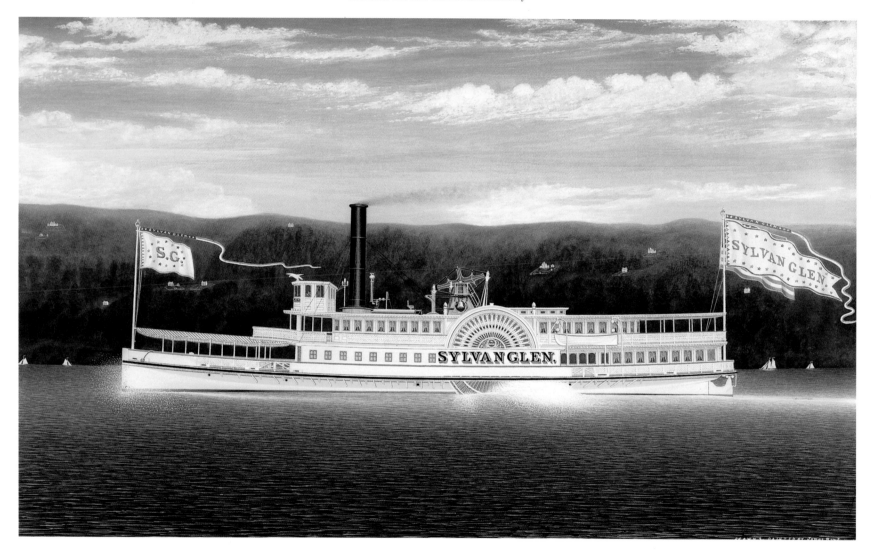

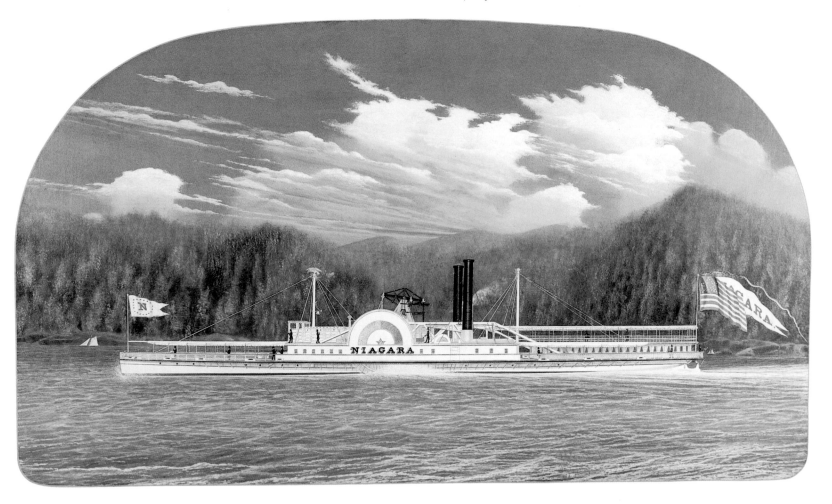

The inscription reads, "Steamer *Niagara* passing Fort Washington Point" (the eastern end of the George Washington Bridge), and informs the viewer that the commander was Albert DeGroot. The *New York Herald* wrote up her launching in June 1845 as follows: "The fitting up and upholstery work is really splendid. The extreme length of her cabin is 270 feet and is furnished in the most tasteful and becoming manner & panels are adorned with beautiful views of American scenery. The ladies cabin is adorned in the like manner and a pianoforte is among the ornaments which are profusely scattered. Statuary beautifies the staircases and all tries to [convey] the idea that one is in a splendid drawing room, rather than a steamboat."

a drawing and a watercolor of *Oakes Ames*.

Bard shunned or was shunned by another robber baron, Daniel Drew, whose personal and business character was most unsavory. For whatever reason, no Bard painting of any of Drew's vessels has survived. There was, of course, the *Daniel Drew*, but the 1860 version is inscribed to Tallman and Collyer and the 1862 version was done after Drew sold her to Van Santvoord.

Albert DeGroot

Albert DeGroot, another very important client of Bard, was also his brother-in-law. Bard's wife, Harriet, and Albert DeGroot were the children of Garrett DeGroot.[6]

DeGroot was born in 1809 on Staten Island, New York, a neighbor of Cornelius Vanderbilt. DeGroot's father was said to be an associate of the Commodore, although New York City directories listed him simply as a "cartman." As the story goes, Albert DeGroot began his steamboat career in true Horatio Alger fashion:

Mr. Cornelius Vanderbilt . . . a rising steamboat captain, builder and owner, was applied to by his neighbor to take the young Albert into his service. When the boy called upon the Commodore, to report for duty, the latter demanded, "What can you do?"

"Almost anything," said he; "Try me, Sir."

The Commodore liked the boy's readiness. He said, "I will Albert. Be a good boy, do right, and you may make your mark on the World."

The lad treasured up to this counsel, and with the example before him, soon rose from deck to command. Vanderbilt then . . . kept an eye on the young man [DeGroot] and took a great interest in him on account of the family relations between the two families, and DeGroot soon became intimate with his patron and employer.[7]

Having worked his way up slowly, DeGroot became master of *Sandusky*, for which unfortunately there is no known painting by Bard. There is a painting, however, of DeGroot's first command,

Albert DeGroot was James Bard's brother-in-law and an important client. (Peluso collection)

Osceola. In a bold scroll at the top of the painting Bard inscribed the name "Captain Albert DeGroot." *Osceola* made regular runs to Fishkill and Poughkeepsie on the Hudson River. In the spirit of competition so characteristic of the time, *Osceola* established her reputation in a successful match race with *Highlander*—another race conducted with little regard to passenger safety.

DeGroot next commanded the day-boat *Niagara*, which Bard painted and inscribed "Albert DeGroot, Commander." The Commander was developing a reputation both good and bad, depending upon the commenting newspapers. His public relations skills were in any case becoming manifest. After a serious crash between *Roger Williams* and *Niagara* in 1847, the *Albany Angus* (quoted in

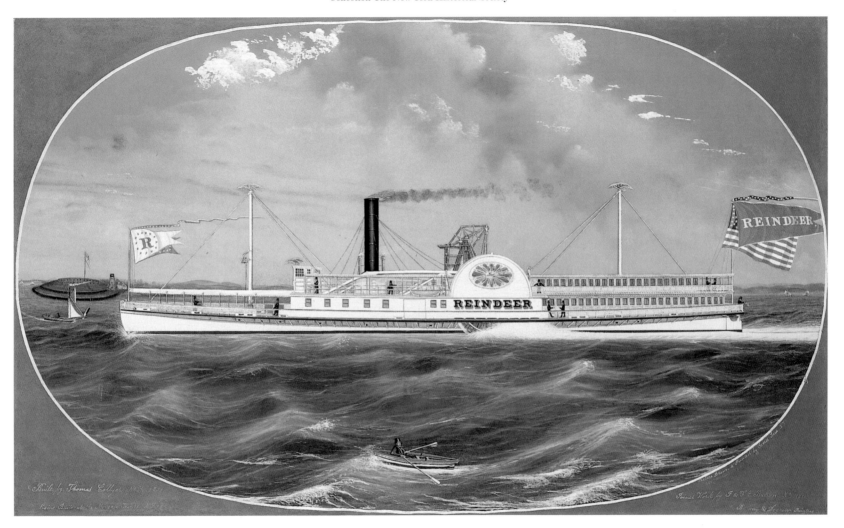

The painstaking drawing and two splendid paintings shown here document an important point in James Bard's career. He was ready to break out artistically and commercially. Two of his important mentors were being served: Thomas Collyer and Albert DeGroot, whose names are inscribed on these works. Bard work of this quality had not been seen before. At thirty-five years of age, James Bard's success was assured. *Reindeer's* career, on the other hand, ended tragically. A boiler exploded, she burst into flames, and thirty passengers lost their lives in September 1852.

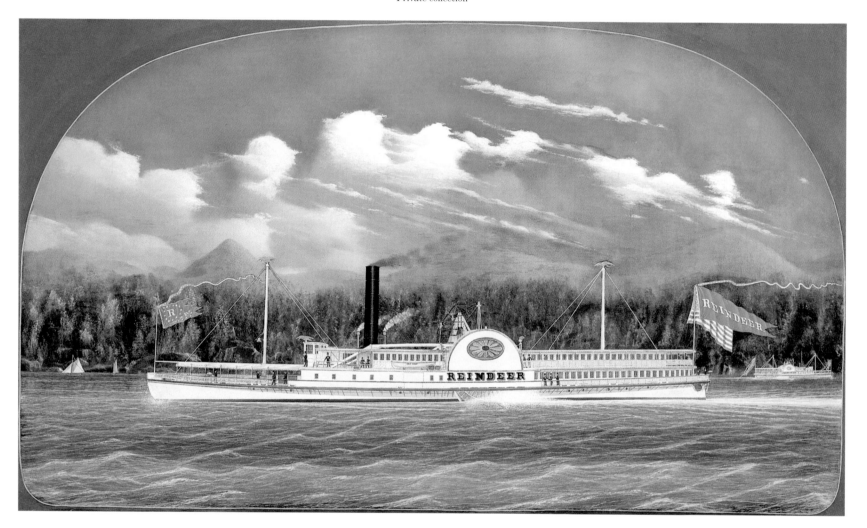

the *Ulster Republican* of August 4, 1847) stated that "the most extravagant stories at first told in regards to the affair—so unusual on the Hudson River—but this we believe to be a correct account. It was one of those accidents which the utmost care is not always to guard against." The article also stated that the captain had "procured physicians at Newburgh and deserves much credit for the care he took of the wounded." The *Ulster Republican* saw it differently: "as usual, nobody is to blame for the catastrophe—human life is cheap, and steamboat captains can sport with it as they please." They went on to say the *Niagara* had been racing for the last six weekends and concluded that the officers of the boat should be convicted of manslaughter. "An example or two of this kind would perhaps lessen the danger of steamboat travel." In a fine bit of follow-up reporting, they revealed in the August 11 issue that Captain DeGroot had "directed the engineer to put on more steam and when informed that it was impossible as the blowers were then arranged, he ordered gearing to be changed as to double their velocity. . .the boilers exploded within 15 minutes." A few years later, in obvious disregard for some of the better known facts, the *Kingston Democratic Journal* commented about Captain DeGroot on April 2, 1851: "None who have traveled in the *Niagara* and other steamers at his command, will forget that, besides the highest excellence in his profession, his urbanity always makes each journey a pleasure trip."

DeGroot's next command was *Reindeer,* a vessel described in the now partisan *Ulster Republican* as a "Bijou of a steam palace." In July 1851 *Reindeer* broke the Albany-New York record with a time of seven hours and twenty-seven minutes. The *Democratic Journal* of August 13, 1851, related one of its adventures:

The popularity of this fleet and charming craft, and its gallant Commander seems to be unlimited. Scarcely a day passed that we do not see or hear of some flattering remark of approbation, or high compliment,

JAMES BARD
CALHOUN
1857. Oil on canvas, 30 × 52"
(76.2 × 132.1 cm). Collection
The Mariners' Museum

Bard rarely painted oceangoing
steamers. *Calhoun* was built to
run to Charleston and Savannah.

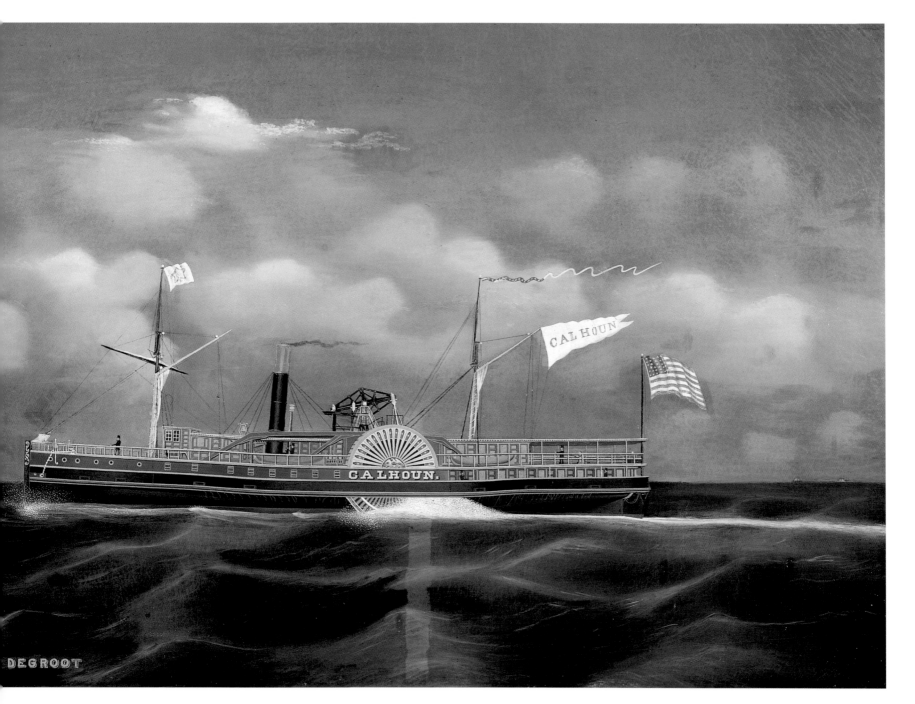

being bestowed upon him. One day last week Miss Jenny Lind was among the passengers on her up trip. Jenny came on board incognito but when recognized by some of the passengers the excitement to see her was very great, and for a part of the passage Capt. DeGroot tendered her in his private saloon. She is expected to return under his charge, some day this week. In grateful appreciation of the courtesies extended to her, Jenny Lind, upon arrival at Albany, presented captain DeGroot with an elegant diamond breast pin.

It is possible that the many encomiums found in the newspapers of the day were accurate comments on DeGroot's personality. Nevertheless, it seems equally likely that DeGroot was a master at planting self-flattering items. The following passage from David Buchman's *Old Steamboat Days on the Hudson River* (1907) may have been closer to the truth:

DeGroot of the Reindeer *would never admit there was boat on the river that could pass him and he was frequently called upon to prove it, which he did to the discomfiture of his rivals. The* Henry Clay *was designed to beat her, but never did. The* New World . . . *was thought to be a match for* Reindeer, *and she proved to be, though DeGroot would never admit it, always claiming something went wrong with the machinery when he found the other boat was pulling away.*

Fortunately for his reputation, DeGroot left command of *Reindeer* before she blew up in September 1852 with the loss of several lives. But this was not before Bard had completed his portrayal of the boat, showing *Henry Clay* lagging behind in the background. The painting was inscribed, "Albert DeGroot, Commodore."

In 1853 DeGroot capitalized on his brief encounter with the popular entertainer Jenny Lind, and named his next steamboat after her.[8] A pencil drawing and watercolor of the ship were done by Bard. On the paddlebox in the drawing, Bard sketched a dowdy portrait of the Swedish singing star. It does not suggest the mystique

established for her by P. T. Barnum, nor probably the image the owner-builder wished to project. Perhaps for this reason an oil was never commissioned. The watercolor has an unadorned paddlebox.

In 1855 Commodore DeGroot "retired from active life on the water, having accumulated quite a fortune."[9] He worked for a time with a firm of bankers, participated in the management of the Prescott Hotel, conducted a towing business, and had two towboats, *Resolute* and *Reliance,* built by Ben Terry. Each was sold to the government at the outbreak of the Civil War. If Bard painted the boats, the works have been lost.

In 1857 DeGroot commissioned a portrait of *Calhoun,* one of the few oceangoing vessels in Bard's oeuvre. As always, the portrait commemorated not only the ship but the patron as well. This time the inscription read, "Presented to William Heading by his friend Albert DeGroot." In 1862 Albert DeGroot took his last chance at boat building with *Jacob H. Vanderbilt,* named for Cornelius Vanderbilt's brother. Bard did a pencil drawing of the boat, but before it came down the ways Vanderbilt evidently decided against its purchase and the boat was renamed *General Sedgwick.* Bard painted the watercolor in 1877 for another client, N. S. Briggs.

N. S. Briggs

Bard had a neighbor on West Tenth Street, not far from Perry Street, by the name of Briggs. He had inherited a stationery business from his father but thought "getting up water excursion parties to picturesque spots around New York" a more rewarding business.

JAMES BARD
MORRISANIA
(detail)
1871. Watercolor on paper, 30⅛ × 49⅞" (76.5 × 126.7 cm).
Collection The Mariners' Museum

Steamboat designers lavished a great deal of attention on the paddlebox decoration. *Morrisania's* paddlebox features what appears to be a sloop race.

JAMES BARD
WILLIAM M. TWEED
Undated.

This photograph shows that there
once was, and there may still be, a
painting of *William M. Tweed*. Its
whereabouts, date, size, and medium
are unknown.

JAMES BARD
JOHN L. HASBROUCK
Undated. Pencil on paper,
13⅞ × 21¼" (35.2 × 54 cm).
Collection The Mariners' Museum

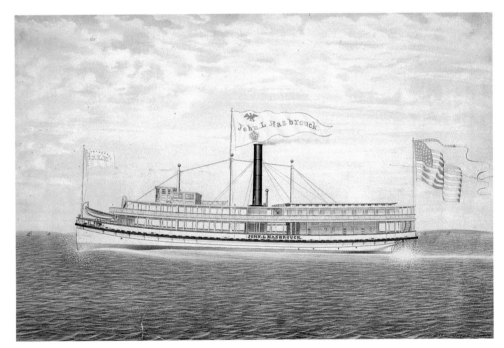

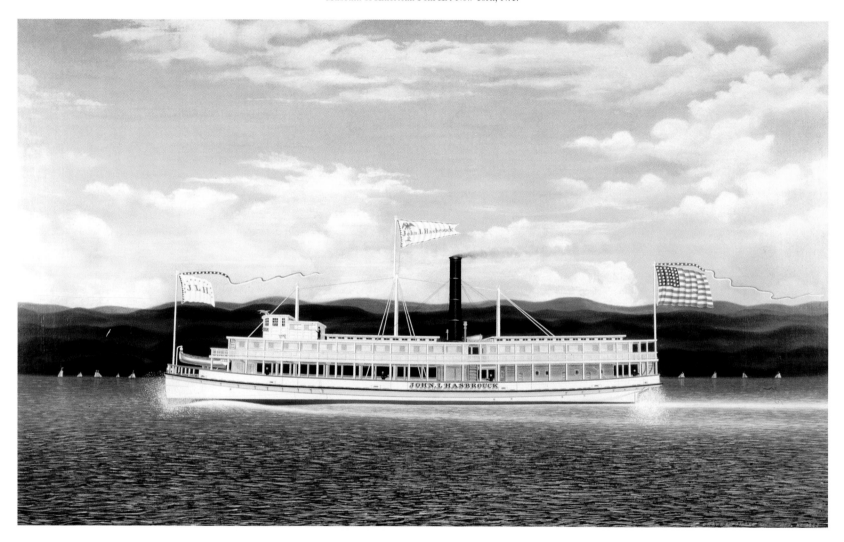

This propeller steamboat had two important moments to celebrate. First, she broke through ten inches of ice at Magazine Point, a narrow part of the river at West Point, to open Hudson River navigation to Newburgh, New York, in February 1882. Second, she brought mourners down-river from Poughkeepsie to the funeral of General Grant in September 1885.

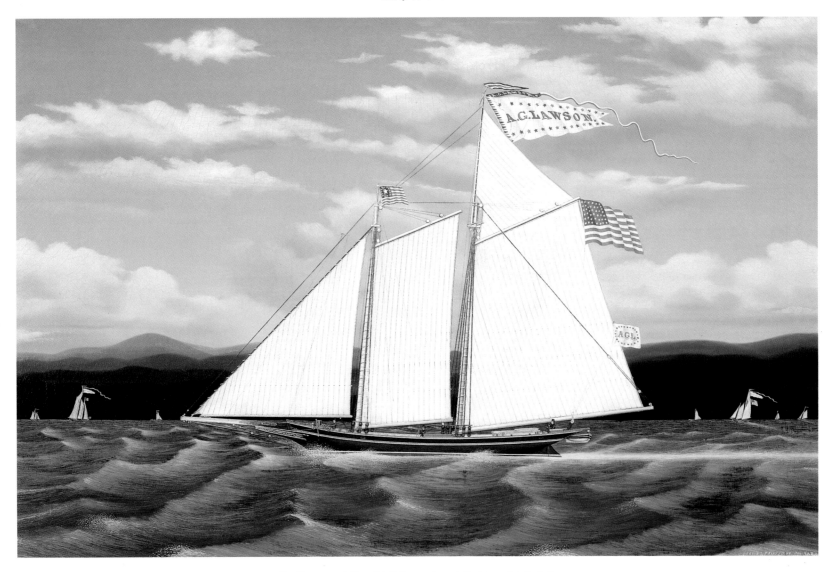

Bard's representation of *A. G. Lawson* in portside, leeward, and windward views is a motif with a long history in European marine painting.

The idea spawned an industry that barely survives today. He fitted out *General Sedgwick* for such service and commissioned Bard to paint the picture. He also commissioned him to paint his tugboat *Mary J. Finn* and her passenger barge, which he used to carry day-trippers. The burgee, or name flag, in the painting reads "Briggs Excursion Boats and Groves 384 West Street." The *Mary J. Finn* was one of four steamboats that Briggs owned at the time of his death in 1884. On these boats, he transported several thousand people each day to such exotic places as Excelsior Grove at the foot of the Palisades, where the pilings may still be seen, or to New Jersey's Oriental Grove, Oscawana Island, or Raritan Beach. Unlike many of his contemporary river rivals, Briggs was described as an "upright and honest" man.[10]

The Business of Sail

James Bard painted some twenty oils of schooners and sloops, but steamboats occupied the largest share of his time and effort. From their first days in 1815, steamboats attracted enthusiasts. There were magazines and societies devoted to their manufacture, design, and performance, and there were collectors to preserve steamboat memorabilia and paintings. On the other hand, schooner and sloop commerce on the Hudson River was in serious decline. In 1840, for example, 608 sailing vessels used Albany's harbor.[11] By the Civil War, only some twenty years later, steamboats and railroads had virtually eliminated the sailing vessel as the leading means of transport on the Hudson River. In his *Sloops of the Hudson River, A Historical and Design Survey* (1994), Paul E. Fontenoy notes that:

The old sloops soldiered on, undermanned and overloaded, through the 1860s and early 1870s. Some sloops survived into the 1890s, others were converted to schooners. Many became unrigged, harbor lighters, but the days when they dominated traffic on the Hudson had ended 40 years earlier.

The one area in which sailing interest grew was, of course, yachting. With the growth of yachting as a sporting pastime, and

Captain Casper Lawson.
Courtesy Leigh Keno American Antiques

with the unmatched success of America's international yachting triumphs, it might be expected that Bard would have received more commissions than the few that have survived. It may have been, however, that this clientele belonged to a different social group than did his own steamboat clientele. It may also have been the self-evident talent of one James Buttersworth, who made that market his alone.

The earliest Bard paintings of sailboats are associated with the Collyer brothers: *William Collyer*, in versions from 1846 and 1848 and *John Griffith* (1855). Others are brick-hauling schooners associated with the Haverstraw, New York, brick industry: *American Eagle, George S. Wood*, and *Robert Knapp*. George S. Wood was part-owner of one of the largest Haverstraw brickyards.

There were many reasons to commemorate sailboats, and speed was one of them. *American Eagle* was known as the fastest sloop in Haverstraw Bay. *Lewis R. Mackey* was also a very fast sailer. *A. G. Lawson* won the July 4th schooner races from Haverstraw to Nyack in 1869 and 1870.[12] Yacht portraits of *America* and *Tidal Wave* were commissioned to celebrate their uncommon speed. The most unusual painting of this group is *Sailing on the Hudson*, which depicts a club race at the Hudson River Yacht Club, then located at West 92nd Street in Manhattan.

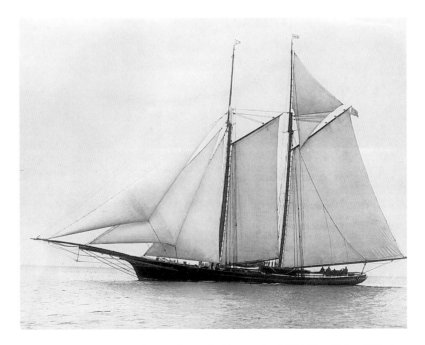

An unknown contemporary photographer made this portrait of *Tidal Wave*. Peluso Collection

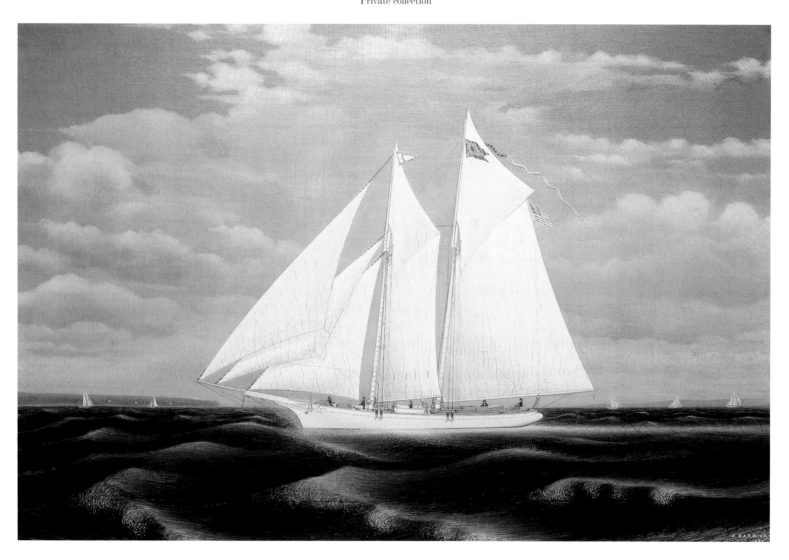

Nyack's newspaper *Rockland County Journal* of July 22, 1871, informs us that at a dinner to honor Commodore Voorhis and "his beautiful yacht *Tidal Wave*. . . . The walls of St. Nicholas Hall were festooned with flags, evergreens and flowers and two paintings of *Tidal Wave*." History does not relate the present location of the other painting.

Notice the flag on this impeccable portrait: *Sylvan Dell* is similarly
adorned. One reason to ride *Harlem* or *Sylvan Dell* was to reach
Harlem Lane, the "speedway," that is now St. Nicholas Avenue. It
ran to 168th Street and was dotted with inns and saloons from which
one could watch trotters and fast horses passing by.

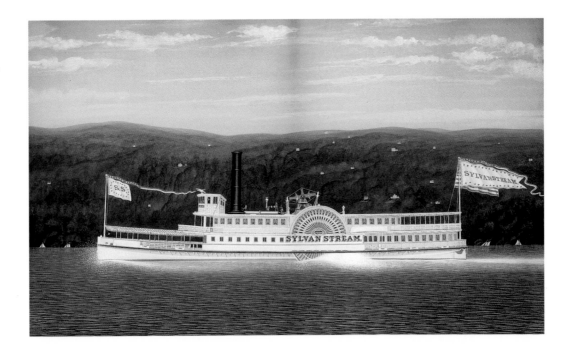

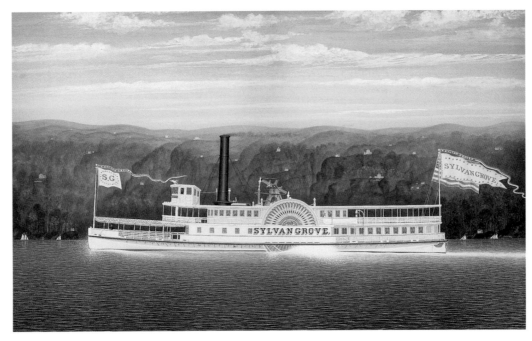

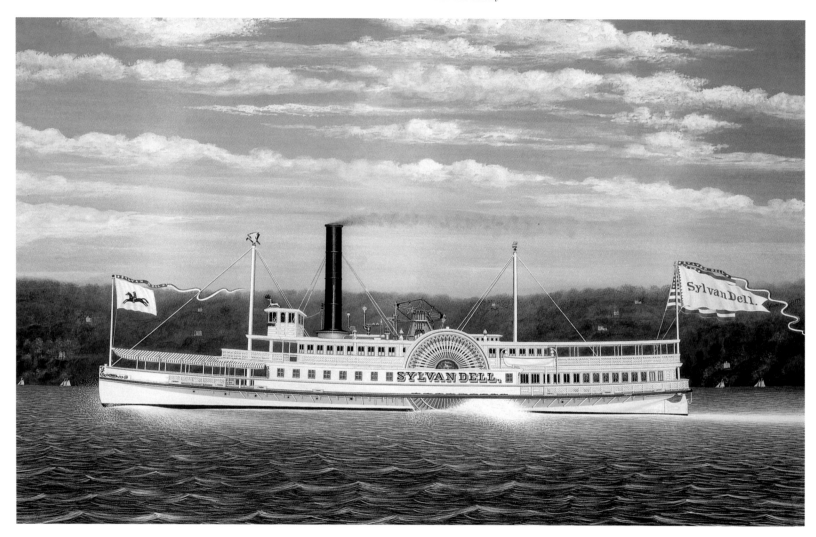

The *Sylvan* fleet ran for the Harlem and New York Navigation Company,
providing service from Harlem to lower Manhattan. For a time business
was robust enough to support a rival line, the Morrisania Navigation
Company with the steamboats *Harlem, Shady Side,* and *Morrisania.*

JAMES BARD
CHRYSTENAH
1867. Oil on canvas, 37½ × 60" (95.2 × 152.4 cm).
Private collection, New Jersey

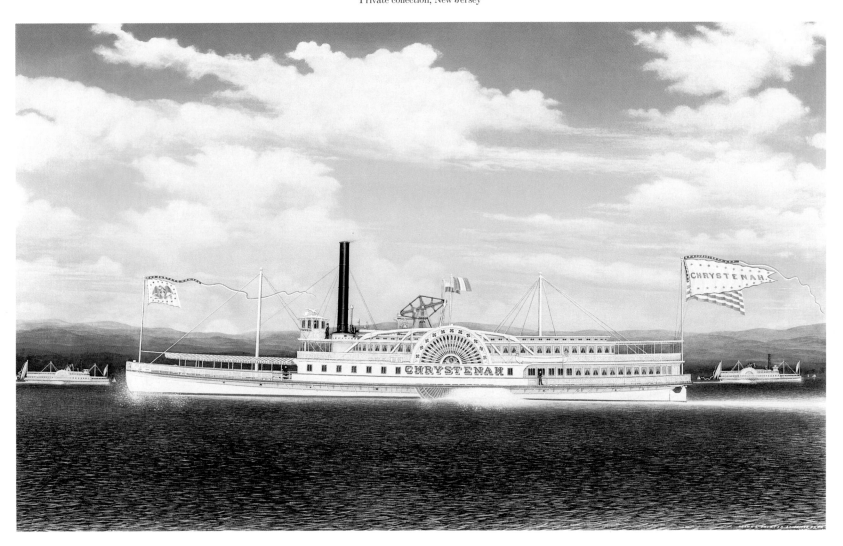

David and Tunis Smith built *Chrystenah* and the other steamboats shown in the background here. *Chrystenah* served long (until 1919) and well, paying fitting homage to the Smith boys' mother, after whom the steamboat was named. Mrs. Smith's portrait was hung at the first landing on the stairway leading from the main deck, and her "sweet face out of the olden time" greeted all passengers. In the details at right are the other steamboats.

Chrystenah (detail)

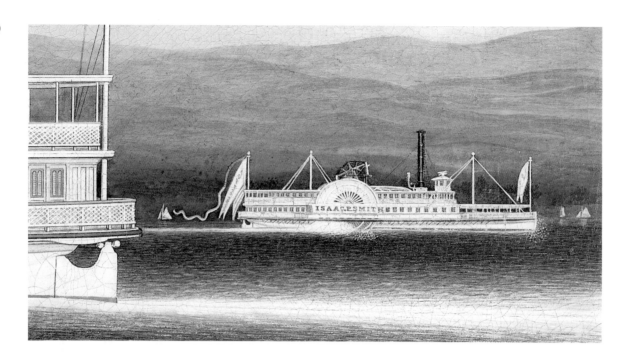

Chrystenah (detail)

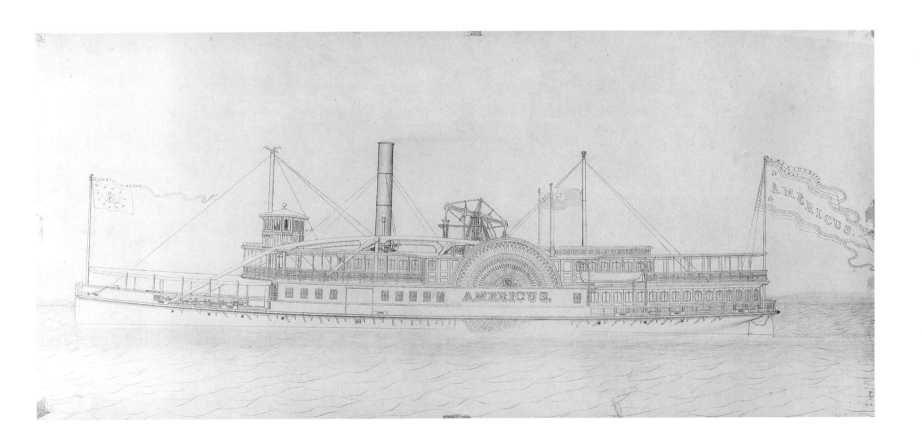

The steamboat may have been named after the Manhattan fire-fighting group Americus Engine Company No. 6. In 1850, "Boss" Tweed became foreman of the company, his first successful political step. The company's uniform buttons featured grinning tigers.

DANIEL DREW

1874. Oil on canvas, 25¼ × 40" (64.1 × 101.6 cm).
The Allan Katz Collection

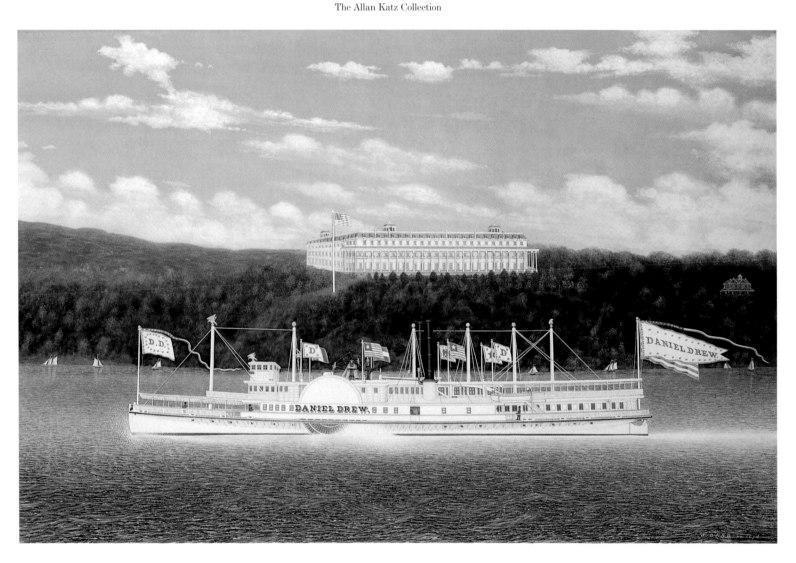

Samuel Ward Stanton wrote that the *Daniel Drew* was "A remarkable, fine and swift river steamer Her mold was one of faultless beauty, having been constructed for speed." Daniel Drew was her first owner, but when this portrait was painted she was owned by Alfred Van Santvoord. Among the places the boat served was the Prospect Park Hotel, seen in the background, at Catskill, New York, which was listed in McQuill's 1874 guidebook, *The Hudson River by Daylight,* as situated in the "Switzerland of America."

AMERICAN EAGLE

1856. Oil on canvas, 32 × 52" (81.3 × 132.1 cm).
Private collection

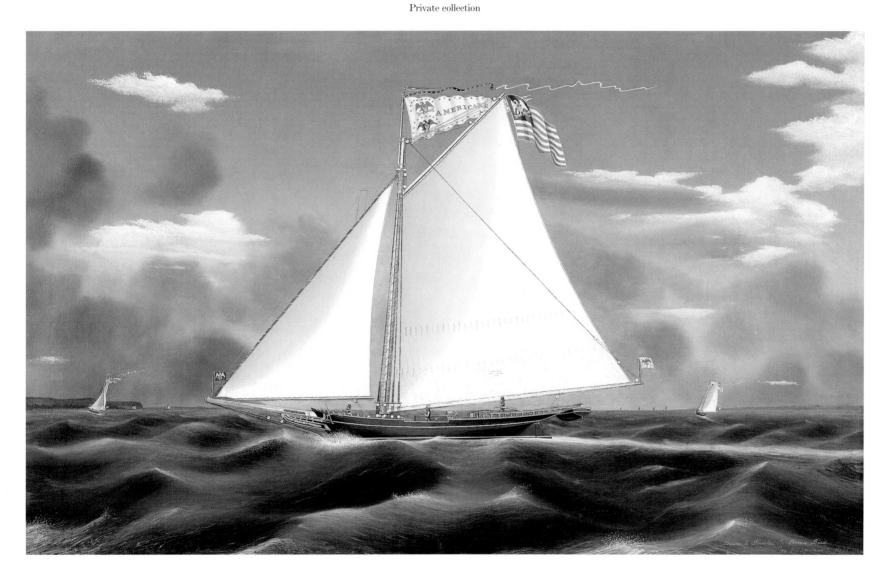

The origin of the name B. Bennett, painted on the mainsail of the sloop, is unknown.

GEORGE S. WOOD

Undated. Oil on canvas, 33¼ × 53" (84.5 × 134.6 cm).
American Folk Art Collection, National Museum of American History, Smithsonian Institution, Washington, D.C.
Gift of Eleanor and Mabel Van Alstyne

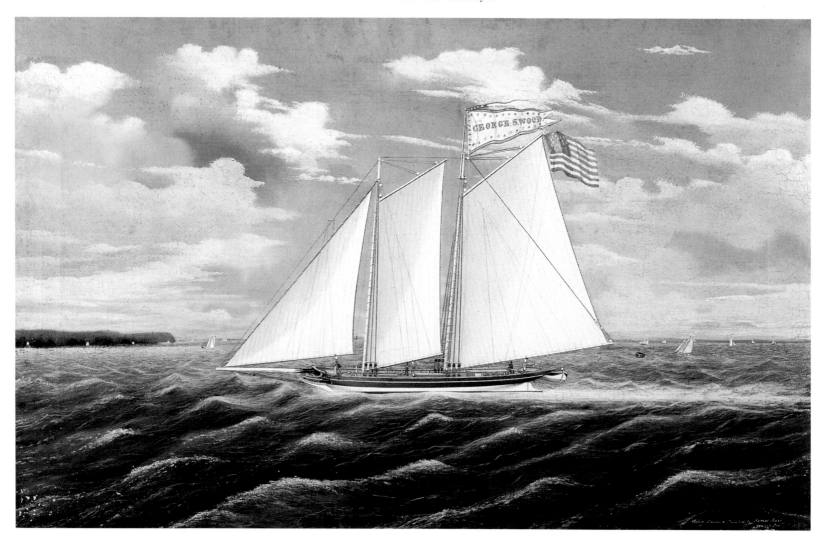

The setting suggests Haverstraw Bay, where the schooner was built
for Mr. Wood, a local brickmaker. In keeping with tradition, Bard shows
the boat twice more in the distance on different tacks.

AMERICA
1851. Oil on canvas, 43¾ × 63¼" (111.1 × 160.6 cm).
Abby Aldrich Rockefeller Folk Art Center, Williamsburg, Virginia

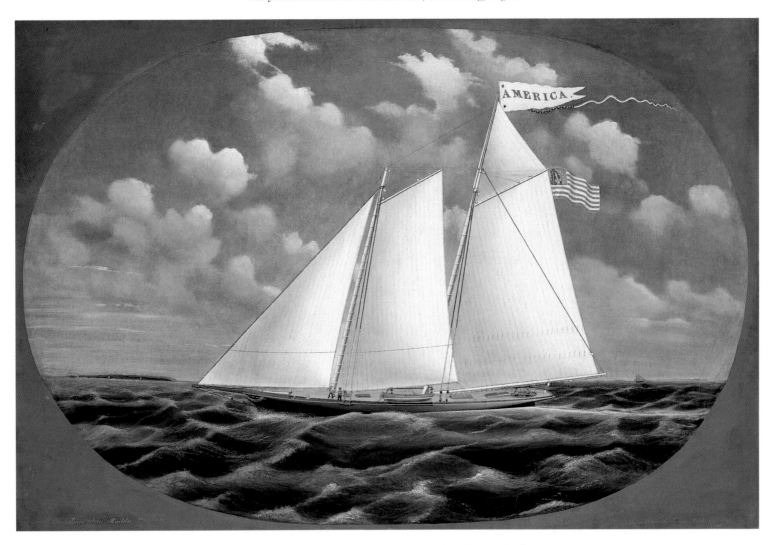

The schooner yacht *America* won the first of the famed international
races, inspiring the name of the trophy cup. This may be the boat's
earliest painted likeness: the race was won on August 22, 1851, and
Bard's painting dates from the same year.

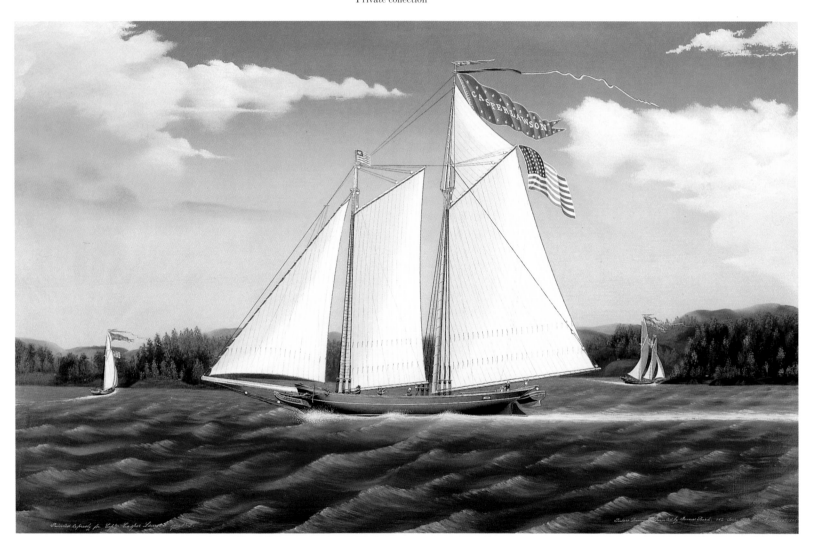

Captain Lawson, to whom the picture is inscribed, was a wholesale
dealer in bricks, and it would have been this schooner's job to carry
them. *A. G. Lawson* also performed this unromantic task.

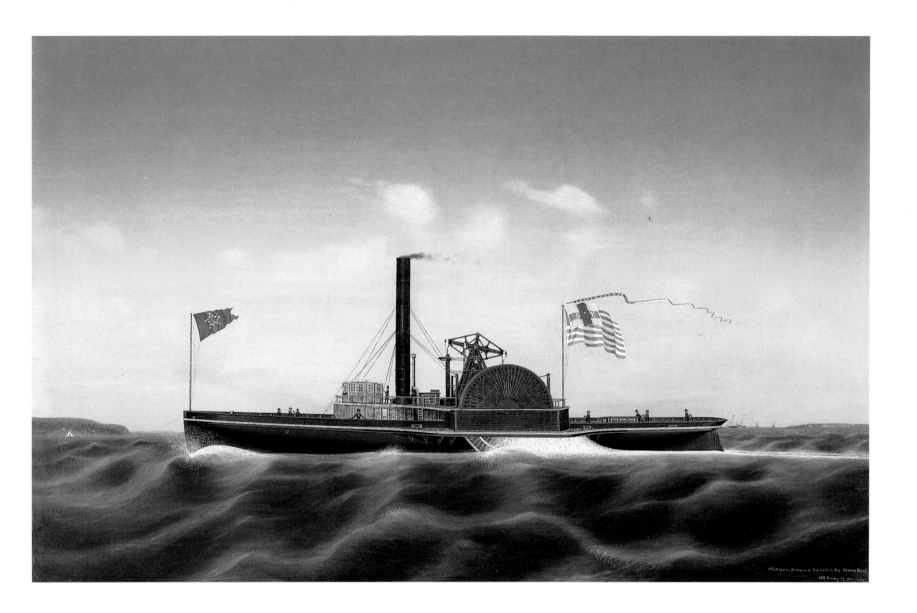

THE MARINE PAINTER'S TRADE AND ART

In his commission for this painting, Bard was presented with the challenge of a black-hull. Without special pains the towboat portrait could have seemed one-dimensional, but the artist shaded delicately in tones of black to suggest the smooth curves of the hull. He presented the paddlebox, constructed of overlapping layers of latticework, again using subtle variations of black, almost photographically.

The *Seaboard* magazine obituary concluded that, "No one in this time compared with James Bard in the matter of making drawings of vessels, and his name will ever be associated with the lists of artists of this country who make a specialty of painting pictures of vessels. In the art he was the father of them all."

Bard, of course, was not alone in his work. His New York competition was robust. While he was among the earliest to focus his artistic eye on the beauty of a steamboat, he was not the only one. Considering the number of men, and a woman, who produced portraits of ships, it is a wonder that Bard was able to dominate his market for as long as he did. With their birth and death dates spanning the years between 1798 and 1920, there were at least seventeen major maritime artists plying their trade in New York. Twice the craft was handed down from father to son. While each had a steamboat or two to his or her credit, none

seems to have seriously intruded on the other's market niche, nor especially on Bard's.

James Buttersworth captured the yachting trade and would have had serious competition from A. Cary Smith had he not turned to yacht design in mid-career. The yachting market also had Fred Cozzens, but he worked only in watercolor and pen and ink. Joseph B. Smith and his son William shared the clipper ship market with Buttersworth until the Civil War took William away. Conrad Freitag and Elisha Baker had careers that fed off South Street commerce, particularly the Long Island–run steamboat companies. Freitag also specialized in pilot boats. (The Pilot Boat Association was located on South Street.) Antonio Jacobsen handled the oceangoing traffic, although Fred Pansing took much of the German and Dutch trade in painting these vessels. Pansing also made much of his association with the American Lithographic Company.

Thomas Willis introduced unique "silk-ware" embroidered portraits. Charles Parsons handled much of the early Currier & Ives's maritime lithographic requirements, and the work of his son, Charles, would be seen almost exclusively in the Endicott firm's many maritime lithographs. John V. Cornell would have provided serious competition for Bard on the Hudson River had he not been lured to California and the goldfields. William G. Yorke, after his breakup with his son, William H. Yorke, would leave Liverpool and work from a sailboat-studio, developing the trade to be had on the Brooklyn waterfront. James Gale Tyler began his career in New York City and signed his earliest works "drawn & painted," in the Bard manner. Samuel Ward Stanton, in addition to his exemplary art, would edit nautical journals, manage an advertising agency with firms engaged in maritime commerce, and create a lucrative

career decorating the interiors of steamboats. There was room for every talent.

Bard knew Jacobsen, Buttersworth, Pansing, Cozzens, and, of course, Samuel Ward Stanton. There is evidence that Jacobsen entertained these artists at his Hoboken home.[1] It is also known that Bard worked with Frances Flora Bond Palmer. It seems likely that he would also have known John Cornell, a one-time neighbor who showed pictures with Bard at the American Institute of the City of New York. While the evidence of personal or business relationships among these painters is slight, it seems clear that they all got along in the shared marketplace of New York. While some of Bard's contemporaries survived him into the twentieth century, the ship-portrait tradition would largely be carried on by means of the new technology of photography.[2]

The majestic *Mary Powell* passes the majestic Palisades.

JAMES BARD
MARY POWELL
1861. Oil on canvas, 30 × 50" (76.2 × 127 cm).
Museum of the City of New York

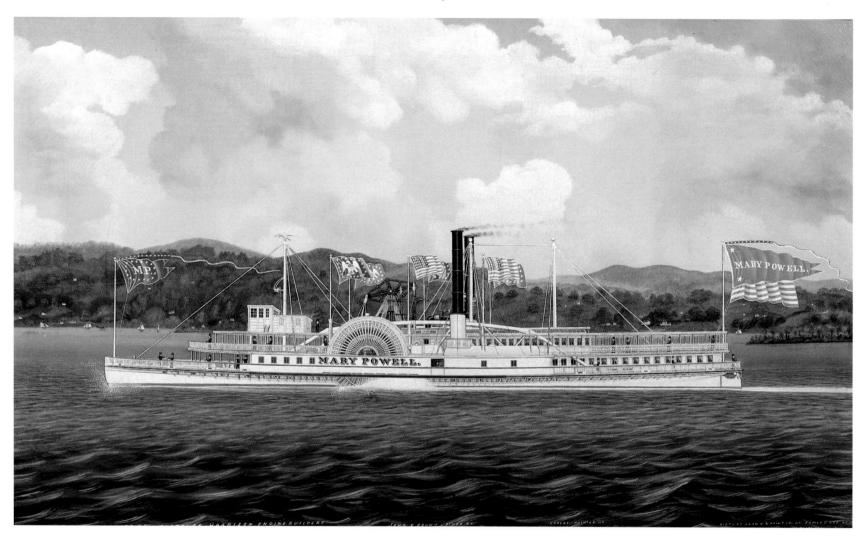

Legend has it that this was the only steamboat on which unchaperoned young ladies were considered "safe." Perhaps substantiating this reputation, her commander, Captain Anderson, was once observed shooing a fly off a handrail.

NELLY BAKER

1855. Oil on canvas, 30 × 52" (76.2 × 132.1 cm).
Private collection

(Opposite) *Nelly Baker,* detail

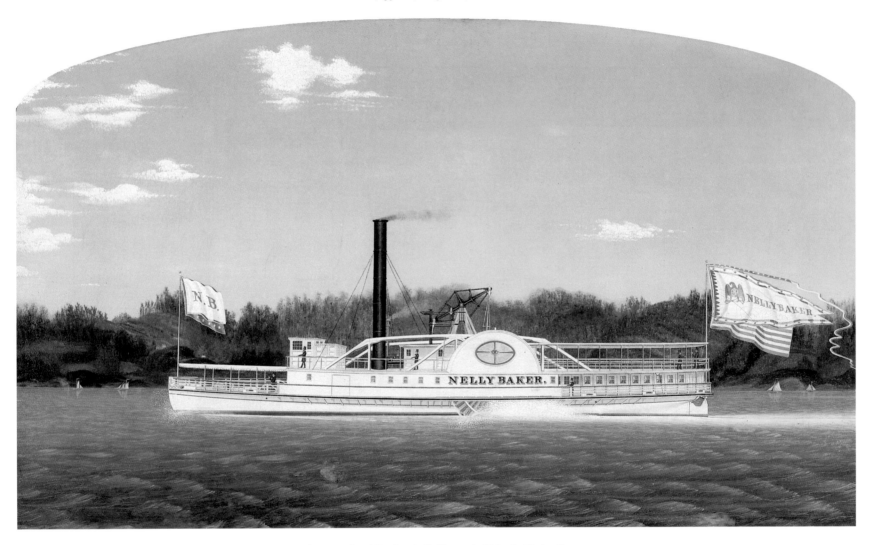

A rare unsigned Bard portrait. She was built for the Boston &
Nahant Steamboat Company at Greenpoint, Brooklyn.

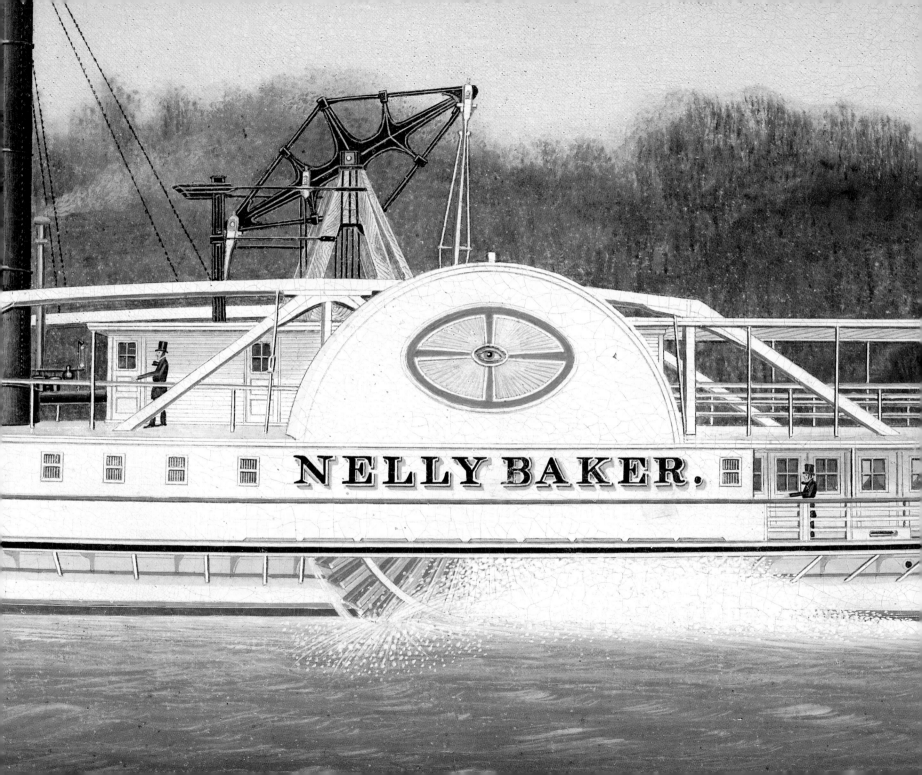

H. R. ROBINSON
CALIFORNIA
1847. Lithograph, 20 × 34¼" (50.8 × 87 cm).
Collection The Mariners' Museum

This H. R. Robinson lithograph of an early work by the Bard
brothers is the only record that now exists of the lost painting.

COMMODORE

1857. Oil on canvas, 34 × 56" (86.4 × 142.2 cm).
Collection The Mariners' Museum

Presumably she was commissioned by Charles W. Farnham, whose name and rank are inscribed on the canvas. The house flag reads, "New York, Albany & Troy Steamboat Passenger & Mail Line," but *Commodore* ended her days on the Stonington (Connecticut) Line. She burst into flames on December 27, 1866, and ran aground at Horton's Point on Long Island Sound, allowing passengers to escape but ending as a total loss.

To allay public fears about steamboat safety (their engines had an
alarming tendency to blow up) the passenger barge was invented.
With no engine and slow speeds derived from being towed, passenger
barges had some mid-century popularity.

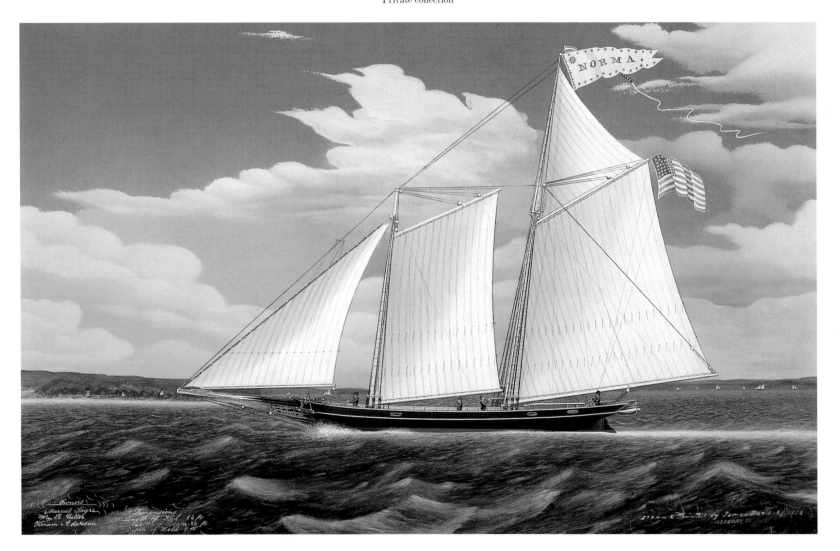

EMMA HENDRIX

1858. Oil on canvas,
32 × 52" (81.3 × 132.1 cm). Private collection

(Opposite) *Emma Hendrix*, detail

Little is known of Emma Hendrix, the person or the schooner. The
painting came to light in a sale at Macy's department store in New
York City in 1927.

GLEN COVE
1855. Oil on canvas, 30 × 52" (76.2 × 132.1 cm).
Glen Cove Public Library, Glen Cove, New York

Built for the New York & Glen Cove Steamboat Company, in 1856 she was transferred to Hudson River duties and was fitted with a calliope (the first), but each time the steam organ was played pressure was diverted from the engine and the boat slowed down. Sold for service on the James River, *Glen Cove* was burned by the Confederate army when they evacuated Richmond.

COMMONWEALTH

Undated. Oil on canvas, 35¾ × 57¾" (90.8 × 146.7 cm).
Maloy Collection

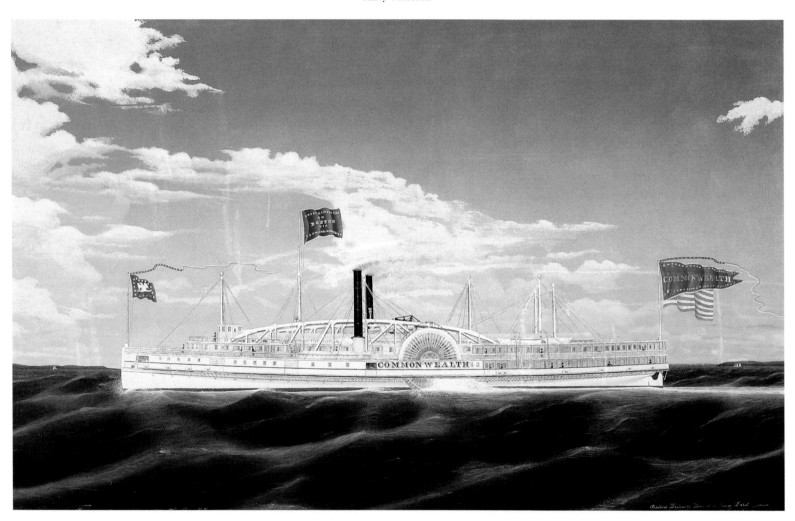

Built by Lawrence & Foulkes for the Norwich & New London Steamboat Company, this 300-foot-long steamer had accommodations for 600 passengers. Advertisements boasted that her "carpets were of Wilton, and velvet, from the store of Stewart & Company, Broadway." Her chairs were rosewood. Of the boat's total building cost of $250,000, some $60,000 was spent on furnishings. Not unexpectedly, she proved expensive to run, changed hands often, and never made much money. She ended her days in flames, while moored near the railroad station at Groton, Connecticut.

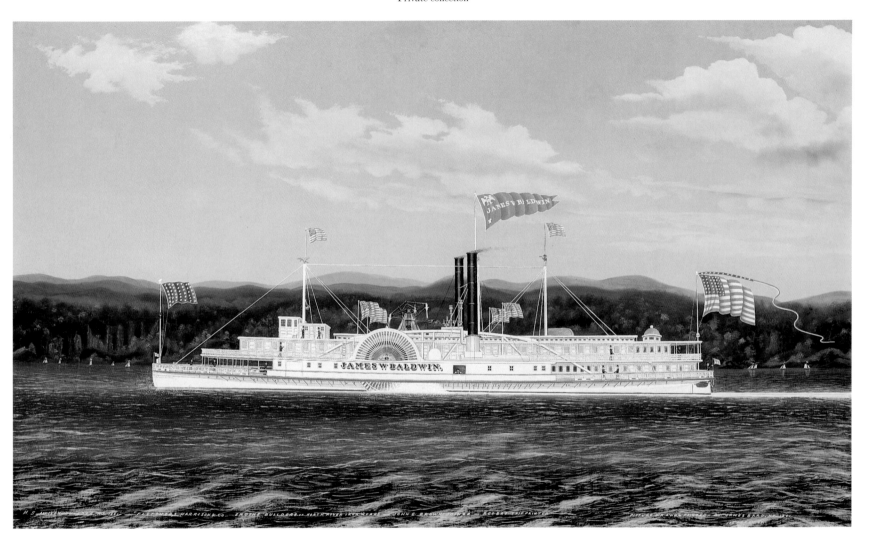

She was to be named *Wyltwyck*, but when owner James W. Baldwin died before the launching, his friend Jacob Tremper and his son-in-law William F. Romer renamed the boat in his honor. She had no major mishaps, except for a collision with the schooner *Ella Persey* in 1882, and some damage to the canal boat *J. G. Cozzens*. In that regard, the *Marine Journal* for July 31, 1886, noted that a resulting suit was dismissed, and added, quite irrelevantly, that the *Baldwin* had been bringing immense quantities of berries from Kingston that week.

JAMES BARD
JESSE HOYT
1862. Oil on canvas, 30 × 50" (76.2 × 127 cm).
Collection Sanford and Patricia Smith, New York

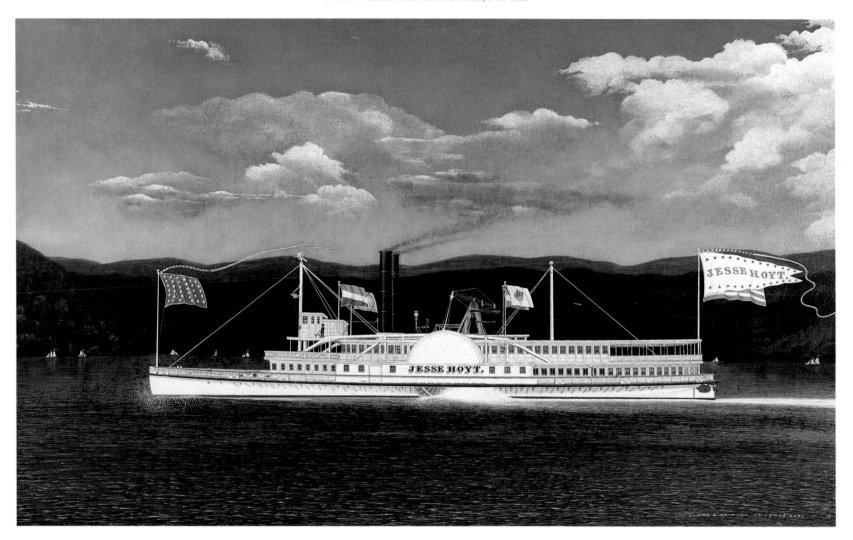

Built for Alfred Van Santvoord to run on the Hudson River, she later
steamed regularly from Brooklyn to Philadelphia in five hours for a
fare of $2. By 1880 she could be seen on the Gowanus Canal converted
into a coal barge.

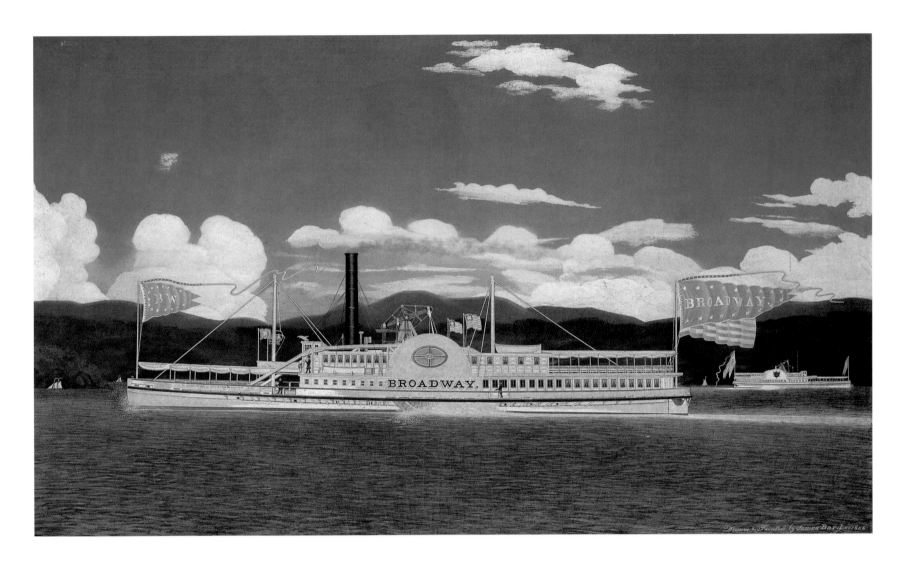

TECHNIQUE OF THE BARDS

In the personals column of the *Marine Journal* of August 24, 1889, James Bard was described as the oldest marine painter in the United States. It noted that he had made over 4,000 paintings of steamboats. His obituary stated that he had "made drawings of almost every steamer that was built at or owned around the port of New York, the total number of these productions being about 4,000." And in a piece in the *New York Sun* on January 7, 1912, the artist and historian Samuel Ward Stanton said, "He used to tell me that he painted over 3,000 steamboats."

Arithmetic would require that the Bards produced an average of one painting each week in order to reach the claimed goal; not impossible, certainly, and almost a necessity for James Bard if, as we believe, he supported his family by this means alone. As a matter of fact, it is known that he painted *Boston*, *Ocean*, and *St. Lawrence* in March 1850. Each canvas is so dated. A fourth and a fifth

—*Reindeer* and *Chingarora*—may also have been painted at that time. *Reindeer* was launched on March 2 and *Chingarora* was launched on March 27.

How did he go about it? Tradition has it that Bard spent much of his time observing his subjects being built and climbing over the unfinished joiner work, measuring heights and widths. His *Seaboard* obituary stated that, "Mr. Bard would measure the boat to be pictured from end to end, and not a panel, stanchion or other part of the vessel, distinguishable from the outside, was omitted, each portion was measured and drawn to scale." The attention to scale can be clearly noted in the drawings of the tug *Brilliant*, the steamboat *Jacob H. Vanderbilt*, and the ferry *Southfield*.

The engineer of the *City of Troy* told of helping Bard when he was securing data for a drawing. The boat was then being fitted out at the Englis yards in Greenpoint, Brooklyn. When finished, it

JAMES BARD
BROADWAY
1858. Oil on canvas, 33 × 56"
(83.82 × 142.2 cm).
Collection The New-York
Historical Society

In a brief life (her boiler exploded in 1865), she served on a regular run from Jay Street to Yonkers, Hastings, Dobbs Ferry, Tarrytown, Sing Sing, and Haverstraw. Her engine was transplanted into *Chrystenah*.

James Bard would often take measurements to complete his drawing for a steamboat at the dry dock run by Devine Burtis, Jr. Here, berthed next to a square rigger, *Nuhpa* (seen above) has been hauled out, perhaps for repairs. (The Mariners' Museum)

was sold to the Citizen's Line, whose fleet would consist as well of *Saratoga* and *Belle Horton*. The latter would be built at the Van Loon & Magee yards at Athens, New York. We can presume that Bard traveled upriver to get the appropriate information firsthand. After taking his measurements, Bard executed a highly detailed pencil drawing to which he added notes concerning color and dimensions. An example of the precision of his notes (albeit with grammatical shortcomings) is found on the drawing of *Galafre*: "The figure on Circle is Representing Neptune Riding in a Car as a large Shell Reddish inside and White outside. The head and face is turned to the Bow and the 2 Horse also the sea is very ruff. He has a Mantel a Flying Back from the Shoulders and lower limbs. He stands in the Attitude of Holding the Thunder Bolt in His Hand, and a Streak of Lightning just by the Bolts." His drawing of the *Idlewild* has color notes for the valve weights, and a reminder that the shade color in each window should be different: "Every other one for variety."

It has been suggested that Bard may have worked from naval architects' drawings. The accuracy of his pictures prompted ship builders to say that they could lay down plans for a boat from one of his pictures, so correct were their proportions. In spite of his accuracy, it seems unlikely that he had access to architects' plans. In the days before photographic reproductions, such plans probably would not have been released to Bard. They were probably deemed too important to have been entrusted to a mere artist, even one of Bard's reputation. If used, they seem, judging from extant examples, to have been entirely unsuited to his purposes. They offered only bits and pieces of ships: cutaways, cross sections, and elevations. Save for the rare full-scale rendering, they did not represent the vessel in complete profile. Furthermore, the perspective in Bard's paintings seems inconsistent with the cold precision of an architectural drawing. Bard's needs were better and more efficiently served by his presence at the yards, on-the-spot measurements, and his own drawings.

JAMES BARD
THOMAS P. WAY
1859. Oil on canvas, 36 × 58½" (91.4 × 148.6 cm).
Private collection

The location of this painting is undetermined: the unique background could be either Staten Island or Keyport, New Jersey, the boat's terminals. It is nonetheless a most pleasing composition. Under the green arch is repeated a soft curve to the left, another among the trees, and still another surrounding the pavilion, all under a peach sky.

These paintings were discovered in different parts of the Hudson Valley, and there is no evidence that they once hung together. Nonetheless, they clearly tell the story of the becalmed sloop *Turkey Glen* and her successful rescue. In the two-painting sequence *P. Crary* offers a line to the ailing sloop, and then tows her to safety.

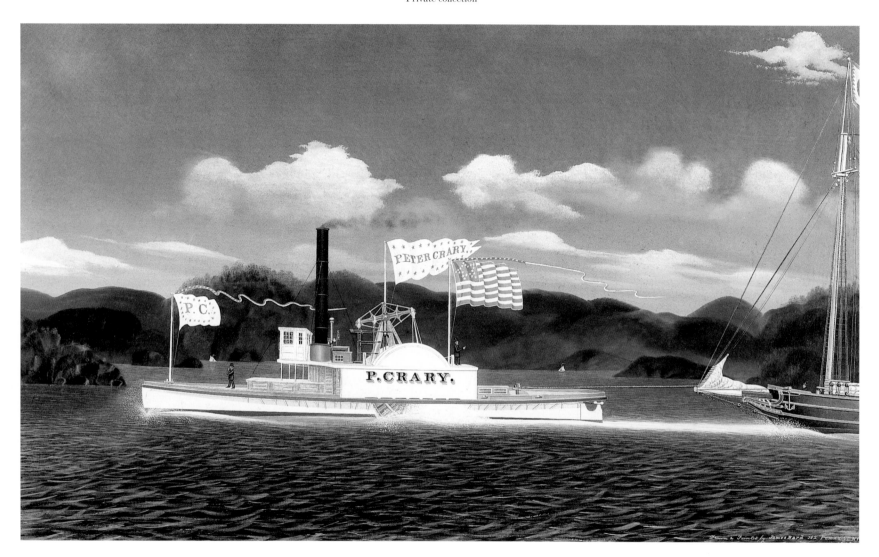

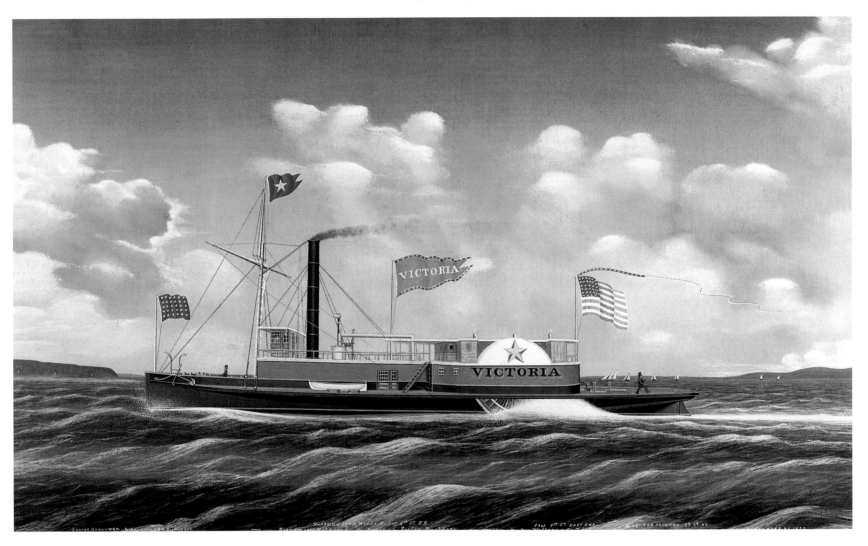

The inscription identifies the boat's builder as "George German
Mistic," evidently signifying Mystic, Connecticut. *Victoria* was built
for service at New Orleans.

The format of certain Bard drawings suggests that they were actually presentation pieces. The drawings for *Alice C. Price, Eliza Hancox,* and *Seneca* contain notes entered on ruled lines above the representation of the vessel. The *Antelope* is gaily colored. It does not seem likely that he would have gone to such pains for his own benefit.

The drawing for *James A. Stevens* appears to have been discussed with the client or to have been brought to the yard for comparison. Before the entries were made, Bard colored the flags and the names, presumably for artistic effect. Then the drawing was covered with specific notes: "No window here"..."No pole here"..."No chock here"..."Narrower beam than this." He even sketched in the location of windows not on his original sketch and crossed out two that were incorrect. With the number of corrections, it is a wonder he obtained the actual commission, but he did. In his usual practice, it is probable that after a drawing was reviewed with his client, corrections would have been banked and used for reference purposes when a painting of that particular vessel was reordered. The contemporary boat portraitist, Antonio Jacobsen, operated in the very same manner. Bard (and Jacobsen) painted as many versions as there were customers.

Before considering the actual methods which may have been used to "assemble" an oil or watercolor, it will be helpful to keep in mind the broad categories into which Bard work may be grouped. The first consists of the work that can be presumed to have been done by both James and John. This period spans the years 1827–49. The second consists of the work done through the end of the Civil War—1850–65. The last consists of the work thereafter until James's retirement in 1890.

The work of the first period is all of a technically unsophisticated character. The words "flat patterning and naive scaling" have been used to describe these paintings, and it is the work of this first period to which the description best applies. Until 1845, the works are all watercolors, employing a palette composed of little more than the primary colors. Figures are poorly drawn, with little regard for proportion. The brothers tried, unsuccessfully, to create the appearance of bubbling water by literally scratching the surface, exposing the paper fibers. Stylistic progress in the work is almost imperceptible, yet the last paintings of the period, including *Senator* of 1849, for example, while still of an amateur quality, demonstrate the Bards' ability to change and learn. Further, they had begun to inscribe their canvases with the names of those most closely associated with the boat: *Naushon* of 1845 bears the legend "Built by Joseph E. Coffee, Esq. for Holmes Smith of Edgartown, Massachusetts," and *Trojan,* of the same year, carries the note "W. & T. Collyer Builders, Decker and Co. Joiners, J. J. Austin Commodore."

Later in the period, the painters devote more attention to settings. The backgrounds of the earliest pictures are unidentifiable and undistinguished. However, in *Brooklyn,* once a Fulton Street ferry, they show the boat leaving Whitehall Slip with the flagstaff "churn" and the slip in the background. However unsophisticated, by this time the Bards were at least attempting to bring more realism to their pictures. No drawings survive from this early period, if, indeed, any were made. Since this work, unlike that of later periods, has a freehand quality, it does seem possible that it was done without preliminary studies.

With John's departure from the partnership, the second period begins, marked by the existence of the oldest drawing, *Jenny Lind,* and the consistent use of the signature form, "Drawn and painted by James Bard 686 Washington Street, New York." The years of "J. & J. Bard" had passed, and, in 1854, James moved to 162 Perry Street and changed his signature again accordingly. Many early 1850s subjects are painted in an oval composition, a format the Bards had never used before. Much but not all of the work bears inscriptions of the names of the builders, captains, joiners, painters, engine builders, and, in the case of *Brother Jonathan,* the name of the block-maker.

JAMES BARD
JAMES A. STEVENS

Undated. Watercolor on
paper, 12¾ × 27⅜"
(32.4 × 69.5 cm). Collection
The Mariners' Museum

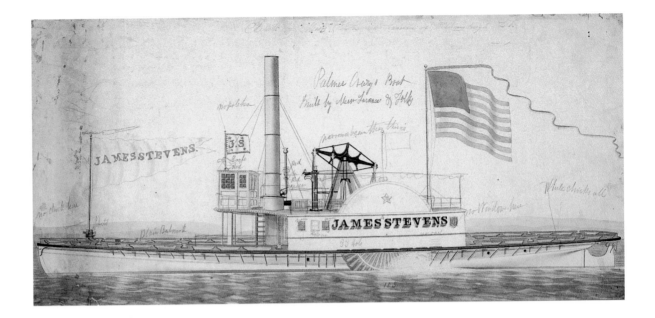

JAMES BARD
JAMES A. STEVENS

1857. Oil on canvas,
30 × 50⅛" (76.2 × 127.3 cm).
Collection The Mariners'
Museum

The man with his foot on the
rail might be Palmer Crary, for
whom the steamboat was built.
She performed as an excursion
boat. In 1860 she took four
hundred passengers to watch
the departure of the steamship
Great Eastern from New York
harbor. The boat ended its ca-
reer on the St. John's River,
Florida, as *Louise*.

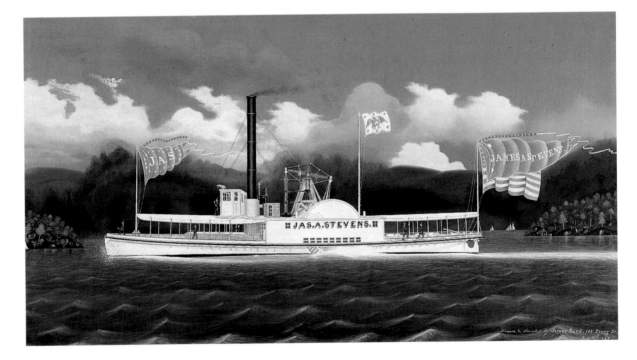

There is no entirely satisfactory explanation of the "Drawn and painted..." signature. Bard may simply have taken great pride in his drawings and may have used them as a means of selling his product. Perhaps the words should simply be taken to mean that he drew his picture first, on a smooth linen surface, then painted over the detailed rendering. Interestingly, the signature note was used by other artists. John V. Cornell was one. (He once lived at 129 Grand Street around the corner from Bard.) Cornell painted *Perry* and *Roger Williams,* and each is signed "Drawn and painted by John V. Cornell for Bootman and Smith, painters, N.Y. 1846." In the same year, the Bard painting *Thomas Powell* is inscribed, "Messers Lawrence & Sneeden, Builders, Engine T. F. Secor & Co. Steamboat painters Bootman & Smith." Another artist who signed his work with the "Drawn and painted..." flourish was Frederick Huge. His work bears some similarity to the Bards' early work even though he worked independently in Bridgeport, Connecticut.

Every Bard work is a manifestation of his meticulous nature. He not only dated most of his work by year, but occasionally recorded the specific date. *Austin,* for example, is signed "Picture drawn and painted by James Bard 162 Perry St NY 1853 August the 8th." The *Lewis R. Mackey* is dated December 23, 1858, and *Crystal Stream* is dated December 31, 1882.

In 1865, Bard began to sign his work simply "J. Bard, N.Y." In this final period, he produced his most realistic oils and returned, with better results, to the demanding gouache medium. He shunned many of the pitfalls of the early period—including fewer figures, for example. Instead he concentrated increasingly on the representation of the steamboat. He reached the highest level of his craft in *Saratoga* and *Kaaterskill,* each from the 1880s, his last working decade.

Bard work divides into three distinct periods, yet there are persistent characteristics throughout the entire progression of his art. The most obvious is his professional handling of lettering, a technique that is not naturally acquired. One must be trained.

Bard probably had this much in common with some of his contemporaries. Thomas Chambers (who may have painted canal boats and gypsy caravans), Thomas Cole, Edward Hicks, William S. Mount, Rufus Porter, and John Quidor (who painted fire engines) each began his career or supplemented his income as a humble sign painter. Bard's fellow maritime artist, Fred Pansing, painted the names on steamboats, and another contemporary, Antonio Jacobsen, painted safe doors.

Furthermore, Bard tried throughout his career to place his subjects in realistic and appropriate settings. It is possible that the attention to accuracy was predicated upon the size of the commission or the prestige of the client. More often than not, however, he created staged settings. Coastwise vessels, for example, often gray-hulled, were always shown against a clear horizon and blue sky. White-hulled coastwise vessels, on the other hand, were always shown against a green shoreline. The contrived contrasts dramatized the overall impression. If Bard painted a Long Island Sound steamer, the water was appropriately choppy, and the waves were of moderate size. When the Hudson River is at slack tide, most waves and all whitecaps disappear. Bard used this slack tide frequently toward the end of his career. It lent the portraits a sense of appropriate calm. With few exceptions—the *R. L. Stevens* is shown moving through ice—all Bard paintings seem set in summertime daylight. (Another wonderful exception, a *Rip Van Winkle* in moonlight, has been lost.)

Bard seems to have known in considerable detail the many Hudson River landscapes that enhance his compositions. For example, *Daniel Drew* is set in Newburgh Bay and is about to pass Storm King Mountain; the *Niagara* passes Fort Washington Point, beside what is now the New York footing of the George Washington Bridge; *Reindeer* is passing Sugarloaf Mountain. Even in a striking miniature, *Francis Skiddy,* Bard painted the entrance to the Hudson Highlands in meticulous detail in the halfmoon above the

JAMES BARD
JENNY LIND
1850. Pencil on paper,
19¾ × 36⅝" (50.2 × 93 cm).
Collection The Mariners'
Museum

steamboat name on the paddle wheel-box—two inches across.

Frequently, there are small "asides" in the Bards' work. A pleased patron might discover a personal reference included in the commission. In the painting *Florence*, a man and woman are shown shaking hands. On the back of the painting, in bold India-ink letters, probably not by Bard, is the sentence, "Presented to Florence S. . . by her grandpa." In the portrait *Emma Hendrix*, Emma herself seems to be aboard and represented in a handsome miniature portrait. Often one vessel is prominently placed in the foreground and another identifiable vessel can be seen in the background. The presence of both suggests some relationship. Sometimes they were rivals. Sometimes they were sister ships. In the painting *Cayuga*, the *Oswego* is in the background. (*Cayuga* was the newer, superseding vessel. Both were owned by Van Santvoord.) The painting *Commerce* depicts a figure holding a watch, standing next to the walking-beam, and apparently timing strokes. The work was once owned by the Fletcher family, whose tradition held that the figure was Andrew Fletcher, who founded the engine-building firm.

On June 1, 1847, George "Live Oak" Law, the owner of the new steamboat *Oregon*, accepted Cornelius Vanderbilt's published challenge to race his new steamboat *C. Vanderbilt* up the Hudson for ". . .any sum from $1,000 to $100,000." Law and Vanderbilt agreed to race from the Battery in Manhattan to Sing Sing and back for a $1,000 prize. Vanderbilt led for a time, then later they raced bow-to-bow. At a turn Law crept ahead, but found he was running low on coal. Undaunted, he instructed the crew to lash an anvil to the safety valve and to dismantle and burn the interiors, which had cost some $30,000. His rash decision allowed him to win. (Meddling by the Commodore in the conduct of his own boat may have helped, too.) Bard painted the race, but in such a way as to suggest that it was probably done for the highly sensitive Vanderbilt. In *C. Vanderbilt*, the losing ship is center stage. Several men glance at timepieces and several look rearward. Emerging from the right-hand corner of the canvas is the prow of a vessel, identifiable only by a portion of the flag and the letter "O." The painting was certainly not commissioned by the owner of *Oregon*.

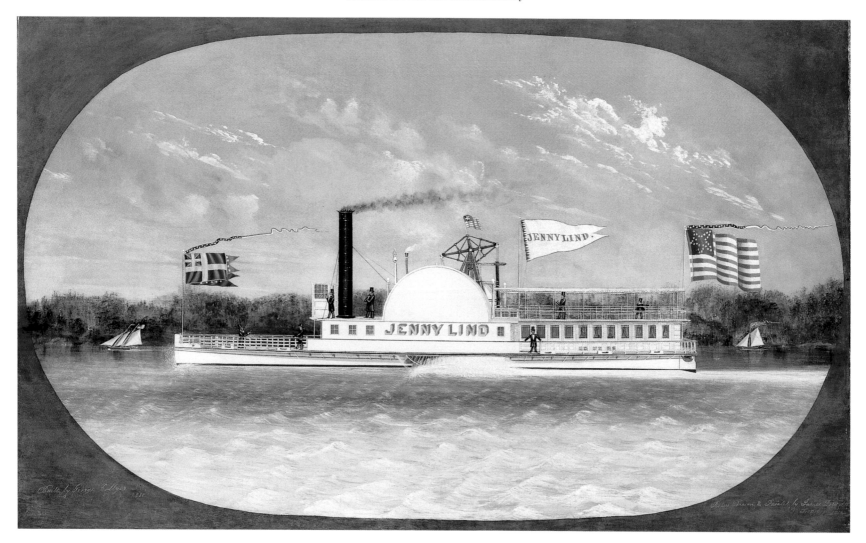

Painted after the final breakup of the brothers, this work shows James
Bard testing his palette, one that would become more and more intense.
Among the many flags is a Swedish one, honoring the namesake's
native country.

JAMES AND JOHN BARD
PERRY
Undated. Oil on canvas, 17 × 34½" (43.2 × 87.6 cm).
Private collection

Opposite: *Perry* (detail)

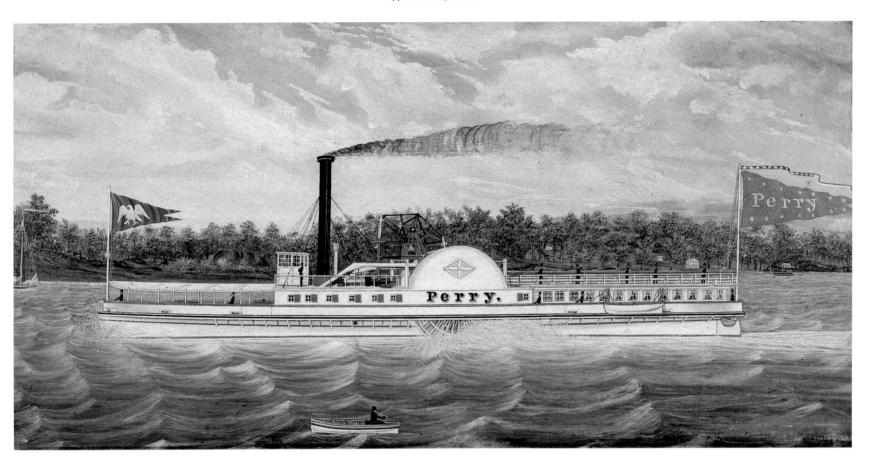

Her first captain was George Woolsey, who captained other vessels
painted by Bard. The rather formally dressed fisherman (shown in
the detail opposite) adds depth to the composition.

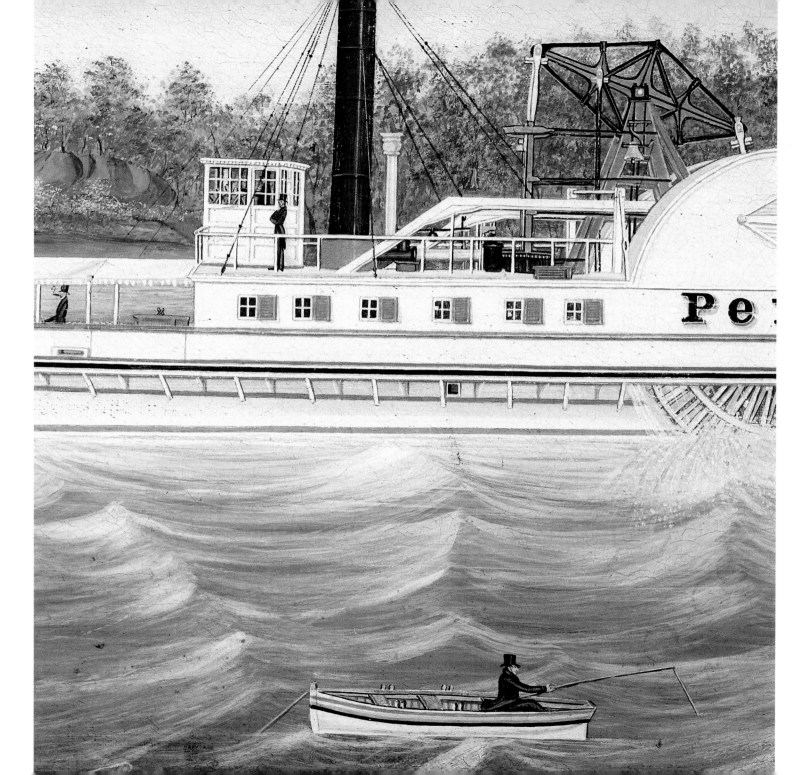

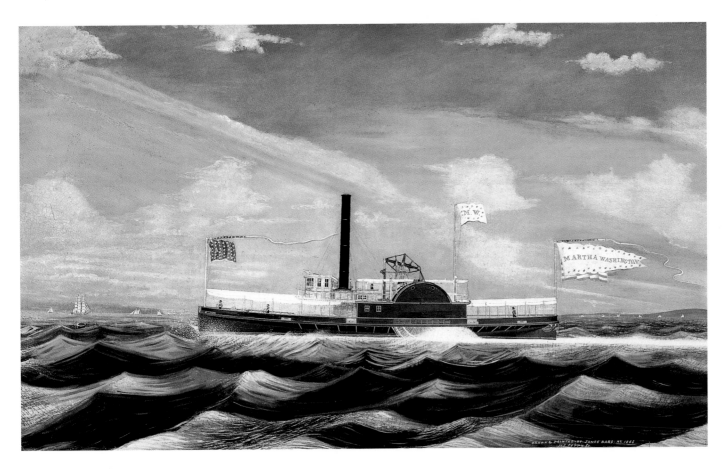

James Bard
Martha Washington
1864. Oil on canvas,
30 × 50" (76.2 × 127 cm).
Collection The Mariners' Museum

Despite her distinguished name, she was an excursion boat, running day-trippers out on fishing parties and following New York Yacht Club regattas. By 1870, her owners thought it prudent to sell. The U. S. Lighthouse Board found a use and changed her name to *Violet*.

James Bard
Martha Washington
1864. Pencil on paper,
14⅞ × 35⅝" (37.8 × 90.5 cm).
Collection The Mariners'
Museum

FRANK HERBERT

1865. Oil on canvas, 34 × 52" (86.4 × 132.1 cm).
Private collection

Bard inscribed the name of the schooner's master, Peter W. Crowell,
at the bottom edge of his picture, and flew a Masonic emblem atop the
fore mast, probably as an indication of Crowell's allegiance to the group.

There is a Bard watercolor of *City of Catskill*, which is half-finished. It gives us an opportunity to look over Bard's shoulder as he painted to see what he did and in what order. First, he completed a painstaking pencil drawing. It is highly detailed, and there are no erasures. Lines are "clicked" as in an architectural drawing and were put down firmly and confidently. The precision of the drawing suggests that it was done at a table, as are mechanical drawings. It is not sketched—one can feel the depressions made by the artist's pencil. The technical look of his drawing suggests that Bard might have had training in naval architectural drawing (although that craft was not highly developed until he was well into his career). He did not work completely freehand. His vertical lines, for example, were probably done with a T-square and a triangle. The sweep of the deck lines could only have been executed with mechanical aids. (The device used at the time was evocatively called "splines and ducks." It involves a process by which a flexible piece of wood or metal is secured to the drawing surface by heavy iron ducks with brass beaks to hold and control the curve desired. The artist then traces the described arc.) It is evident that in representing the deck fencing, Bard probably used his drafting tools to precisely draw the crossed slats or wires as narrow as three-sixteenths of an inch. As well, in each window there are eleven right-to-left diagonal lines and eleven left-to-right diagonals, all equally spaced. The eagle atop the wheelhouse also appears to have been drawn with an aid: its one continuous sure-handed line was perhaps achieved with a template.

Next, he began to paint the smokestack and the lettering of the guards black. He may have used a straightedge to draw the connecting rods and guy wires, but the flag lines are slack, gracefully at rest, and probably done freehand. His notes on other drawings suggest that he used India ink. He then made a wash of the black ink to convey the smoke coming from the stack. Next, he blocked in the water and window shadows in gray, and with the same color, he gave dimension and shape to the stack. With white, he blocked in the wheelhouse, the sails of the boats in the background, the cargo doors and surf (including the bubbling spray at the bow). He probably worked from top to bottom. He applied gold leaf to the decorative balls atop the flag poles, to the eagle, and to certain supporting members or "knees." Finally he would have added the color of the flags, sky, background, and water. The only portion of the painting that was finished when Bard left it was the smokestack, but, curiously, the work had already been signed, "J. Bard, N.Y. 1880."

There are also a number of Bard's oil-painting techniques which can be identified. First, along with many of his academic colleagues (with whom he had this one habit in common) he purchased his canvas from Edward Dechaux at 306 Broadway, or from S. N. Dodge's Artists & Painters Supply Store, 189 Chatham Street. Their stencils are often seen on the reverse of Bard's paintings[1] Bard commonly used a more or less standard 30 × 52-inch canvas size although occasionally he worked up to 32 × 54 inches and beyond. The canvas was pre-primed, and the smooth finish afforded Bard a comfortable work surface. There is no hint of canvas texture in his oils: it has been primed away. It is likely that he began with a pencil drawing, as he did with the watercolor, and he could do this only on a very smooth surface.

There are no unfinished oils to give us clues as to the order in which he laid down color, but it seems clear that sky, background, and water were painted first, and that the ship must have been painted last. The vessel itself was painted in undiluted, thick paint so that there was an actual, albeit subtle, difference between the plane of the background and the plane of the boat. A most distinctive technique is found in Bard's continuing effort to add realism. He did this by adding elements that stood up from the picture dimensionally, creating, in effect, bas-relief. Flagpoles, spar balls, eagles, pilothouse figures, fenders, blocks, posts, and rails were often collaged

Records suggest that *Ranger* was intended for government service
in San Francisco, but little is known of the boat's history.

in this way. Apparently Bard cut out these elements in cardboard and glued them to the canvas surface. He then gessoed them (gesso is a plasterlike substance) and painted them over. As a consequence you can feel a Bard as well as see one. The technique fools the viewer by creating an actual spatial relationship between the background and the steamboat. Bard's final touch would have been the gilding of the spar balls and pilothouse eagle. As for framing the works, we know that at least in later years he used a professional firm, Erback & Diffenbaugh, 166 William Street.[2]

Considering the technical demands Bard placed upon himself for the achievement of accuracy—requiring a drawing on canvas or paper before he began to paint—it seems obvious that all his work was produced in the studio. There is no practical way to paint a moving steamboat. And considering the amount of paint he used and the special appliqué elements he added, it seems obvious that his work was done flat and not at an easel.

In many of the early compositions, Bard inserted a solemn and forlorn figure just behind the wheelhouse, a figure clearly meant to represent the captain. Artistically this seems to detract from the bright, positive character of the composition. Nevertheless, the Lincolnesque figure is appropriate. It was customary at the time for steamboat captains to wear a black silk top hat and frock coat. It was not until 1874 that the first uniforms were worn by steamboat officers.[3]

In addition to captains, Bard populated many of his early works with passengers. The watercolor of *Swallow*, a ship which later burned and sank, shows fifty people on board. Perhaps they were included because the client wished to demonstrate his vessel's popularity. *Alida* holds the record number of passengers, sixty-three, of whom thirteen are women. Note that not one woman is wearing the same color or print and not one is facing the viewer. In most of the pre–Civil War paintings the passengers are at ease: walking the decks, chatting in pairs, sitting and watching the passing scene. Befitting the celebratory nature of the paintings, passengers are often shown shaking hands.

Bard's technique was simple, straightforward, and unencumbered. His design was to produce an immediate and positive viewer response. However, in evaluating the many and various techniques he employed, we might have to acknowledge that that response actually required a complicated, subtle, and nuanced artistic endeavor.

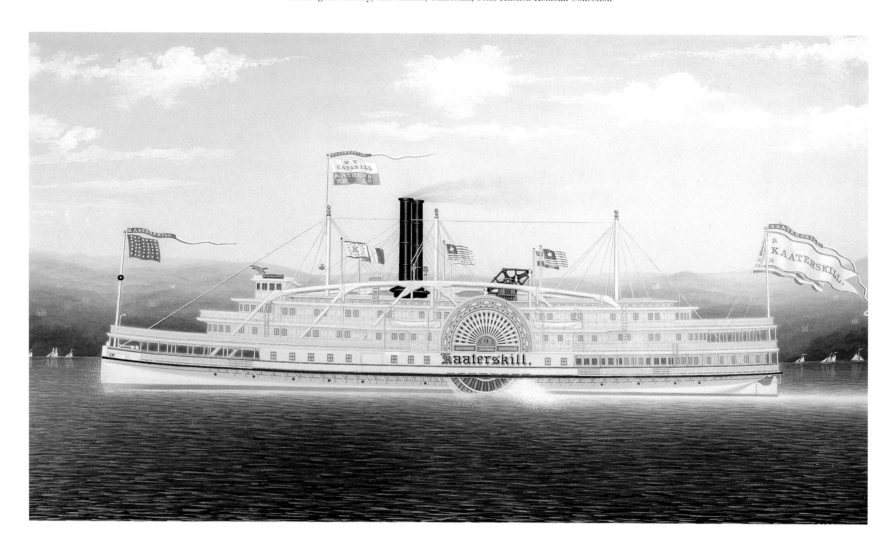

She was built at Athens, New York, and served the New York, Catskill
and Athens Steamboat Company. Her business was bringing vaca-
tioners to the Catskills. She ended her career ignominiously, being
burned in 1914 for a motion picture scene.

James Bard
WIEHAWKEN
Undated. Oil on cardboard, 14½ × 33½" (36.8 × 85.1 cm).
Museum of the City of New York

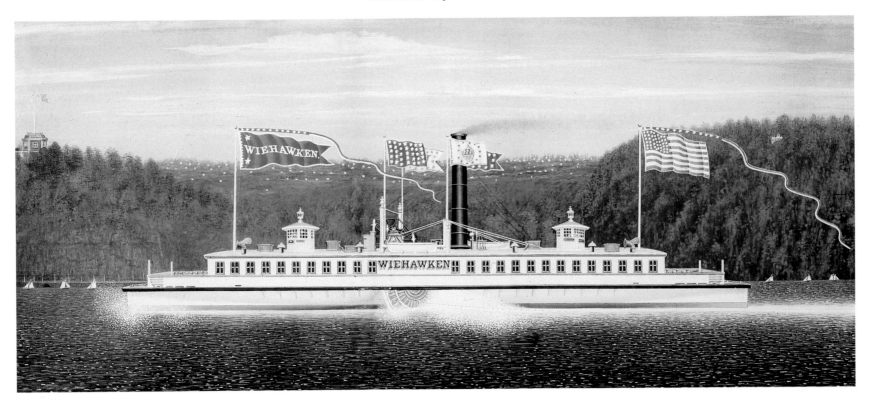

The double-ended ferry, with the paddle wheel serving as a visual
fulcrum, was a perfect subject for Bard's technique of assigning
equal weight of form and color to both sides of a painting.

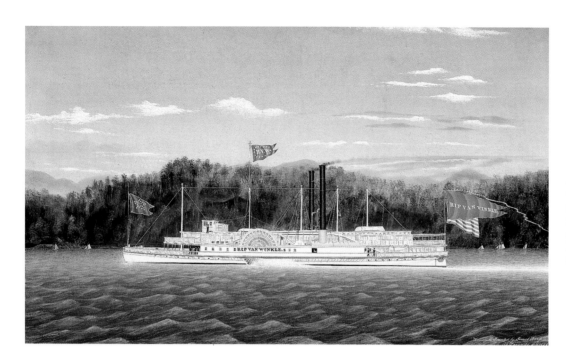

RIP VAN WINKLE

1854. Oil on canvas,
31¼ × 53" (79.4 × 134.6 cm).
Courtesy of Museum of
Fine Arts, Boston,
Gift of Mrs. Maxim Karolik
for the M. and M. Karolik
Collection of American
Paintings, 1815–1865

Rip Van Winkle lacked speed. Built to compete with the other day liners, she was quickly hauled off for the installation of staterooms so she could operate as an overnight boat. In 1872 she ran into the railroad bridge at Albany and was dismantled.

JAMES BARD

LONG ISLAND

1860. Oil on canvas, 32 × 54"
(81.3 × 137.2 cm).
Collection William G. Osofsky,
Albuquerque, New Mexico

Every afternoon except Sunday, *Long Island* left from the Fulton market in Manhattan for Northport, with stops along the north shore at Baylis's, Great Neck, Sand's Point, Glen Cove, Lloyd's Dock, and Oyster Bay. Advertisements described her as "commodious." She was lost in 1863 while in Civil War service.

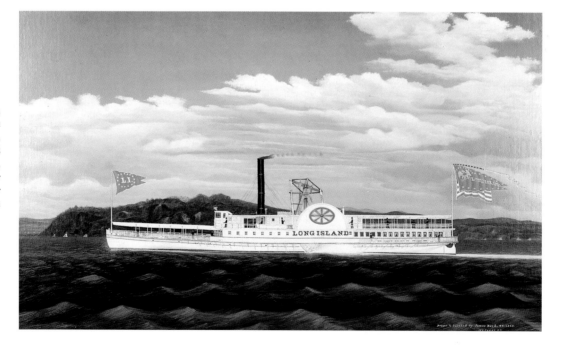

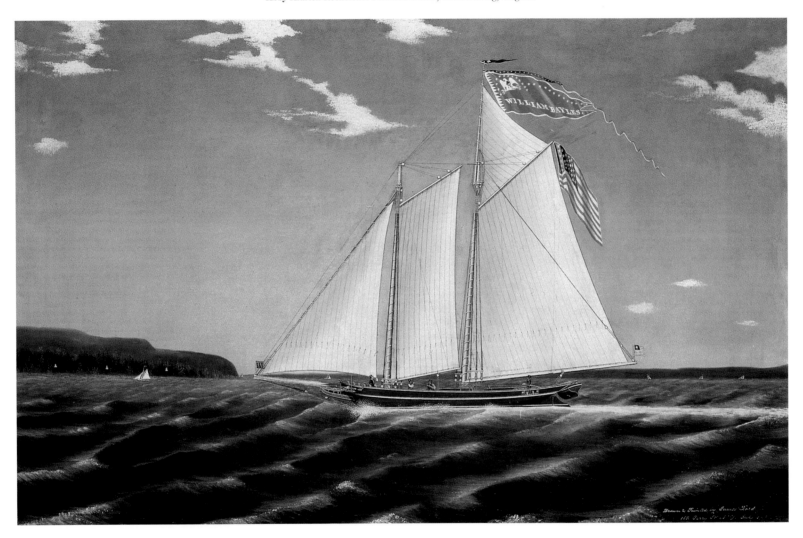

This is one of three extant examples of paintings of this schooner.

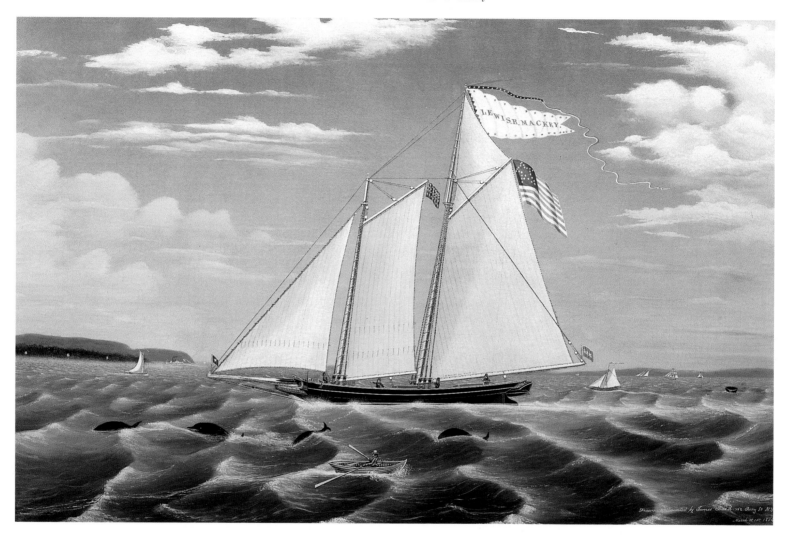

The presence of dolphins in the painting may seem unusual, but a 1920s book by Henry C. Brown reveals that, "In those far off days, residents of Yonkers were occasionally entertained by the sight of a school of porpoises sporting in the river. This was a rare occurrence and was purely accidental. It was undoubtedly the result of an un-usually heavy tide and the pursuit of a school of menhaden from the bay up the river. These visits were necessarily brief as the fish quickly discovered that they were in strange and dangerous waters. They apparently turned at Tappan Bay and were soon again out on the broad Atlantic."

ISAAC SMITH

1861. Oil on canvas, 30 × 52" (76.2 × 132.1 cm).
Private collection

Opposite: *Isaac Smith* (detail)

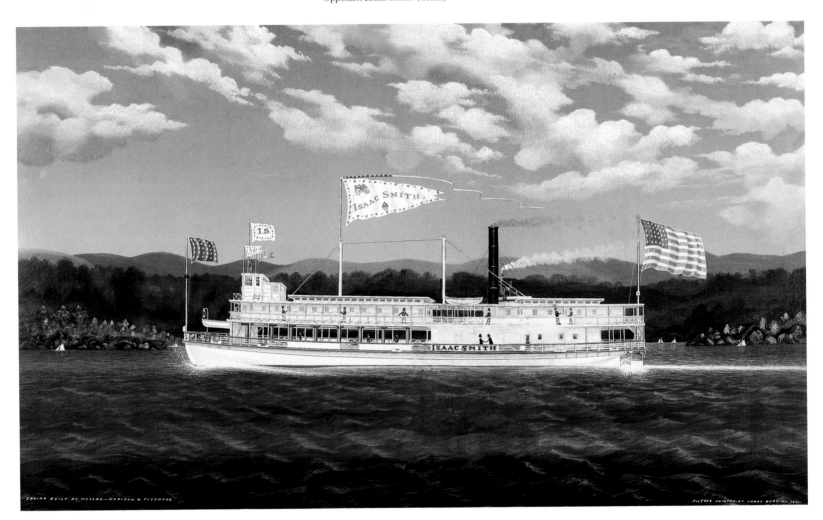

Built to run to Poughkeepsie, *Isaac Smith* was purchased by the
navy before entering peacetime service. She served briefly as a gun-
boat, but was captured by the Confederates at Stono River, South
Carolina, and became CSS *Stono*.

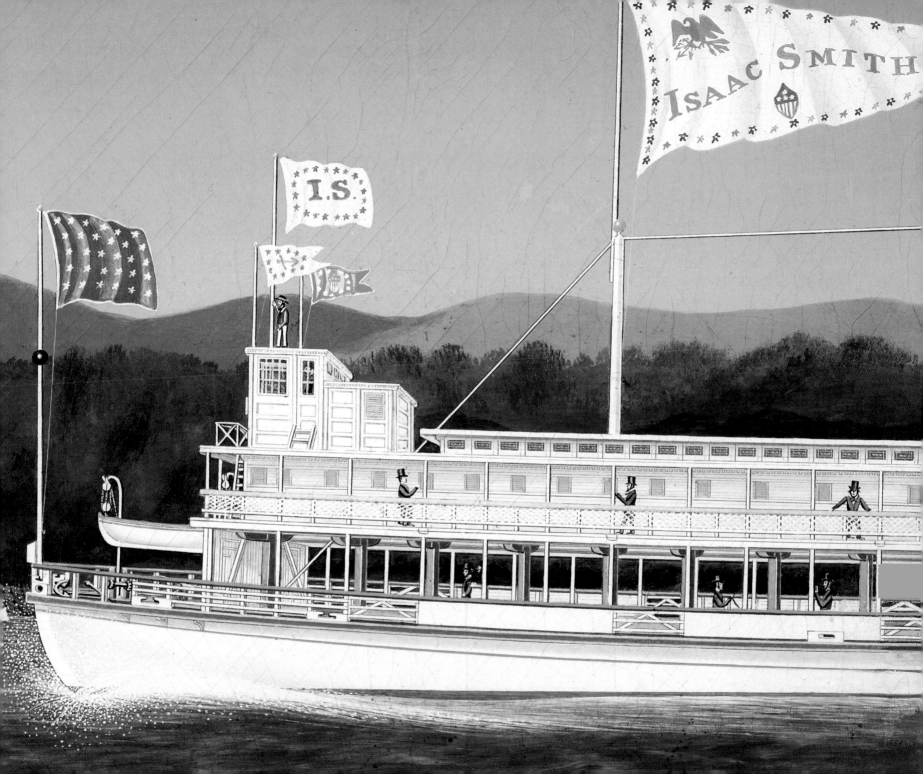

JAMES BARD
ELIZA HANCOX

1863. Pencil on paper,
15 × 39½" (38.1 × 100.3 cm).
Collection The Mariners' Museum

This fine drawing looks like a presentation piece rather than a preliminary to a painting. *Eliza Hancox* served in New York harbor, Boston, Wilmington, Savannah, and on the St. John's River, Florida.

JAMES BARD
ANNIE J. LYMAN

1863. Oil on canvas,
30 × 50" (76.2 × 127 cm).
Private collection

It was customary for inland steamboats to be painted white, with oceangoing boats in black. Bard gave it all an ocean feel by adding the man with the spyglass, a steamer to the right, and a ship to the left. In the detail, note the passengers with cigars.

Opposite: *Annie J. Lyman* (detail)

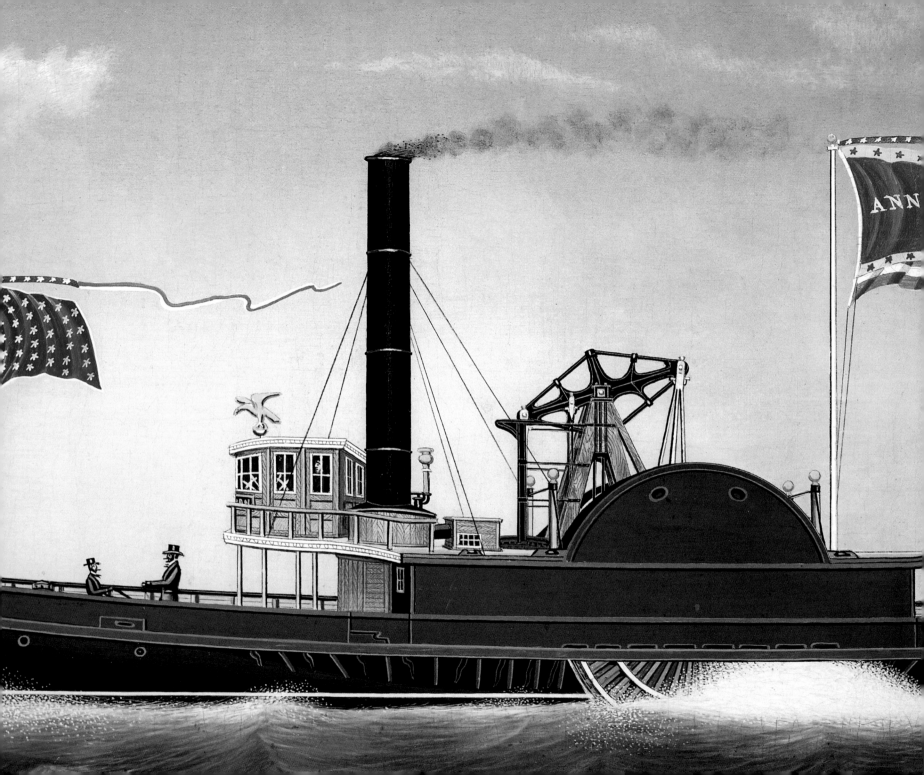

AMANDA WINANTS
Undated. Oil on canvas, 29¾ × 50" (75.6 × 127 cm).
Collection The Mariners' Museum

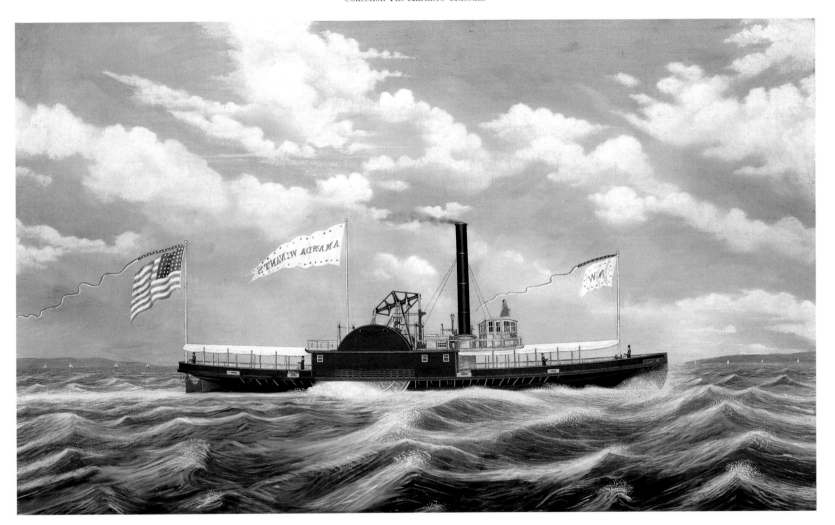

Amanda Winants foundered off Georgetown, South Carolina, with
the loss of sixteen lives in September 1874. This orientation of the
boat, with the flags reading in reverse, contradicts James Bard's
usual preference for portside views.

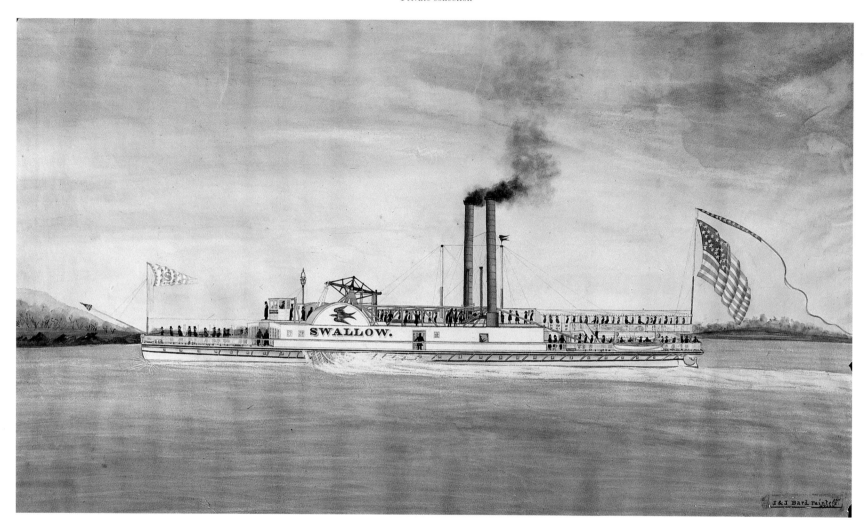

In April 1845, while running downriver in a snowstorm, *Swallow* caught fire and sank near Athens, New York. More than thirty lives were lost. The number of passengers shown in this painting was probably an accurate portrayal of her popularity.

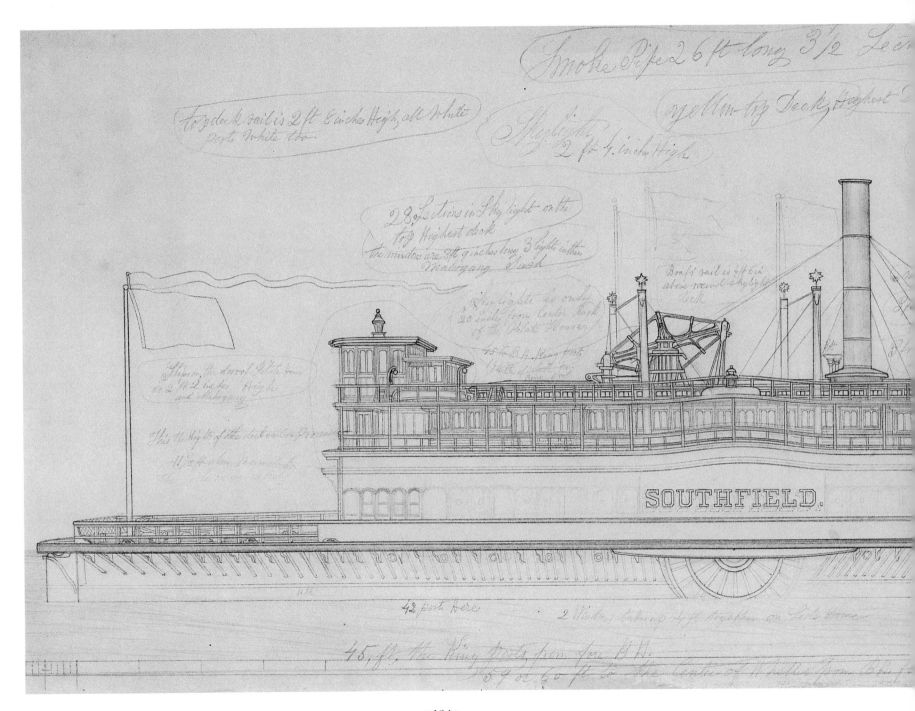

JAMES BARD
SOUTHFIELD
1882. Pencil on paper, 14⅛ × 36¾"
(35.9 × 93.35 cm). Collection The
Mariners' Museum

The first double-deck Staten Island
ferry, *Southfield* served until 1905, be-
came a hospital in 1907, was declared
unfit for service in 1912, and sank in
1923. Only the drawing survives.

Built for the Hudson River service, *Grey Hound* was drafted for
Civil War duty, became General Ben Butler's dispatch boat, and was
burned in 1864. Note that Bard lavished special attention on the
paddlebox, itself a fine work in miniature.

As with other Bard works, the drawing survives, but the painting is
lost, known only in this case as some others by a photograph (see
page 106). *Nuhpa* survived until 1897.

BRILLIANT

1868. Pencil on paper, 14 × 35⅜" (35.6 × 89.8 cm).
Collection The Mariners' Museum

Tug boats of the type drawn here came late in Bard's career; few paintings survive. Bard drew the detail down to the grain in the wood. Note his scale at the lower left.

PAINTING AMERICA UNDER STEAM AND SAIL

JAMES BARD
ARROWSMITH
1869. Oil on canvas,
30 × 50" (76.2 × 127 cm).
Private collection

She had a busy and successful career, serving first on the Keyport, New Jersey to New York route. During the Civil War she ferried wounded from the James River. Her later years were spent in service on the Potomac River. The painting marks a transition in Bard's style. He seems to be moving from an exuberant middle-period style to the more architectural and muted works of his later years.

Bard has always been appreciated by the historians and enthusiasts of steamboat and Hudson River lore. His work provided accurate portrayals of vessels for which other visual evidence was lacking. Then in 1924—for the first time since 1842—Bard was viewed as an artist. Two Bard works, *Alida* and *Francis Skiddy,* were included in the Whitney Studio Club show of early American art.[1] Since then, the work has suffered through the uncertainty of those who attempted to classify it.

The most comfortable niche has been folk art. Unfortunately, no one has come forward to identify this aesthetic. American folk art has been written about and collected, but it has never been defined. In the case of the Bards the label "folk artist" gives them a measure of attention and collectibility, but little basis on which to appreciate their art.[2] The time in which the Bards worked was one when the vernacular was accepted and applauded—at least,

by some. It was a time when America was developing its own voice. Sadly, when noticed, it was a voice that found little critical favor in establishment or academic circles.

As our cultural institutions developed, including an American critical voice, perceptions became "sacralized" and we turned from and rejected our native art, looking to Europe for inspiration and validation.[3] After World War I the cultural restraints of a sacralized art gradually lifted and Americans turned once again to the secular, to the vernacular, to a more comfortable appreciation and acceptance of the achievements of all the Americans of our nation's youth. Whatever the turmoil, and the often bewildering debate over taste and artistic values in academic circles and among connoisseurs, it seems to have had little effect on the work of James Bard. He was benignly neglected and failed all contemporary notice.

Shortly after she was built *Shady Side* joined *Morrisania* and *Harlem* of the Morrisania Steamboat Company taking passengers to upper Manhattan, in what is now the Bronx, by way of the East River. For a time she ran to Stamford, Connecticut, and later to Fort Lee, New Jersey, with stops at Shady-side, Gutenburg, and Tilly Toodlum. She ended her career on the Black Star Line, an enterprise owned by Marcus Garvey. She was abandoned in 1922.

Henry James visited an exhibition of the work of Winslow Homer at the National Academy of Design and offered the essay "On Some Pictures Lately Exhibited," to *The Galaxy* (July 1875). In it he said:

He not only has no imagination, but he contrives to elevate this rather blighting negative into a blooming and honorable positive. He is almost barbarously simple, and to our eye, he is horribly ugly. . .We frankly confess that we detest his subjects. . .but the picture was its author's best contribution, and a very honest, vivid, and manly piece of work. Our only complaint with it is that it is damnably ugly.

Would James have not seen an exhibited Bard as "a very honest, vivid, and manly piece of work"?

It was not until 1895 that there was a published acknowledgment of Bard's work. It appeared in Samuel Ward Stanton's *American Steam Vessels*. And, save for his 1897 obituary, no more would be written until the publication, fifty-two years later, of an article by Alexander Crosby Brown and Harold Sniffen of The Mariners' Museum, "James and John Bard, Painters of Steamboat Portraits" (*Art in America*, April 1949). Stanton, Brown, and Sniffen focused, legitimately, on the Bards as chroniclers of American steamboat history, and on the wonder of their prodigious output and exceptional accuracy. Sniffen and Brown lauded the fact that the Bards "left an enviable record as American primitive artists and since their pictures so faithfully described better than words the steamboat of their day, they deserve perhaps even greater credit as marine historians."

In recent times, what little art criticism of Bard exists has relied heavily upon personal and emotional reaction. Mary Black and Jean Lipman in their *American Folk Painting* enjoyed the "gaiety. . .of the early pieces." In Virgil Barker's article "From Native Painting—A Re-Evaluation" (*Art in America*, Winter 1952), he stated that:

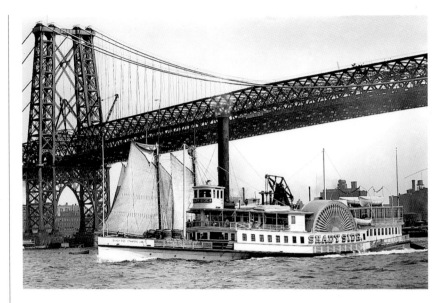

Shady Side passes a schooner on the East River. Collection The Mariners' Museum

Bard translated everything into a completely different kind of vision. All the lines became semi-mechanistic in their exactness; the silent shadings in the white mass of the boat are equally arbitrary in their disregard of atmosphere; and the little silhouetted human figures inserted here and there only increase the feeling that a sign painter's intention to be irrefutably accurate in reporting visual facts, can only be a hairbreadth away from intentional abstraction.

John K. Howat, author of *The Hudson River and Its Painters*, credited Bard with membership in the very broad-based Hudson River School as "Marine historian-cum painter." E. P. Richardson in his *Painting in America, 1502 to the Present*, described Bard paintings as

executed in a flat, gaily decorative artisan style with all that technique's merits of crisp, exact outline and cheerful color. They form the most attractive tribute made by painting to the Hudson River steamboat,

Built to run from Franklin Street, North River, to Red Bank, New
Jersey, *Albertina* did it in just two hours and for only fifty cents. The
drawing demonstrates the pains Bard took to be accurate.

a beautiful creation of American technology that after flourishing for little more than a century, vanished in our own time.

Francis Waring Robinson described the Bard style, particularly that manifest in the *Sylvan* paintings, as "crisp, brilliant and clean." He thought that the paintings "showed off the vessel as an automobile advertisement shows off the car."[4]

One hint at a turn in the cultural tide appeared in 1931, in Lewis Mumford's *The Brown Decades, A Study of Arts in America:*

If we at last realize that the Brown Decades, with all their sordidness, their weaknesses, their monstrosities, are not without their contribution to our "usable past." Through all the dun colors of that period the work of its creative minds gleams—vivid, complex, harmonious, contradicting or enriching the sober prevalent browns. The treasure has long been buried. It is time to open it up.[5]

Mumford may never have seen a Bard but did nonetheless sense that there had been something out there that was "vivid, complex, harmonious, contradicting or enriching the sober prevalent browns." It is possible that Bard's creative mind might have gleamed.

The sociologist Paul DiMaggio offers us a synthesis:

We must stop viewing, once and for all, "high culture" as a distinctive kind of cultural product, and recognize that high and popular culture are, at one level, historically evolved systems of classification whose strength, substance, and significance vary constantly; and, at another, separate systems of production and distribution with systematically different consequences for the art that passes from them. . . .Recognizing that ideas about high and popular culture are ideological classifications embodied in organizational forms that give them flesh permits us to study the causes of variation in the classifications themselves and, perhaps, to begin to understand tastes, not simply as an aspect of demand, but something which, over a longer term and less through conscious design, is as much a special production as is a work of art itself.[6]

So whereas the urge to label is insatiable, to do so is to assign Bard to a historically evolving, constantly varying system of classification. Certainly no label is adequate and any label of itself only diminishes the Bards and discourages a true and complete regard for their art. The spirit described by James Jackson Jarves might have come closest to a real appreciation of the Bards' work. It was freely developed. It was virtually invented by them. It looked to the past, to the history of ship portraiture, but certainly was not "overborne" by it. Government, religion, and social caste played no role whatsoever in their art. And it was "fresh and vigorous," indeed: "enterprising, energistic and ambitious, hesitating at no difficulties," and, of course, "giving birth to new ideas, which are ever passing on new forms."

Emerson wrote in his essay "Civilization" that "The ship, in its latest complete equipment, is an abridgment and compend of a nation's arts." We should see a Bard painting in that cultural context. In 1950, *Art News* suggested

No symbol more nearly characterizes the spirit of the nineteenth-century America than the steamboat. Here, in a single unit, were epitomized the desire for adventure and exploration, the means of travel and transportation, the expression of mechanical ingenuity and skill of manipulation, the realization of power and speed and the attainment of luxury (for the passengers) and wealth (for the owners). The broad, handsome boats plowing the rivers held a tremendous fascination; their massive paddlewheels churning the muddy waters and their great black plumes floating overhead—a momentary ostentation caused by throwing a little pitch on the fires—filled the spectator with awe and wonderment. There was something dramatic and exciting about these gigantic forms that seemed to hover over the water like the magic carpet.[7]

The steamboat was a technological achievement. It was one of the wonders of the age. It was an invention only as old as the Bards themselves. Their paintings treated the steamboat with the awe in which it was then held.

This Bard portrait was not painted at the time of the boat's launching, in 1841, but in 1873. The steamer's hog frame, bridgelike structure, and other wire supports made her unattractive, yet Bard managed to transform the boat into a pleasingly mechanical marvel. She lasted only until 1875 when the Troy, Albany, and New York Towing Company lost their investment to fire at the Watervliet Arsenal wharf.

THOMAS McMANUS
1872–73. Oil on canvas, 30 × 52" (76.2 × 132.1 cm).
Private collection

Opposite: *Thomas McManus* (detail)

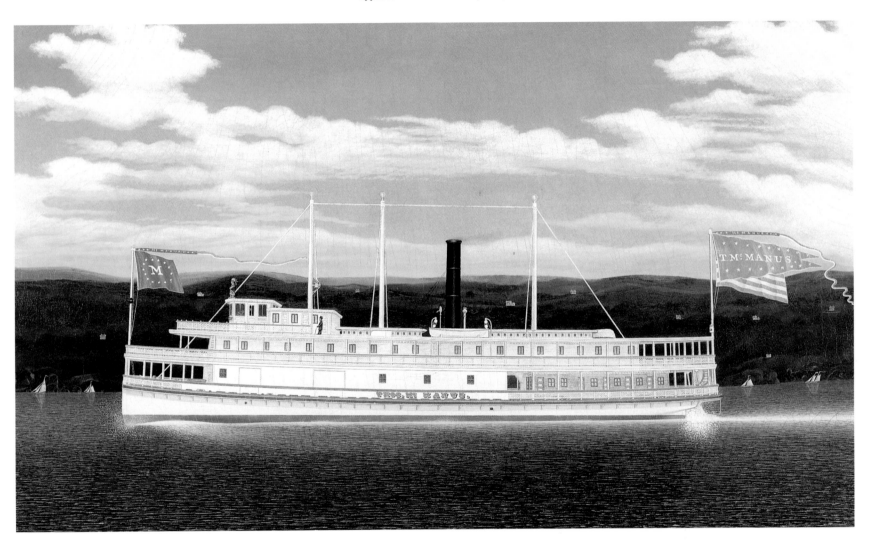

The painting is dated 1872–73, when a new propeller engine had been installed by Fletcher. *Thomas McManus* ran from Manhattan to Coxsackie, New York, and from time to time to Germantown, Hudson, Malden, and Smith's Dock, but ended its days as an abandoned hulk in the Hoboken flats. The detail shows the Indian pilot house figure and a somber passenger.

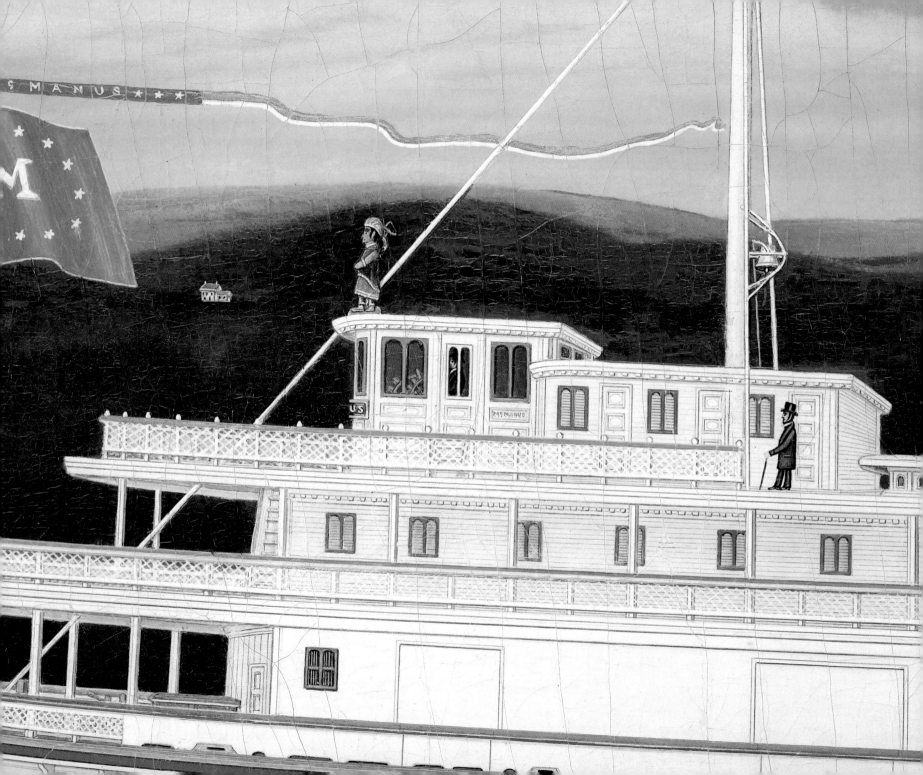

CITY OF CATSKILL

1880. Watercolor on paper, 21¾ × 46" (55.2 × 116.8 cm).
Collection The Mariners' Museum

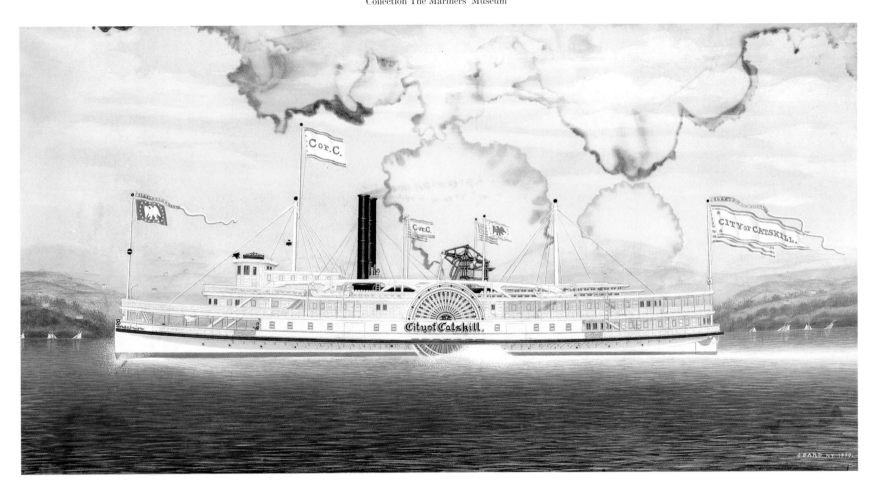

The *City of Catskill* did not lead a happy life. One night in 1882 she ran over a skiff in Rondout Creek: two of the sailors drowned. One Sunday morning in 1883, she caught fire and burned to the waterline. In May 1883 the *Nautical Gazette* reported that she had been added to the "boneyard" at Port Ewen, New York.

JAMES BARD
S. A. STEVENS
1873. Watercolor on paperboard, 25 × 39½" (63.5 × 100.3 cm).
National Museum of American Art, Smithsonian Institution, Washington, D.C.
Gift of Lynne B. Litterine and Marc Kaufman in memory of Louis B. Litterine

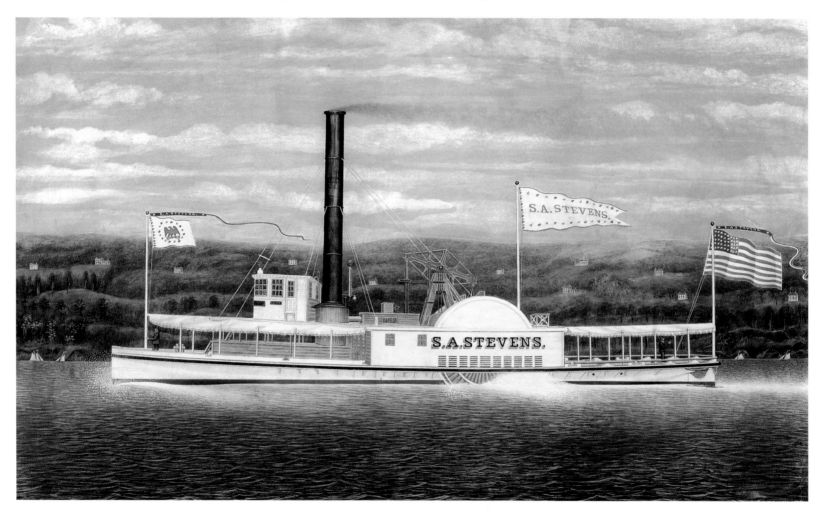

This painting shows a trim late period Bard. *S. A. Stevens* was launched
in Boston, but was working in New York harbor in the 1860s, when
she came to Bard's notice. The "S" in *S. A. Stevens* stands for "Sarah."
Notice Bard's deft handling of the woodwork under the smokestack.

JAMES BARD
J. PUTNAM BRADLEE
1876. Watercolor on paper,
14 × 32¾" (35.6 × 83.2 cm).
Museum of the City of
New York, Gift of Mr.
Andrew Fletcher

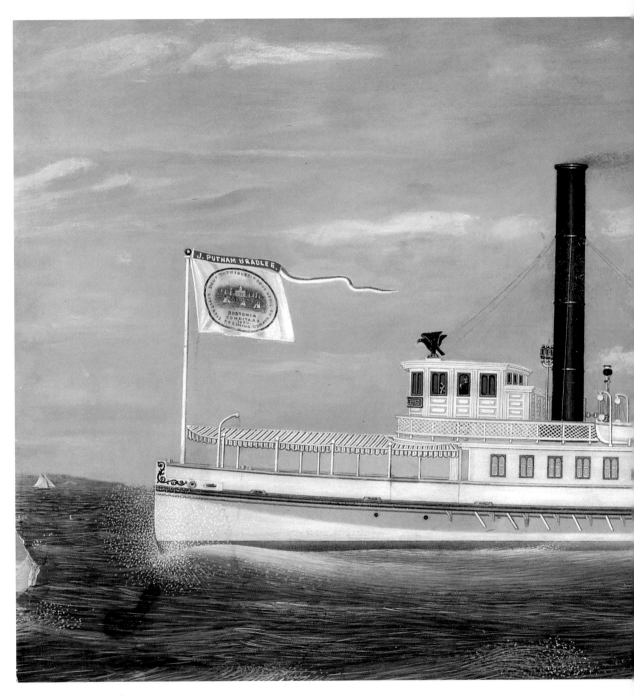

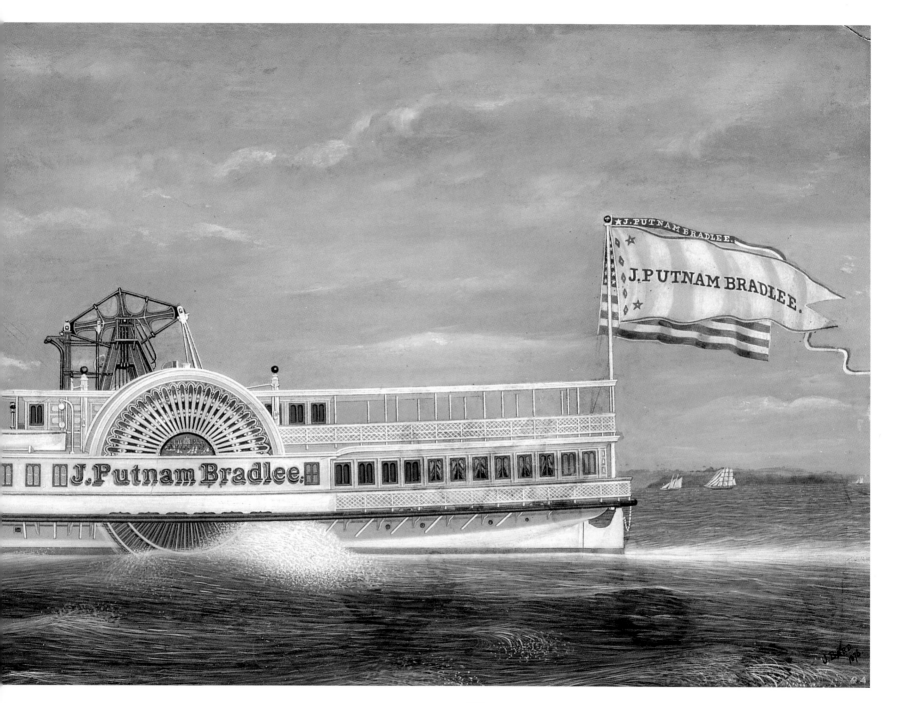

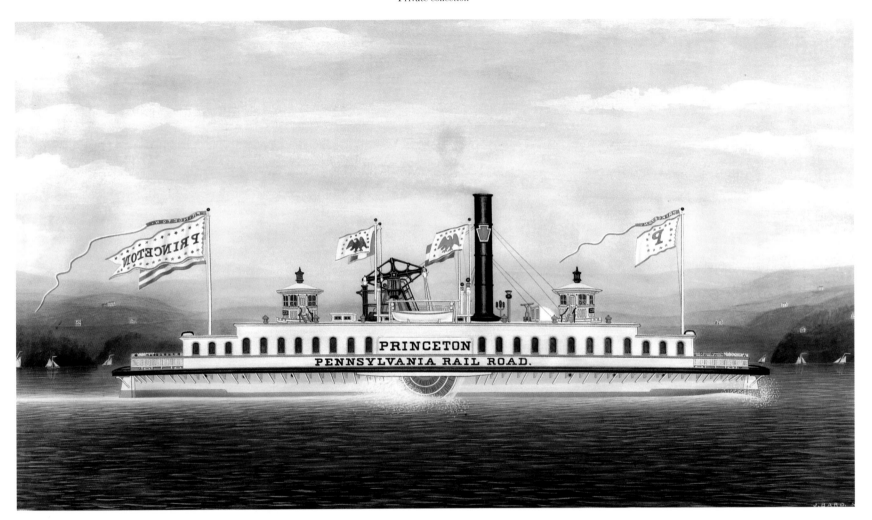

This pleasing portrait of a double-ended ferry with twin pilot houses
is a study in proportion. *Princeton* was repainted in 1882, and the
traditional white of a river boat became covered by Pennsylvania
Railroad red. She served uneventfully until 1906.

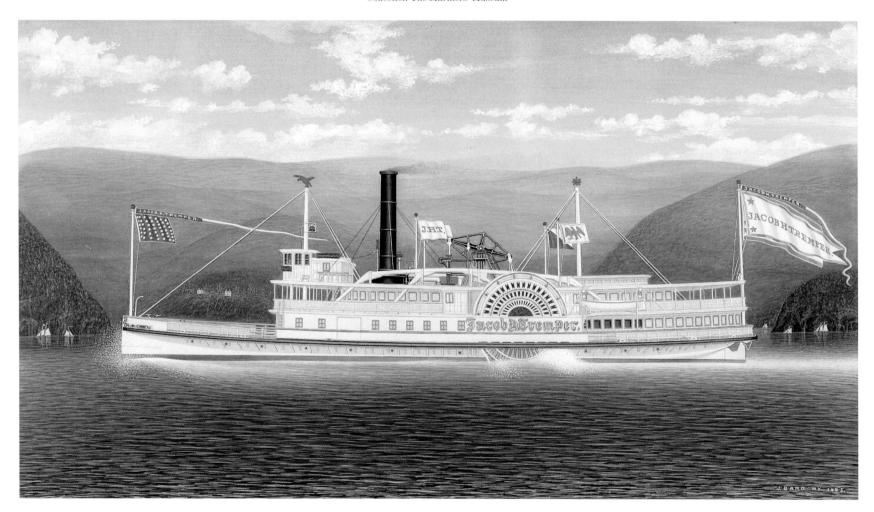

When *Jacob H. Tremper* was launched, the *Nautical Gazette* described
her, whimsically, "as attracting more than the usual amount of at-
tention among the up river steamboat men. She is looked upon as a
'daisy,' and is proving herself an acceptable and very fast boat."

This is Bard's last oil painting. *Southampton* worked for the East River Ferry Company.

The one time this freight steamer assumed a different role, taking passengers to watch the America's Cup challenge in 1887, she ran down the tug *J. C. Harrt* just outside Sandy Hook. Bard also painted *City of Fall River* for the Old Colony Steamship Company, which had commissioned this painting.

Compare the 1841 painting (of an earlier version of the steamboat *New York*) with the one dated 1888 on page 161. Note the continuing development of Bard's style and contrasting differences in technique. Also notice the similarity of the blueprint on the following page and Bard's later painting. This is strong evidence that Bard may have worked from blueprints in the very last days of his career. The last Bard drawings date from 1882.

New York

1887. Blueprint, 15½ × 43½" (39.4 × 110.5 cm).
Private collection

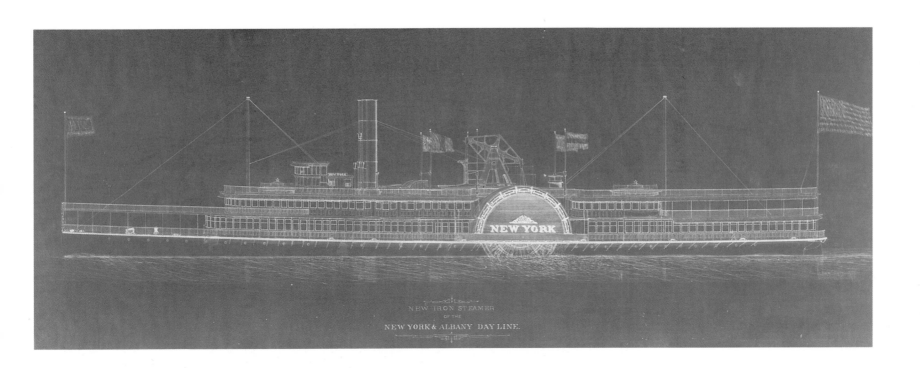

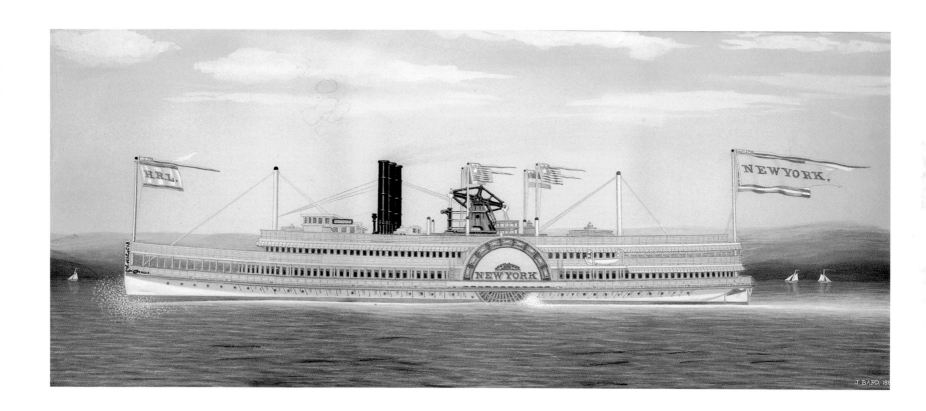

NOTES

CHAPTER ONE
A Career Born Young

1. Basic information about the lives of the Bard brothers may be found in James Bard's obituary, *Seaboard* (Apr. 1, 1897), which was probably written by Samuel Ward Stanton.

2. See Carl Carmer, "Upriver in a Teakettle," in *Illustrated Rivers of America, The Hudson* (New York, 1939).

3. "Last Will and Testament of Joseph Bard," *Surrogate's Court, County of New York, NY*, Liber 76 (Aug. 28, 1837): 519–21.

4. In the United States Census of 1830 (14th Ward, p. 462), Joseph Bard is listed as the head of the household, aged between fifty and sixty years. There is one male child between five and ten years of age, and two between ten and fifteen, James and John. Of the females, one, Ellen (or Nellie), is listed as between age fifty and sixty; one between fifteen and twenty; and one between twenty and thirty. In the affidavit of serve in connection with the will, the Surrogate lists Ellen, Mary, George, James, John, and Joseph—Joseph being the minor. Thus James and John had two brothers: George between fifteen and twenty and Joseph, born since the last census, under ten. They may also have had two older sisters, but they were not served. Also they had a younger sister named Margaret, mentioned in the will, presumably born after 1830.

5. See David Ellis, *Landlords and Farmers of the Hudson-Mohawk Region 1790–1850* (New York, 1946).

6. Death Records, New York City Archives.

7. American Institute of the City of New York, *Official Catalogue of the 15th Annual Fair,* (1842), entry no. 147.

8. See Ralph Nading Hill, *Sidewheeler Saga* (New York, 1952), 120.

9. Alms-House Records, Blackwell's Island, *Admissions Records Book* (volume 05), New York City Archives. The entry refers to "John Boyd" but it is certainly John Bard.

10. Ibid.

11. George McCabe, Jr., *Lights and Shadows of New York Life; or Sights and Sensations of a Great City* (Philadelphia, 1872), 638.

12. Alms-House Records, Blackwell's Island, Death Records, p. 0256, no. 210, New York City Archives. Here again he is listed as "John Boyd" but is further identified as a forty-year-old white painter, born in New York City. The cause of death is recorded as "Direct, erysipelas, ulcer cruris debilitas." The latter refers to the bed sores about his hips, suggesting a long and painful confinement.

 Green-Wood Cemetery, Burial Transcript: Lot 8998, grave 427, section A, records a "John Baird," and gives the date of death as October 17, 1856. He is listed as married but his wife's name is not given. His last address is 162 Ferry [*sic*] Street, undoubtedly his brother's Perry Street address.

 Death Records, New York City Archives, lists John Bard age forty-one years and fourteen days as having died October 18, 1856, at the "Alms-House-Bk. Isl." and states that he was buried at "G. Wood Cemetery."

13. United States Census records: 1850, 2nd District, 9th Ward, Dwelling 359, 1860, 2nd District, 9th Ward, p. 139; 1870, 7th Election District, 9th Ward, p. 34; 1880, District No. 1, Enumeration District 230, p. 10.

14. "Report of Richard L. Hopkins Overseer of the Poor, Town of White Plains 1895–1896," published by the *Westchester News* (Apr. 3, 1897). The names of the many recipients are listed but Bard's is not among them. Mary Hickerson, of Croton, New York, a student of the Collyer shipbuilding enterprise, reported that she had found a note in George Collyer's papers with the entry "$25 to James Bard, White Plains, for coal and food."

15. Reported by the late Elizabeth Stanton Anderson, Samuel Ward Stanton's daughter.

CHAPTER TWO
Clientele: Captains, Commanders, Commodores, Friends

1. Henry Noble McCracken, *Blithe Dutchess* (New York, 1958), 171.

2. "The Famous Englis Shipyard," *Master, Mate & Pilot* (July 1911).

3. Most of the yards were concentrated from Corlear's Hook up on the East River shoreline to Eleventh Street. See G. W. Sheldon, "The Old Ship-Builders of New York," *Harper's* (July 1882). Others were located directly across the river at Greenpoint, Brooklyn.

4. See Tallman's obituaries in the *New York Times* (Aug. 15 and 20, 1871), and the *Rockland County Journal* (Aug. 21, 1871).

5. See Alexander B. Callow, *The Tweed Ring* (New York, 1977), and Leo Hershkowitz, *Tweed's New York, Another Look* (Garden City, New York, 1977).

6. In the *Record of the Proceedings and Ceremonies Pertaining to the Erection of the Franklin Statue in Printing House Square... Presented to the Press and Printers of the City of New York* (New York [privately printed], 1872), and in Albert DeGroot's obituaries in the *New York Times* (Sept. 20, 1884), and the *Richfield Springs Mercury* (Sept. 27, 1884), his father is listed as Garrett DeGroot. In Harriet E. Bard's White Plains death certificate of Jan. 5, 1897, she is listed as the daughter of Garrett DeGroot.

7. *Record of the Proceedings,* op. cit. A slightly different version of this story also appeared in each of the DeGroot obituaries cited above.

8. See DeGroot's *New York Times* (Sept. 20, 1884) obituary cited above.

9. Ibid.

10. Obituary in the *New York Times* (Dec. 10, 1884).

11. See J. C. Curtis, "Sloops of the Hudson 1880–1850," in *New York History,* Volume XIV (Jan. 1933).

12. *Rockland County Journal* (July 22, 1871).

CHAPTER THREE
The Marine Painter's Trade and Art

1. A. J. Peluso, Jr., "The Hoboken School," *Maine Antique Digest* (Aug. 1977).
2. A. J. Peluso, Jr., "Heaven's Broad and Simple Sunshine, The Marblehead Marine Photographs," *Maine Antique Digest* (Aug. 1986); "Charles E. Bolles: Photographs of Yachts Under Sail and Steam," *Maine Antique Digest* (June 1990); and "New York's Maritime Photographers," *Maine Antique Digest* (May 1992).

CHAPTER FOUR
Technique of the Bards

1. *American Artists' Materials Suppliers Directory, Nineteenth Century* (Park Ridge, New Jersey, 1987) reports that "[T]he firm of Dechaux was a major New York art supplier and its clientele reads like a Who's Who of American artists. Their artist patrons included Thomas Sully, John W. Jarvis, Henry Bryant, John W. Audubon, William S. Mount and his brother Shepard A. Mount, Asher Durand, George W. Flagg, John Verderly, Henry Inman, Daniel Huntington, Charles Elliot, Sanford R. Grifford, Jasper Cropsey and James Bard, just to name a few."
2. Erback & Diffenbaugh, according to their business card, also offered "Looking Glasses and Picture Frames / Mouldings of all kinds for frames and decorations / Oval frames for photographs and paintings / Cords and tassels for picture and window shades / Window cornices of various patterns." Their card is affixed to the *Columbia* and *Vanderbilt* paintings of 1873.
3. See Fred Erving Dayton, *Steamboat Days* (New York, 1925), 173.

CHAPTER FIVE
Painting America Under Steam and Sail

1. Note that Bard never exhibited at the National or American Academies, nor at the Brooklyn Art Association. He belonged to no art club, such as Salmagundi or Century, and he was not a member of the Art Students League.
2. Among many sources are "What is American Folk Art? A Symposium," *The Magazine Antiques* (May 1950): 355–62; *Beyond Necessity: Art in the Folk Art Tradition* (Winterthur, Delaware, 1977); and *Five-Star Folk Art* by Jean Lipman (New York, 1990).
3. The term "Hudson River School," for example, was initially used as a term of opprobrium. "American" art was generally sold through the academies. The first commercially successful gallery to feature American art—William McBeth's—was not opened until the 1890s. Whereas the gallery held a pioneering sale in 1919 of the "Hudson River Group," it was not until 1931 that they held their first sale of the "Hudson River School."
4. Francis Waring Robinson Papers (Detroit Institute of Fine Arts), Archives of American Art.
5. Mumford's "Brown Decades" encompass the second half of the nineteenth century.
6. Paul DiMaggio, "Cultural entrepreneurship in nineteenth-century Boston, part II: the classification and framing of American art," *Media Culture and Society* 4 (1982).
7. Clay Lancaster, "Floating palaces aground. How the steamboat fostered a little-known U.S. style, 'Steamboat Gothic,' creating strange mansions that now crumble on the riverbanks of the Midwest," *Art News* (Sept. 1950).

Select Bibliography

Garrett, Wendell. "James (1815–97) and John (1815–56) Bard, Maritime Artists and Historians of the Hudson River." *Americana and Decorative Arts (Property of the New-York Historical Society).* Sotheby's, New York. January 29, 1995.

Hoffman, Renoda. *It Happened In Old White Plains.* White Plains, New York 1989.

Jensen, Oliver. "Side-wheels and Walking Beams." *American Heritage.* August 1961.

Lipman, Jean. "J. & J. Bard: Picture Painters." *New York Times* (Westchester County Weekend Edition). June 5, 1977.

Peluso, A. J., Jr. "J. & J. Bard, Picture Painters."

American Neptune, Volume XXXVI, No. 3, July 1976.

———. *J. & J. Bard, Picture Painters.* New York, 1977.

Sands, John. "The River Bards." *FMR.* October 1984.

Sniffen, Harold. "James and John Bard." In *American Folk Painters of Three Centuries* (Whitney Museum of American Art), edited by Jean Lipman and Tom Armstrong. New York, 1980.

Sniffen, Harold, and Alexander Crosby Brown. "James and John Bard, Painters of Steamboat Portraits." *Art In America.* April 1949.

LIST OF KNOWN BARDS

This is a list of Bard works that are known to have existed at one time, but which are not necessarily extant. Cases in which very little information is given usually indicate that the work is known only from a photograph. When it was possible to infer the medium from the photograph, the medium is given here, followed by a question mark.

The following abbreviations are used in the list:

AAR	Abby Aldrich Rockefeller Folk Art Center, Williamsburg, Va.
ABS	American Bureau of Shipping, New York, N.Y.
AH	America Hurrah, New York, N.Y.
AIHA	Albany Institute of the History of Art, Albany, N.Y.
BHS	Brooklyn Historical Society, Brooklyn, N.Y.
CBS	CBS, Inc., New York, N.Y.
CC	Colby College, Waterville, Maine
CMB	Chase Manhattan Bank, N.A., New York, N.Y.
DMM	M. H. DeYoung Memorial Museum, Fine Arts Museums of San Francisco, San Francisco, Calif.
FRHS	Fall River Historical Society, Fall River, Mass.
GCHS	Green County Historical Society, Xenia, Ohio
GCPL	Glen Cove Public Library, Glen Cove, N.Y.
HL	Huntington Library, San Marino, Calif.
HMA	Hood Museum of Art, Dartmouth College, Hanover, N.H.
HRMM	Hudson River Maritime Museum, Kingston, N.Y.
MAFA	Museum of American Folk Art, New York, N.Y.
MAG	Memorial Art Gallery of the University of Rochester, Rochester, N.Y.
MCHA	Monmouth County Historical Association, Freehold, N.J.
MCNY	Museum of the City of New York, New York, N.Y.
MFAB	Museum of Fine Arts, Boston, Mass.
MM	Mariners' Museum, Newport News, Va.
MS	Mystic Seaport, Mystic, Conn.
N/A	Not available
NBMAA	New Britain Museum of American Art, New Britain, Conn.
NGA	National Gallery of Art, Washington, D.C.
NMAA	National Museum of American Art, Smithsonian Institution, Washington, D.C.
NMAH	National Museum of American History, Smithsonian Institution, Washington, D.C.
NYHS	New-York Historical Society, New York, N.Y.
NYSHA	New York State Historical Association, Cooperstown, N.Y.
NYSM	New York State Museum, Albany, N.Y.
PC	Private Collection
PEM	Peabody Essex Museum, Salem, Mass.
QHS	Queens Historical Society, Flushing, N.Y.
RIHS	Rhode Island Historical Society, Providence, R.I.
SG	Smith Gallery, New York, N.Y.
SHSC	Steamship Historical Society Collection at the University of Baltimore Library, Baltimore, Md.
SHSHS	Senate House State Historic Site, Kingston, N.Y.
SL	Sotheby's, London, England
SM	Shelburne Museum, Inc., Shelburne, Vt.
SMNC	Stamford Museum & Nature Center, Stamford, Conn.
SPLIA	Society for the Preservation of Long Island Antiquities, Long Island, N.Y.
USCG	U.S. Coast Guard Academy Museum, New London, Conn.
WA	Wadsworth Atheneum, Hartford, Conn.

SUBJECT	BUILT	MEDIUM	SIZE	WHEREABOUTS	SIGNED
A. G. Lawson (schooner)	1866	Oil	34 × 43"	PC	1868
Addison F. Andrews (revenue cutter)	1863	Oil	20½ × 29½"	CC	1865
Adelphi	1863	Oil?	N/A	N/A	1863
Albany	1880	Watercolor	N/A	MCNY	1880
Albany	1880	Watercolor	17⅛ × 25⅝"	MM	1881
Albany	1880	Watercolor?	N/A	N/A	1880
Albany	1880	Watercolor	N/A	PC	1882
Albertina (on reverse *M. . .*)	1882	Watercolor	16 × 37½"	MCNY	1882
Albertina	1882	Watercolor	22½ × 39½"	MM	1882
Albertina	1882	Drawing	20¾ × 39¾"	MM	1882
Alice C. Price	1853	Drawing	14⅞ × 35¾"	MM	1853
Alida	1847	Oil	30 × 50"	MM	1847
Alida	1847	Oil	30 × 52"	PC	1848
Alida	1847	Oil	29 × 49"	SM	Undated
Alida (as rebuilt)	1856	Oil	30 × 48"	MM	1873
Alida (as rebuilt)	1856	Oil	30 × 52"	MM	1856
Almendares	1845	Oil	29 × 49"	PC	1846
Amanda Winants	1863	Oil	29¾ × 50"	MM	N/A
America	1852	Oil	32¾ × 52"	SHSHS	1852
America	1852	Oil	32½ × 51"	PC	Undated
America	1852	Oil	35¾ × 56"	NMAH	Undated
America	1852	Oil	34 × 53"	MM	1853
America	1852	Oil	N/A	AIHA	1852
America (schooner yacht)	1851	Oil	43¾ × 63¼"	AAR	1851
America-Dispatch (steam yacht)	1876	Watercolor	15 × 23¾"	MCNY	Undated
American Eagle (sloop)	1850	Oil	28½ × 40"	PC	Undated
American Eagle (sloop)	1850	Oil	32 × 52"	PC	1856
Americus	1871	Drawing	18⅜ × 40½"	MM	1871
Andrew Fletcher	1864	Drawing	15 × 19⅞"	MM	1864
Andrew Fletcher	1864	Oil?	N/A	N/A	1864
Andrew Fletcher	1864	Oil	16 × 26"	MCNY	1864
Andrew Harder	1864	Oil	30 × 50"	MM	1864
Anglo-American	1849	Oil	N/A	PC	1849
Anna	1854	Oil	30 × 52"	MM	1858
Annie J. Lyman	1862	Oil	30 × 50"	PC	1863
Antelope	1862	Drawing	14½ × 40¼"	MM	1862

SUBJECT	BUILT	MEDIUM	SIZE	WHEREABOUTS	SIGNED
Armenia	1847	Watercolor	29³⁄₁₆ × 49³⁄₁₆"	WA	1848
Armenia	1847	Watercolor	N/A	PC	Undated
Armenia	1847	Watercolor	27¼ × 49"	SM	Undated
Arrowsmith	N/A	Oil	30 × 50"	PC	1869
Aurora	1849	Oil?	N/A	N/A	1849
Austin	1853	Oil	30 × 52"	NMAH	1853
Austin	1853	Oil	N/A	PC	1861
Austin	1853	Oil	30 × 52"	SHSHS	1857
Austin	1853	Oil	30 × 52"	MM	1857
Balloon	1839	Watercolor	N/A	NYSM	Undated
Balloon	1839	Watercolor	18 × 32"	MM	N/A
Baltic	1848	Oil	29 × 49"	PC	1848
Baltic	1848	Watercolor?	N/A	N/A	1848
Belle	1837	Oil	29 × 48⅞"	MM	Undated
Belle Horton	1881	Oil?	N/A	N/A	1881
Belle Horton	1881	Watercolor	19½ × 38⅜"	MM	N/A
Bellona	1818	N/A	N/A	N/A	1827
Berkshire	1864	Drawing	16⅜ × 45⅝"	MM	1864
Berkshire	1864	Oil?	N/A	N/A	1864
Black Warrior	1852	Oil	35 × 54"	MM	1853
Blackbird	1864	Oil	N/A	PC	1864
Blackbird (on reverse *Galafre*)	1864	Drawing	15¼ × 34½"	MM	1864
Block Island	1882	Drawing	17½ × 40⅝"	MM	1882
Boston	1850	Oil	30 × 54¼"	SM	1850
Brilliant	1868	Drawing	14 × 35⅝"	MM	1868
Broadway	1837	Oil	33 × 56"	NYHS	1858
Brooklyn	1836	Oil	N/A	BHS	1846
Brother Jonathan	1850	Oil	N/A	PC	1851
C. P. Smith	1853	Oil	27 × 48"	NYSHA	1854
C. P. Smith	1853	Oil	30 × 50"	MM	1857
C. Vanderbilt	1847	Oil	34 × 56"	MM	1873
C. Vanderbilt	1847	Oil	N/A	PC	1847
C. Vanderbilt	1847	Oil	28 × 47"	SM	1847
C. Vanderbilt (schooner)	1847	Oil	27⅛ × 40½"	PC	1846
C . . .	N/A	Oil	N/A	HL	1853
Calhoun	1851	Oil	33 × 54"	SHSHS	1856
Calhoun	1851	Oil	30 × 52"	MM	1857
Casper Lawson	N/A	Oil	33 × 52"	PC	1862
Castleton	1870	Oil?	N/A	N/A	1870
Catherine (on reverse *Rattler*)	1850	Drawing	12½ × 39¼"	MM	Unsigned
Cayuga	1849	Oil	29 × 52"	MM	1849
Cayuga	1849	Oil	29 × 49"	NYHS	1849
Cayuga	1849	Oil	N/A	PC	1849
Chauncey Vibbard	1864	N/A	N/A	N/A	1864
Chrystenah	1866	Watercolor	N/A	PC	1870
Chrystenah	1866	Oil	37½ × 60"	PC	1867
City of Albany	1863	Oil?	N/A	N/A	1863
City of Brockton	1886	Watercolor	N/A	FRHS	Undated
City of Brockton	1886	Watercolor	24 × 48"	MM	1887
City of Catskill	1880	Watercolor	21¾ × 46"	MM	1880
City of Catskill	1880	Watercolor?	N/A	GCHS	Unsigned
City of Catskill	1880	Watercolor	25⅞ × 51"	PC	1880
City of Catskill	1880	Watercolor	26 × 51"	MM	1880
City of Fall River	N/A	Watercolor	22 × 48"	PC	1884
City of Hudson	1864	Drawing	14⅜ × 40¾"	MM	Undated
City of Hudson	1864	Oil?	N/A	N/A	Undated
City of Kingston	1884	Watercolor	25½ × 47½"	SHSHS	1884
City of Troy	1867	Oil?	N/A	N/A	1878
Cleopatra	1836	Gouache?	N/A	N/A	1836
Cleopatra	1836	Watercolor	10 × 22¾"	MCNY	Undated
Columbia	1841	Oil	30 × 48"	MM	1873
Columbine	1862	Oil?	N/A	N/A	1862
Columbus	1838	Drawing	13⅝ × 35⅛"	MM	Undated
Columbus	1838	Watercolor	22¾ × 32⅝"	NYHS	Undated
Commerce	1825	Gouache?	N/A	N/A	Undated
Commerce	1825	Watercolor	12½ × 24"	MCNY	Undated
Commodore	1848	Oil	34 × 56"	MM	1857
Commonwealth	1855	Oil	35¾ × 57¾"	PC	Undated
Confidence	1849	Oil	30 × 50"	PC	1850
Connecticut	1848	Oil	34 × 56"	MS	1873
Connecticut	1848	Oil	34 × 56⅝"	MM	Undated
Cornelia	1852	Oil	N/A	PC	1852

SUBJECT	BUILT	MEDIUM	SIZE	WHEREABOUTS	SIGNED
Crystal Stream	1873	Watercolor	24½ × 39⅜"	MM	1882
Crystal Stream	1873	Drawing	15 × 19⅞"	MM	Undated
Cuba	1854	Oil	30 × 52"	PC	1854
Cygnus	1881	Watercolor	26½ × 51¼"	MM	1881
D. R. Martin	1863	Watercolor	12 × 29"	MCNY	1866
Daniel Drew	1861	Oil	N/A	ABS	1862
Daniel Drew	1861	Oil	25¼ × 40"	PC	1874
Daniel Drew	1861	Oil	30 × 50"	NYSM	1860
Daniel Drew	1861	Oil?	N/A	N/A	1861
Daniel S. Miller	1862	Oil	N/A	PC	1862
Delaware	1852	Oil	32 × 52"	MM	1852
Dewitt Clinton	1828	Watercolor	22⅝ × 36⅜"	MM	Undated
Dewitt Clinton	1828	Watercolor	N/A	PC	N/A
E. Corning, Jr.	1854	Oil	N/A	PC	1861
E. Corning, Jr.	1854	Oil	30 × 50"	N/A	1861
El Dorado	1851	Oil	46 × 64"	NYHS	1851
Eliza Hancox (cut down)	1863	Oil	18⅝ × 36½"	PC	1864
Eliza Hancox	1863	Drawing	15 × 39½"	MM	1863
Ella	1859	Oil	N/A	PC	1859
Ella	1859	Oil	30 × 50"	PC	1860
Ella	1859	Oil	29¼ × 48"	SMNC	1860
Ella Jane (sloop)	N/A	Oil	N/A	PC	1852
Elm City	1855	Oil	35 × 58⅛"	MM	1860
Emma Hendrix (schooner)	N/A	Oil	32 × 52"	PC	1858
Empire of Troy	1843	N/A	N/A	N/A	1843
Enoch Dean	1852	Oil	29 × 49"	AAR	1852
Eureka	1840	Pencil tracing	9⅝ × 28⅞"	MM	1840
Fanny	1825	Watercolor	19 × 32"	MM	1831
Fanny	1863	Drawing	14⅜ × 38⅛"	MM	Undated
Fanny	1863	Oil	30 × 50"	MM	1863
Fessenden (revenue cutter)	N/A	Oil	36 × 56"	PEM	1866
Florence	1868	Oil	N/A	PC	Undated
Florence	1868	Drawing	15⅜ × 35¹¹⁄₁₆"	MM	Undated
Flushing	N/A	Oil	N/A	QHS	Undated
Forest City	1854	Oil?	N/A	N/A	N/A
Francis Skiddy	1852	Oil	36 × 64"	HRMM	1859
Francis Skiddy	1852	Oil	36 × 55"	MM	1856
Francis Skiddy	1852	Oil	34 × 55"	PC	1853
Frank	1834	Watercolor	N/A	PC	N/A
Frank Herbert (schooner)	N/A	Oil	34 × 52"	PC	1865
Fulton	1836	Oil	N/A	BHS	1846
Galafre (on reverse *Blackbird*)	1864	Drawing	15¼ × 34½"	MM	1864
Galveston	N/A	Oil?	N/A	NYHS	N/A
General Sedgwick	1864	Watercolor	22½ × 35⅝"	MM	1877
General Sedgwick	1864	Watercolor	21 × 42"	PC	1882
George Birkbeck, Jr.	1853	Oil	28¾ × 48⅞"	MM	Undated
George Law	1852	Oil	32 × 52¼"	MM	1853
George Mark	1852	Watercolor	15 × 24"	MCNY	1864
George S. Wood (schooner)	N/A	Oil	33¼ × 53"	NMAH	Undated
George T. Olyphant	1861	Drawing?	N/A	N/A	1861
George T. Olyphant	1861	Drawing	14⅛ × 40⅛"	MM	1861
Glen Cove	1854	Oil	30 × 52"	PC	1855
Glen Cove	1854	Oil	30 × 52"	GCPL	1855
Globe	1842	Watercolor	26 × 39"	PC	Undated
Governor Andrew	1874	Watercolor	N/A	MCNY	1876
Grey Hound	1863	Oil	30 × 50"	MM	1864
Harlem	1871	Watercolor	24½ × 49¼"	HL	1878
Harlem	1871	Oil	30 × 50"	MM	1872–73
Henry Andrew	1859	Oil	13 × 29"	MCNY	Undated
Henry Clay	1851	Oil	30 × 52"	MM	1851
Henry Clay	1851	Oil	30 × 52"	PC	Undated
Henry E. Bishop	1856	Watercolor	N/A	PC	1886
Henry Smith	1854	Watercolor	18 × 29"	PC	Undated
Hero & North America	1846	Oil?	N/A	N/A	1846
Highlander	1835	Watercolor	N/A	PC	Undated
Highlander (ferry)	1876	Watercolor	18 × 35"	MCNY	N/A
Hudson	1852	Tracing	14⅞ × 29"	MM	N/A
I. N. Seymour	1860	Oil	10½ × 21¼"	MCNY	1866
Idlewild	1876	Drawing	14⅜ × 41¾"	MM	1876
Idlewild	1876	Watercolor	N/A	PC	1889
Illinois	1837	Watercolor	22¼ × 39"	MM	1837
Indiana	1840	Watercolor	25¾ × 31¾"	MM	1840

SUBJECT	BUILT	MEDIUM	SIZE	WHEREABOUTS	SIGNED
Isaac Smith	1861	Oil	30 × 52"	PC	1861
Isaac Smith	1861	Oil?	N/A	N/A	1861
Island City	1850	Oil	30 × 50"	PC	1850
J. Putnam Bradlee	1875	Drawing	N/A	MM	Undated
J. Putnam Bradlee	1875	Watercolor	14 × 32¾"	MCNY	1876
J. T. Waterman (ferry)	1858	Oil?	N/A	N/A	1858
Jacob H. Tremper	1885	Watercolor	22 × 39¾"	MM	1885
Jacob H. Tremper	1885	Watercolor	21½ × 39½"	PC	1885
Jacob H. Vanderbilt	1862	Drawing	15⅞ × 40¾"	MM	1862
Jamaica (ferry)	1837	Oil	N/A	BHS	1846
James A. Stevens	1857	Oil	30 × 50⅛"	MM	1857
James A. Stevens	1857	Watercolor	N/A	PC	1873
James A. Stevens	1857	Watercolor	12¾ × 27¾"	MM	1857
James F. Freeborn	1862	Oil	30 × 50"	MM	1863
James H. Elmore	1855	Drawing	5¼ × 8¾"	MM	Undated
James N. Thompson	1867	Watercolor	20 × 40"	PC	1883
James W. Baldwin	1860	Oil	35 × 60"	NMAH	Undated
James W. Baldwin	1860	Oil	34½ × 59½"	PC	1861
James W. Baldwin	1860	Oil	34 × 58¼"	MCNY	1861
James W. Baldwin	1860	Oil	34½ × 59½"	NYHS	1865
Jas. F. Fisk, Jr.	1869	Oil	N/A	MAG	1870
Jay Cooke	1867	Oil?	N/A	N/A	N/A
Jay Gould	1868	Drawing	16⅝ × 40"	MM	1868
Jenny Lind	1850	Drawing	19¾ × 36⅝"	MM	1850
Jenny Lind	1850	Oil	28¾ × 47¾"	NYHS	1850
Jesse Hoyt	1862	Oil	30 × 50"	SG	1862
Jesse Hoyt	1862	Oil	30 × 50"	MM	1862
Jesse Hoyt	1862	Oil	30 × 50"	SM	Undated
John Birkbeck	1854	Oil	29⅞ × 52⅜"	NGA	1854
John Birkbeck	1854	Oil	30¼ × 52½"	MM	1860
John Birkbeck	1854	Oil	30 × 50"	NYHS	1858
John Griffith (schooner)	1854	Oil	30 × 52"	HRMM	1855
John L. Hasbrouck	1862	Oil	30 × 52"	MAFA	1865
John L. Hasbrouck	1862	Watercolor	13⅞ × 21¼"	MM	1864
John L. Hasbrouck	1862	Drawing	13⅞ × 21¼"	MM	Undated
John P. Jackson	1860	Oil	32 × 53½"	MM	1860
John Sylvester	1866	Watercolor	N/A	PC	Undated

SUBJECT	BUILT	MEDIUM	SIZE	WHEREABOUTS	SIGNED
Joseph Belknap	1849	Oil	30 × 50"	PC	Undated
Joseph Belknap	1849	Oil	N/A	MM	1850
Joseph C. Doughty	N/A	Oil?	N/A	N/A	1861
Kaaterskill	1882	Watercolor	30 × 50"	SM	1882
Kaaterskill	1882	Watercolor	N/A	PC	1884
Kaaterskill	1882	Watercolor	26¾ × 48½"	HL	1882
Kaaterskill	1882	Watercolor	30½ × 52½"	MM	1883
Keyport	1853	Oil	32 × 52"	PC	1853
Keyport	1853	Oil	N/A	MCHA	1853
Kingbird (schooner)	1855	Oil	29½ × 52¼"	PC	1855
Leader	1883	Watercolor	24 × 40"	MM	1883
Leviathan	1853	Oil	32 × 50"	PC	1855
Lewis R. Mackey (schooner)	N/A	Oil	33½ × 52"	NYHS	1854
Lewis R. Mackey (schooner)	N/A	Oil	30 × 50"	PC	1858
Lewis R. Mackey	N/A	Oil	31 × 33"	MM	1853
Lexington	1835	Watercolor	19⅝ × 31⅞"	MM	Undated
Lexington	1835	Watercolor	15 × 20"	PEM	Undated
Long Island	1859	Oil	32 × 54"	PC	1860
M . . . (on reverse Albertina)	N/A	Drawing	16 × 37½"	MCNY	Unsigned
Marion	1876	Drawing	14¼ × 40½"	MM	1876
Martha (tug)	1862	Oil	30 × 50"	MM	1863
Martha Washington	1864	Oil	30 × 50"	MM	1864
Martha Washington	1864	Drawing	14⅞ × 35⅝"	MM	1864
Mary J. Finn	N/A	Oil	28 × 48"	MM	1876
Mary J. Finn	N/A	Watercolor	26½ × 47⅝"	PC	1876
Mary Powell	1861	Oil	22 × 33¼"	MM	Undated
Mary Powell	1861	Oil	30 × 50"	MCNY	1861
Mattano	1857	Oil	30 × 50"	PC	1859
Matteawan	1862	Oil	30 × 50"	PC	1863
McCulloch (revenue cutter)	N/A	Oil	36¼ × 56"	NBMAA	1866
McDonald	1852	Oil	32 × 53"	MM	1858
Menemon Sanford	1854	Drawing	N/A	HMA	Undated
Menemon Sanford	1854	Oil	N/A	PC	1855

SUBJECT	BUILT	MEDIUM	SIZE	WHEREABOUTS	SIGNED
Metamora	1846	Oil	24 × 54"	SM	1859
Metamora	1846	Oil	28¾ × 49"	MM	1855
Metamora	1846	Oil	33 × 53"	NYHS	1858
Milton Martin	1863	Oil	30 × 50"	PC	1868
Milton Martin	1863	Oil?	N/A	N/A	1863
Minnie Cornell	1879	Watercolor	34¾ × 50½"	MM	1880
Minnie Cornell	1879	Oil	N/A	PC	1864
Minnie R. Child	1856	Oil?	N/A	N/A	N/A
Montauk (ferry)	1846	Oil	N/A	BHS	1846
Montijo	1867	Drawing	12⅛ × 37⅛"	MM	1867
Montpelier	1862	Gouache?	N/A	N/A	1862
Morrisania	1871	Watercolor	30⅛ × 49⅞"	MM	1871
Moses Taylor	1859	Oil	30 × 50"	PC	1859
Mount Washington	1846	Oil	30 × 50"	MM	1873
Nantasket	1857	Oil	N/A	PC	N/A
Nantasket	1857	Oil	30 × 52"	SM	1857
Nantasket	1857	Oil	30 × 50"	MM	1857
Nassau (ferry)	1853	Oil	N/A	BHS	1846
Naushon	1845	Oil	26 × 40¼"	MM	1846
Nautilus	1866	Drawing	18½ × 45¼"	PEM	Undated
Nelly Baker	1854	Oil	30 × 52"	PC	1855
Nelly White	1866	Oil	N/A	PC	1867
Nelly White	1866	Drawing	14½ × 40"	MM	Undated
Neversink	1865	Oil	28 × 41½"	PC	1866
Neversink	1866	Oil	30 × 50"	PC	1866
New York	1841	Watercolor	17 × 29¼"	PEM	1841
New York	1887	Watercolor	14¾ × 33½"	CMB	1888
New York	1887	Watercolor	17½ × 35"	MCNY	1887
New York	1887	Watercolor	24 × 29½"	PC	1887
New York	1887	Watercolor	N/A	SHSC	1887
Niagara	1845	Oil	34¼ × 56¼"	NYSHA	1852
Norma	N/A	Oil	30 × 52"	PC	1858
North America	1840	Oil	31 × 53¼"	MM	1854
North America	1840	Oil?	N/A	N/A	1840
North America	1840	Watercolor	23½ × 33½"	PC	Undated
North America	1840	Watercolor	N/A	PC	1854
North Star	1852	Oil	42 × 64"	PC	1852

SUBJECT	BUILT	MEDIUM	SIZE	WHEREABOUTS	SIGNED
Nuhpa	1868	Drawing	14⅝ × 32⅝"	MM	Undated
Nuhpa	1868	Gouache?	N/A	N/A	1864
O. M. Pettit	1857	Oil	28 × 48"	PC	1857
Oakes Ames	1868	Drawing	11¾ × 27⅞"	MM	Undated
Oakes Ames	1868	Oil?	N/A	N/A	Undated
Oakes Ames	1868	Watercolor	14¾ × 33"	MCNY	Unsigned
Ocean	1849	Oil	29¼ × 35½"	PEM	1850
Oleander	1863	Drawing	14½ × 35¼"	MM	Undated
Olive Branch	1833	Oil	N/A	BHS	1846
Ontario	1825	Oil	22 × 34⅞"	MM	Undated
Orange (ferry)	1886	Watercolor	20 × 40"	PC	1887
Oregon	1845	Tracing	11 × 40½"	MM	N/A
Osceola	1838	Oil	22 × 34"	PC	1855
Oswego	1848	Oil	30 × 52"	MM	N/A
Over	1842	Oil	N/A	BHS	N/A
P. C. Schultz	1863	Gouache?	N/A	N/A	1863
Penobscot	1844	Tracing	10⅜ × 14⅞"	MM	N/A
Perry	N/A	Oil	17 × 34½"	PC	Undated
P. Crary	1852	Oil	30 × 52"	AH	1858
P. Crary	1852	Oil	30 × 50"	MM	1858
Plainfield	N/A	Oil?	N/A	N/A	N/A
Pleasant Valley	1870	Watercolor	13 × 29"	MCNY	1870
Pleasant Valley	1870	Oil?	N/A	N/A	N/A
Pomona	1861	Oil	N/A	PC	N/A
Pomona	1861	Oil?	N/A	N/A	1861
Port Royal	1862	Drawing	14⅛ × 35½"	MM	Undated
Princeton (ferry)	1880	Watercolor	21 × 37"	PC	1880
Providence	1832	Watercolor	23¾ × 33⅞"	RIHS	Undated
Ranger (schooner)	N/A	Oil	30 × 52"	PC	1865
Rattler (on reverse *Catherine*)	1850	Drawing	12½ × 39¼"	MM	1853
Red Ash	1858	Watercolor	15 × 36"	MCNY	Undated
Reindeer	1850	Oil	30 × 51"	PC	1850
Reindeer	1850	Drawing	15⅝ × 39"	MM	1850
Reindeer	1850	Oil	32 × 54½"	NYHS	1850
Reindeer	1850	Lithograph	23½ × 33¾"	MM	Undated
Rhode Island	N/A	Watercolor	N/A	PC	N/A

SUBJECT	BUILT	MEDIUM	SIZE	WHEREABOUTS	SIGNED
Rip Van Winkle	1845	Oil	30¾ × 31⅞"	MM	1854
Rip Van Winkle	1845	Oil	31¼ × 53"	MFAB	1854
Rip Van Winkle	1845	Watercolor	N/A	PC	N/A
Rip Van Winkle	1845	Oil?	N/A	N/A	N/A
Robert Knapp (schooner)	1850	Oil	33 × 52"	MM	1854
Robert Knapp (schooner)	1850	Oil	33 × 52"	CBS	Undated
Robert Knapp (schooner)	1850	Oil	33 × 52"	PC	1854
Robert L. Stevens	1835	Watercolor	17¾ × 32"	MM	Undated
Robert L. Stevens	1835	Oil	22 × 38½"	MM	Undated
S. A. Stevens	1855	Watercolor	25 × 39½"	NMAA	1873
Sailing on the Hudson	N/A	Oil	26 × 40"	PC	1874
San Rafael	1877	Watercolor	18½ × 40"	PC	1877
Saratoga	1877	Watercolor	28½ × 52"	NYHS	1881
Saucelito	1877	Drawing	16½ × 39½"	MM	Undated
Saugerties	1882	Watercolor	27 × 49"	MS	1890
Saugerties	1882	Watercolor	27¼ × 50⅛"	MM	1890
Seawanahka	1866	Drawing	15¾ × 48½"	MM	1866
Seawanhaka	1866	Oil	33 × 52"	SPLIA	1868
Seawanhaka	1866	Oil	30 × 50"	MM	1868
Seawanhaka	1866	Oil	30 × 50"	PC	1868
Senator	1847	Oil	29¼ × 49"	MM	1849
Seneca	1863	Oil	30 × 50"	MM	Undated
Seneca	1863	Oil	N/A	PC	Undated
Seneca	1863	Drawing	13⅝ × 35⅞"	MM	1863
Seth Low	1861	Watercolor/ Drawing	9³⁄₁₆ × 14¹⁵⁄₁₆"	MM	Undated
Shady Side	1873	Drawing	14¾ × 35⅝"	MM	Undated
Shady Side	1873	Oil	25¾ × 47⅞"	MM	Undated
Shady Side	1873	Watercolor	26 × 47¾"	MM	Undated
Silver Star	1863	Watercolor	13½ × 26½"	MCNY	Undated
Silver Star	1863	Oil?	N/A	N/A	1863
Sleepy Hollow	1865	Oil	N/A	PC	N/A
Smith Briggs	1862	Drawing	16¾ × 40⅛"	MM	1862
Smith Briggs	1862	Oil	N/A	PC	1863
Southampton (ferry)	1869	Oil	26 × 38"	NYHS	1880
Southerner	1846	Oil	30 × 50"	PEM	1846
Southfield (ferry)	1882	Drawing	14⅛ × 36¾"	MM	1882
St. Lawrence	1850	Oil	28⅞ × 48"	NGA	1850
St. Lawrence	1850	Oil	31½ × 52"	MM	1852
St. Nicholas	1845	Oil	N/A	PC	1845
Suffolk	1841	Watercolor	N/A	BHS	1841
Swallow	1836	Watercolor	8½ × 14¼"	MM	Undated
Swallow	1836	Watercolor	20 × 35½"	PC	1837
Sylvan Dell	1872	Watercolor	22¾ × 28½"	NYHS	Undated
Sylvan Dell	1872	Watercolor	18 × 38"	MCNY	1872
Sylvan Dell	1872	Watercolor	24¼ × 49"	MM	1878
Sylvan Dell	1872	Oil	N/A	PC	1873
Sylvan Dell	1872	Oil	N/A	N/A	1873
Sylvan Dell	1872	Oil	N/A	PC	1872
Sylvan Glen	1869	Watercolor	11⅝ × 21½"	MM	N/A
Sylvan Glen	1869	Watercolor	13 × 29"	MCNY	1870
Sylvan Glen	1869	Watercolor	22¾ × 28½"	NYHS	1870
Sylvan Grove	1858	Watercolor	23½ × 39"	NYHS	1871
Sylvan Grove	1858	Oil?	N/A	N/A	1858
Sylvan Shore	1858	Oil	N/A	SHSC	N/A
Sylvan Shore	1858	Oil?	N/A	N/A	N/A
Sylvan Shore	1858	Watercolor	25 × 39½"	NYHS	Undated
Sylvan Stream	1863	Watercolor	23½ × 38½"	NYHS	1871
Sylvan Stream	1863	Drawing	12⅝ × 34¼"	MM	Undated
Syracuse	1857	Oil	N/A	DMM	1858
Syracuse	1857	Oil	30 × 50"	NYHS	1858
Syracuse	1857	Oil	30 × 54"	PC	1857
Syracuse	1857	Oil	N/A	N/A	1858
Syracuse	1857	Oil	29¼ × 51¼"	PEM	1857
Syracuse	1857	Oil	N/A	AIHA	1857
T. F. Secor	1846	Oil	20½ × 29½"	PC	N/A
T. V. Arrowsmith	1860	Oil?	N/A	N/A	N/A
T. V. Arrowsmith	1860	Watercolor	N/A	PC	1869
Telegraph	1837	Watercolor	18¾ × 32⅛"	MM	1837
Thomas Collyer	1850	Oil	25¾ × 45¼"	PC	1850
Thomas Collyer	1862	Oil	35 × 55¼"	HRMM	1864
Thomas Collyer	1864	Oil	30 × 50"	PC	1874
Thomas Cornell	1863	Oil	N/A	PC	Undated
Thomas Cornell	1863	Watercolor	24½ × 49"	SHSHS	1879

SUBJECT	BUILT	MEDIUM	SIZE	WHEREABOUTS	SIGNED
Thomas E. Hulse	N/A	Oil	29¾ × 50"	NYHS	1851
Thomas Hunt	1851	Oil	N/A	MCHA	1853
Thomas Hunt and America	1851	Oil	34½ × 64½"	PC	1852
Thomas McManus	1861	Oil	30 × 52"	PC	1872–73
Thomas P. Way	1859	Oil	36 × 58½"	PC	1859
Thomas Powell	1846	Oil	21 × 38⅞"	MM	1846
Thomas Powell	1846	Oil	N/A	PC	1859
Thomas Powell	1846	Oil	30½ × 53½"	PC	1846
Tidal Wave (yacht)	1870	Oil	32 × 48"	PC	1871
Trojan	1845	Oil	25 × 38"	MM	1845
Union	1844	Oil	N/A	BHS	1846
United States (formerly *Bienville*)	1851	Oil	42 × 64"	PC	1852
Unknown (revenue cutter)	N/A	Oil	N/A	USCG	1866
Unknown (revenue cutter)	N/A	Watercolor	19⅝ × 35¾"	MM	N/A
Utica	1836	Watercolor	N/A	N/A	N/A
Utica	1836	Watercolor	15¼ × 22½"	MM	Undated
Utica	1836	Watercolor	19½ × 33"	PC	1839
Victoria	1859	Oil	N/A	PC	1859
Victoria	1859	Oil	30 × 50"	AH	1859
Virginia	1857	Tracing	13⅝ × 35⅞"	MM	N/A

SUBJECT	BUILT	MEDIUM	SIZE	WHEREABOUTS	SIGNED
Virginia Seymour	1862	Oil	30 × 50"	PC	1864
Virginia Seymour	1862	Oil?	N/A	N/A	1863
West Point	1860	Watercolor	13¼ × 29½"	MM	Undated
Westchester	1832	Sketch	5½ × 9"	PC	1892
Wiehawken (ferry)	1868	Watercolor	14½ × 33½"	MCNY	Undated
William Bayles (schooner)	N/A	Oil	32¾ × 52"	AAR	1860
William Bayles (schooner)	N/A	Oil	32¼ × 51¼"	MCNY	1854
William Bayles (schooner)	N/A	Oil	34 × 52"	PC	1860
William Collyer (schooner)	1846	Oil	26¾ × 42"	PC	1846
William Collyer (schooner)	1846	Oil	29 × 42"	MM	1848
William Cutting	1827	Oil	N/A	BHS	1846
William Fletcher	1864	Oil?	N/A	N/A	1864
William H. Morton (passenger barge)	1854	Oil	30 × 50"	MM	1856
William Harrison	1864	Oil	18 × 27¾"	MM	1865
William M. Tweed	N/A	N/A	N/A	N/A	N/A
William Tittamer	1864	Oil	N/A	PC	1864
Wilson G. Hunt	1849	Oil	28½ × 48¾"	MM	1849
Wyoming	1853	Watercolor	24 × 38"	PC	1870
Young America	1853	Oil?	12 × 15"	N/A	N/A
Young America	1853	Oil	30 × 50"	PC	1854

INDEX

NOTE:
Pages in *italics* refer to illustrations or captions.

A

A. G. Lawson, 74; *72, 87*
Adirondack, 43
Albertina, 144, 145
Alice C. Price, 111
Alida, 122, 141; *31*
Allaire engines, 45
Almendares, 32
Alms House Buildings (Blackwell's Island),
 25; *26*
Amanda Winants, 132
America (schooner yacht), 27, 74; *86*
America (towboat), *50*
America-Dispatch, 58; *46*
American Eagle, 74; *84*
American Folk Painting (Black and Lipman),
 143
American Institute of the City of New York,
 The, 19, 90
American Lithographic Company, 89
"American Steam Navigation" (Stanton), 29
American Steam Vessels (Stanton), 11, 28,
 29, 143
America's Cup, 27, 35; *86, 158*
Americus, 58; *82*
Americus Engine Company No. 6, *82*
Anderson, Captain, *91*
Andrew Fletcher, 49
Annie J. Lyman, 130, 131
Antelope, 111
Armenia, 55; *54*
Arrowsmith, 140, 141
Arrowsmith, T. V., *51*
Art News, 146
Astor, John Jacob, 55

Austin, 40, 41, 113
Austin, J. J., 111; *53*
Austin & Gillespie, *41*

B

Baker, Elisha, 89
Baldwin, James W., *102*
Baltic, 51
Banks, Simon, 58
Barbizon school, 11
Bard, Ellen, 16, 19, 28
Bard, Emily, 19
Bard, George, 19
Bard, Harriet, 28–29
Bard, James, 7, 8, 9–13, 15–16, 19, 25,
 27–29, 35, 36, 40, 45, 55, 58, 61, 68, 73,
 74, 89, 90, 105–06, 111, 113, 114, 115,
 120, 122, 141, 143, 144, 146; *18, 20, 22,
 24, 28, 29, 31, 32, 33, 37, 38, 41, 46, 48, 56,
 62, 66, 72, 86, 89, 92, 94, 106, 116, 124,
 130, 132, 136, 138, 139, 141, 147, 151, 156,
 158, 159*
Bard, James, Jr. (name of two sons of James
 Bard), 19
Bard, John, 7, 8, 9–13, 15–16, 19, 25, 27, 29,
 35, 36, 40, 105, 111, 113, 141, 146; *17,
 18, 26, 31, 32, 37, 94*
Bard, Joseph, 15, 16, 19
Bard, Julia, 19
Bard, Mary, 19
Bard, Nellie Purvis, 15
Barker, Virgil, 143
Barnum, P. T., 68
Belknap, Joseph, 58
Belle Horton, 106
Bellona, 15, 16, 36
Bennett, B., *84*
Birch, Thomas, 11

Bishop & Simonson, 45
Black, Mary, 143
Black Ball, 35
Black Star Line, 142
Blackwell's Island, 25; *26*
Bootman & Smith, 113
Boston, 25, 105
Boston & Nahant Steamboat Company, *92*
Bradlee, Francis B. C., 12, 45
Brainard & Lowler, 45
Briggs, N. S., 68, 73
Brilliant, 105; *139*
Broadway, 104, 105
Brooklyn, 111
Brooklyn Historical Society, 12
Brooklyn Yards, 40
Brother Jonathan, 111
Brown, Alexander Crosby, 143
Brown, Henry C., *127*
Brown, William H., 45
Brown & Bell, 45
*Brown Decades, A Study of Arts in America,
 The* (Mumford), 146
Buchman, David L., 11, 68
Bullock, C. Seymour, 12
Burtis, Devine, 45
Burtis, Devine, Jr., *106*
Butler, Ben, *136*
Buttersworth, James, 36, 74, 89, 90

C

Calhoun, 68; *66–68*
California, 94
Capture of the H.B.M. Frigate Macedonian
 by U.S. Frigate United States, *October 25,
 1812* (Chambers), *10*
Carmer, Carl, *54*
Casper Lawson, 87

Castleton, 40
Cayuga, 40, 114
Chambers, Thomas, 113; *10*
Chatterton Hill Church, 29
Chauncy Vibbard, 58
Chingarora, 105
Choules, Reverend, *38*
Chrystenah, 58; *80, 81, 105*
Citizen's Line, 106; *43*
City of Albany, 36
City of Brockton, 158
City of Catskill, 120; *150*
City of Fall River, 158
City of New York, 35
City of Troy, 105–6
"Civilization" (Emerson), 146
Civil War, 35, 68, 73, 89, 111; *37, 100, 125,
 128, 136, 141*
Cleopatra, 16, 36; *24–25*
Coffee, Joseph E., 111
Cole, Thomas, 113
Collyer, 61
Collyer, George, 36, 40, 74; *52*
Collyer, Thomas, 27, 36, 40, 55, 58, 74, 111; *62*
Collyer, William, 36, 40, 74, 111
Columbia, 147
Columbus, 17
Commerce, 16, 114; *17*
Commodore, 95
Commonwealth, 101
Confidence, 27; *33*
Cornelius Vanderbilt, 36, 114; *32, 34, 35*
Cornell, John V., 90, 113
Cozzens, Fred, 89, 90
Cozzens Hotel, 55
Crary, Palmer, 40; *112*
Crowell, Peter W., *119*
Cruise of the Steam Yacht North Star, *The*
 (Choules), *38*

Crystal Stream, 113; *157*
Currier & Ives, 90; *26*

D

Daily Graphic, The, 55
Daniel Drew, 58, 61, 113; *83*
Dart, 55
Dechaux, Edward, 120
Decker and Co. Joiners, 111
DeGroot, Albert, 13, 61, 66, 68; *60, 61, 62*
DeGroot, Garrett, 61
DeGroot, Harriet, 19, 61
Dewitt Clinton, 16; *22*
Dickens, Charles, 35
Dickey, William, 58
DiMaggio, Paul, 146
Dodge, S. N., 120
Drew, Daniel, 61; *24*
Dunham, H. R., 45

E

Eames, Charles, 7
Early American Art (Whitney Studio Club), 11
Early American Steamers (Heyl), 58
East River Ferry Company, *156*
Edison Electric Light Company, *43*
Eldredge, Elwin M., 12
Eliza Hancox, 111; *130*
Ella Jane, 58
Ella Persey, 102
Ellis Island, *51*
Emerson, Ralph Waldo, 8, 13, 146
Emma Hendrix, 114; *98, 99*
Endicott, 90
Englis Shipyard, 40, 105
Enoch Dean, 37
Erback & Diffenbaugh, 122
Erie Canal, 16

F

Fanny (1831), 16, 19, 36; *20*
Fanny (1863), *20, 21*

Farnham, Charles W., *95*
Fletcher, Andrew, 36, 58, 114; *148*
Fletcher engine, 46
Florence, 114
Fontenoy, Paul E., 73
Forest City, 40
Forrest, Edwin, *56*
Francis Skiddy, 113–14, 141
Frank, 16
Frank Herbert, 119
Freitag, Conrad, 89
"From Native Painting—A Re-Evaluation"
 (Barker), 143
Fulton, Robert, 15, 16

G

Galafre, 106
Garvey, Marcus, *142*
General Jackson, 16, 36
General Sedgwick, 68, 73
George S. Wood, 74; *85*
Germain, John, 55
German, George, *110*
Gibbons, Thomas, 16
Gibbons v. Ogden, 15–16
Glen Cove, 100
Gloucester Inner Harbor (Lane), *9*
Graham Line, *47*
Grant, Ulysses S., *71*
Great Eastern, 35; *112*
Great Republic, 35
Green-Wood Cemetery, 25, 27
Grey Hound, 136, 137

H

Harlem, 76, 79, *142*
Harlem and New York Navigation Company, *79*
Harlem Gaslight Company, 58
Haverstraw brickyards, 74; *85*
Heading, William, 68
Hendrik Hudson, 33
Hendrix, Emma, *98*
Henry Clay, 27, 40, 55, 58, 68

Hermione, 43
Heyl, Eric, 58
Hicks, Edward, 113
Highlander, 16, 40, 61; *32*
History of New York Shipyards (Morrison),
 27
Holbrook, 43
Homer, Winslow, 143
Hospital for Incurables (Blackwell's
 Island), 25
Howat, John K., 143
Hudson River and Its Painters, The (Howat),
 143
Hudson River by Daylight, The (McQuill), *83*
Hudson River Day Line, 29, 36
Hudson River School, 143
Hudson River Yacht Club, 74
Hudson, The (Carmer), *54*
Huge, Frederick, 113
Hunt, Thomas, *33*

I

Idlewild, 106
Illinois, 16; *18*
Indiana, 30
Irving, Washington, 29
Isaac Smith, 128, 129

J

J. C. Harrt, 158
J. G. Cozzens, 102
J. G. Emmoms, 51
J. Putnam Bradlee, 152–53
J. S. Terry, 51
Jacob H. Tremper, 155
Jacob H. Vanderbilt, 68, 105
Jacobsen, Antonio, 11, 89, 90, 111, 113; *50*
James, Henry, 143
James A. Stevens, 111; *112*
"James and John Bard, Painters of Steamboat
 Portraits" (Brown and Sniffen), 143
James W. Baldwin, 102
Jarves, James Jackson, 146

Jas. F. Fisk, Jr., 40, 58
Jay Gould, 40, 58
Jenny Lind, 111; *114, 115*
Jesse Hoyt, 36; *103*
John Birkbeck, 27; *51*
John Griffith, 40, 74
John L. Hasbrouck, 70, 71
John P. Jackson, 27–28
Joseph Belknap, 27, 58

K

Kaaterskill, 113; *123*
Keyport, 51

L

Lane, Fitz Hugh, 8; *9*
Law, George "Live Oak," 114
Lawrence & Foulkes, 45; *101*
Lawrence & Sneeden, 45, 113
Lawson, Casper, 87; *74*
Leviathan, 88, 89
Lewis R. Mackey, 74, 113; *127*
Lexington, 16, 36; *23*
Lind, Jenny, 68
Lipman, Jean, 143
Livingston, Robert R., 16
Long Island, 125
Long Island Historical Society, 12
Long Island & North Shore Passenger &
 Freight Transportation Company, *54*
Louise, 112

M

McCullough, James, 31
Magazine of Old Glass, The, 27
Mapes, James, 55
Marine Journal, 28
Marshall, John, 15, 16
Martha Washington, 118
Mary J. Finn, 73
Mary Jane Tweed, 58
Mary Powell, 90, *91*

Master, Mate and Pilot, 29
Menemon Sanford, 40
Metamora, 55; *56, 57*
Metamora, Chief of the Wampanoags, 56
Mexico, 47
Moore, Clement Clark, 15
Morgan Iron Works, 45
Morrisania, 68, 69, 79, 142
Morrisania Navigation Company, *79*
Morrisania Steamboat Company, *142*
Morrison, John H., 11, 27
Morse, Samuel, *30*
Morton & Edmonds, 45
Mount, William S., 113
Mumford, Lewis, 146
Murdock, George W., 12

N

Naushon, 111
Nelly Baker, 92, 93
Neptune Iron Works, 45
New Jersey Railroad, 27
New World, 68; *33*
New York, 159, 160, 161
New York, Albany & Troy Steamboat Passenger
 & Mail Line, 55; *95*
New York, Catskill and Athens Steamboat
 Company, *123*
New York & Galway Line, 47
New York & Glen Cove Steamboat Company,
 100
New York & Harlem Transportation Company,
 58
New York Historical Society, 12
New York Yacht Club, *118*
Niagara, 61, 66, 113; *60*
Niblo's Garden, 19
Norma, 97
North River Iron Works, 36
North Star, 36; *38, 39*
Norwich, 22
Norwich & New London Steamboat Company,
 101
Nuhpa, 106, 138

Nyack, New York, 58

O

Oakes Ames, 61
Ocean, 25, 105
Odell, John S., *30*
Ogden, Aaron, 16
Old Colony Steamship Company, *158*
Old Houses Corner Pearl & Elm, 16
Old Steamboat Days on the Hudson River
 (Buchman), 68
Oregon, 114; *34, 35*
Osborne, Cora, 55
Osceola, 61
Oswego, 36, 114

P

P. Crary, 108, 109
Painting in America, 1502 to the Present
 (Richardson), 143, 146
Palmer, Frances Flora Bond, 90
Pansing, Fred, 89, 113
Parsons, Charles, 90
Parsons, Charles (son of Charles Parsons), 90
Peabody Museum, 12
Pennsylvania Railroad, *154*
People's Line, The, *15*
Perry (Cornell), *113*
Perry (James and John Bard), *116, 117*
Perry Street (Manhattan), *27*
Pilot Boat Association, 89
Pleasant Valley, 40
Porter, Rufus, 113
Powelson, Gustavus A., *28*
Prescott Hotel, 68
Princeton, 154
Prospect Park Hotel, *83*
Providence, 16

Q

Quidor, John, 113

R

Raleigh, Charles S., *10*
Ranger, 121
Raritan River yards, 40
Red Ash, 36
Red Star, 35
Reindeer, 27, 66, 68, 105, 113; *62, 63, 64–65*
Reliance, 68
Resolute, 68
Richardson, E. P., 143, 146
Rip Van Winkle, 113; *125*
Robert Fulton, 29
Robert Knapp, 48, 74
Robert L. Stevens, 16, 113; *22*
Robinson, Francis Waring, 146
Robinson, H. R., *94*
Rochester, 16
Roger Williams, 61, 66, 113
Romer, William F., *102*
Rural Cemetery, 28, 29

S

S. A. Stevens, 151
Sailing on the Hudson, 74
St. John, 43
St. Lawrence, 105
Sandusky, 61
San Rafael, 40; *42*
Saratoga, 40, 106, 113; *43, 44, 45*
Saucelito, 40
Saugerties, 28
Schnakenberg, Henry, 11, 12
Seawanhaka, 54, 55
Secor, T. F., & Co., 45, 113
Senator, 19, 111
Seneca, 36, 111
Shady Side, 143; *79, 142*
Skiddy, Francis, *31*
*Sloops of the Hudson River, A Historical
 and Design Survey* (Fontenoy), 73
Smith, A. Cary, 89
Smith, David, *80*
Smith, Henry, 58

Smith, Holmes, 111
Smith, Isaac, 55, 58
Smith, James, 58
Smith, Joseph B., 89
Smith, Tunis, *80*
Smith, William, 89
Sniffen, Harold, 143
Southampton, 156
Southerner, 19
Southfield, 40, 105; *134–35*
Sovereign of the Seas, 35
Stanton, Samuel Ward, 11, 28, 29, 90, 105,
 143; *29, 83*
Starin, John H., *52*
Steam Navigation in New England (Bradlee), 45
Steers, George, 27
Stonington (Connecticut) Line, *95*
Stono, CSS, 128
Stoudinger, 15
Superior, 16
Supreme Court, 15–16
Swallow, 16, 122; *133*
Swallowtail, 35
Swiftsure Line, 36
Sylvan Dell, 58, 146; *76, 79*
Sylvan Glen, 146; *59*
Sylvan Grove, 58, 146; *78*
Sylvan Shore, 58, 146; *77*
Sylvan Stream, 58, 146; *78*

T

Tallman, John, 55, 58, 61
Tallman, Tunis, 55
Telegraph, 16, 19; *30*
Terry, Benjamin C., 40, 68
Thomas Collyer, 52
Thomas E. Hulse, 37
Thomas Hunt and America, 2–3, 4
Thomas McManus, 148, 149
Thomas P. Way, 107
Thomas Powell, 113; *32*
Tidal Wave, 58, 74; *74, 75*
Titanic, 29
Toccata for Toy Trains, 7

Traveller, 36
Traveller's Steamboat and Railroad Guide to the Hudson River, 25, 27
Tremper, Jacob, *102*
Trojan, 40, 111; *53*
Troy, Albany, and New York Towing Company, *147*
Truesdell, M. H., *15*
Turkey Glen, 108
Tweed, William M. "Boss," 58, 61; *82*
Tyler, James Gale, 90; *50*

U

Union Ferry Company, 12
United States, 47
U.S. Lighthouse Board, *118*
U.S. Patent Office, 8
Utica, 14, 15

V

Vanderbilt, Cornelius, 13, 15, 19, 36, 61, 114; *23, 24, 35, 38*
Van Loon & Magee, 45, 106
Van Rennsselaer, Stephen, 16, 19
Van Santvoord, Alfred, 36, 58, 61, 114; *83, 103*
Victoria, 110
Violet, 118
Voorhis, Commodore, *75*

W

Wakeman, Burr, 58
War of 1812, 8, 11; *10*
Washington Irving, 29
Westchester, 28; *29*
West Street (Manhattan), *27*
White Plains, New York, 28–29

Whitman, Walt, 35
Whitney Studio Club, 11, 141
Wiehawken, 124
William Bayles, 126
William Collyer, 74
William H. Morton, 96
William M. Tweed, 58; *70*
Willis, Nathaniel Parker, *31*
Willis, Thomas, 90
Wilson G. Hunt, 19
Wood, George S., 74
Woolsey, George, *116*
Wyltwyck, 102

Y

Yacht America, The (Raleigh), *10*
Yorke, William G., 90
Yorke, William H., 90